AN ILLUSTRATED BRIEF HISTORY
BRIEF HISTORY
of CHINESE
PORCELAIN

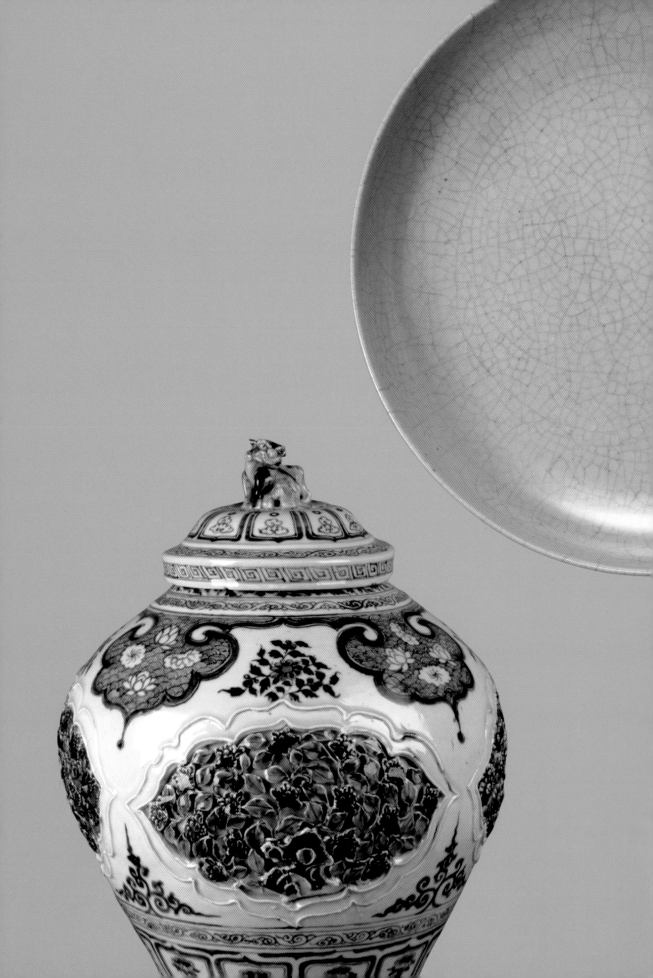

History · Culture · Aesthetics

AN ILLUSTRATED BRIEF HISTORY *of* CHINESE PORCELAIN

By Yang Guimei

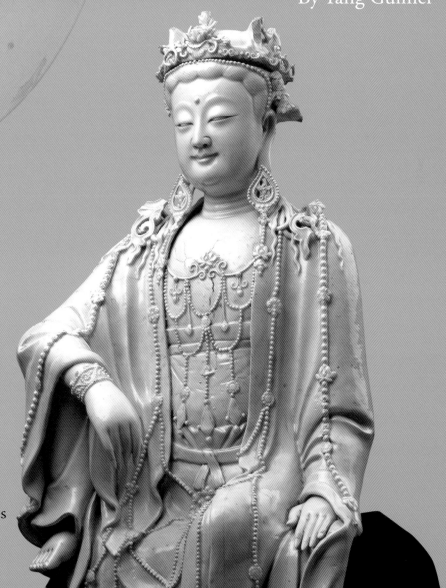

Better Link Press

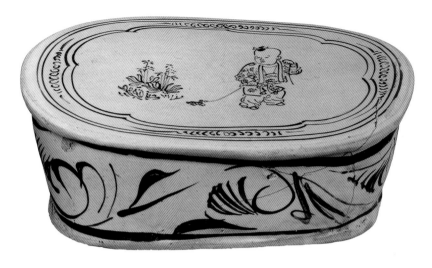

This book is edited and designed by the Editorial Committee of *Cultural China* series.

Text and Image by Yang Guimei
Translation by Alison Hardie
Cover Design by Wang Wei
Interior Design by Li Jing and Hu Bin (Yuan Yinchang Design Studio)

Editor: Wu Yuezhou
Editorial Director: Zhang Yicong

Senior Consultants: Sun Yong, Wu Ying, Yang Xinci
Managing Director and Publisher: Wang Youbu

ISBN: 978-1-60220-173-6

Address any comments about *An Illustrated Brief History of Chinese Porcelain: History · Culture · Aesthetics* to:

Better Link Press
99 Park Ave
New York, NY 10016
USA

or

Shanghai Press and Publishing Development Co., Ltd.
F 7 Donghu Road, Shanghai, China (200031)
Email: comments_betterlinkpress@hotmail.com

Printed in China by Shanghai Donnelley Printing Co., Ltd.

1 3 5 7 9 10 8 6 4 2

On page 2, left
Fig. 1 Large Lidded Jar with Pierced Panels Decorated in Underglaze Blue and Red (see page 68)

On pages 2 and 3
Fig. 2 Ru-Ware Celadon Plate (see page 37)

On page 3, right
Fig. 3 *Qingbai*-Glazed Figurine of Water-Moon Guanyin from Jingdezhen (see page 58)

Fig. 4 Cizhou-Ware White-Glazed Pillow with Design of Children at Play in Black Pigment
Song dynasty
Height 10 cm, length 25 cm, width 18.5 cm
Haidian Museum, Beijing

This was a common type of domestic porcelain item in the Song dynasty. The style of decoration in black on a white ground is characteristic of Cizhou ware.

(Illustration from: Haidian Museum ed., *Masterworks of Haidian Cultural Relics* [Haidian wenwu jingxuan ji], Beijing: Cultural Relics Press [Wenwu chubanshe], 2014.)

CONTENTS

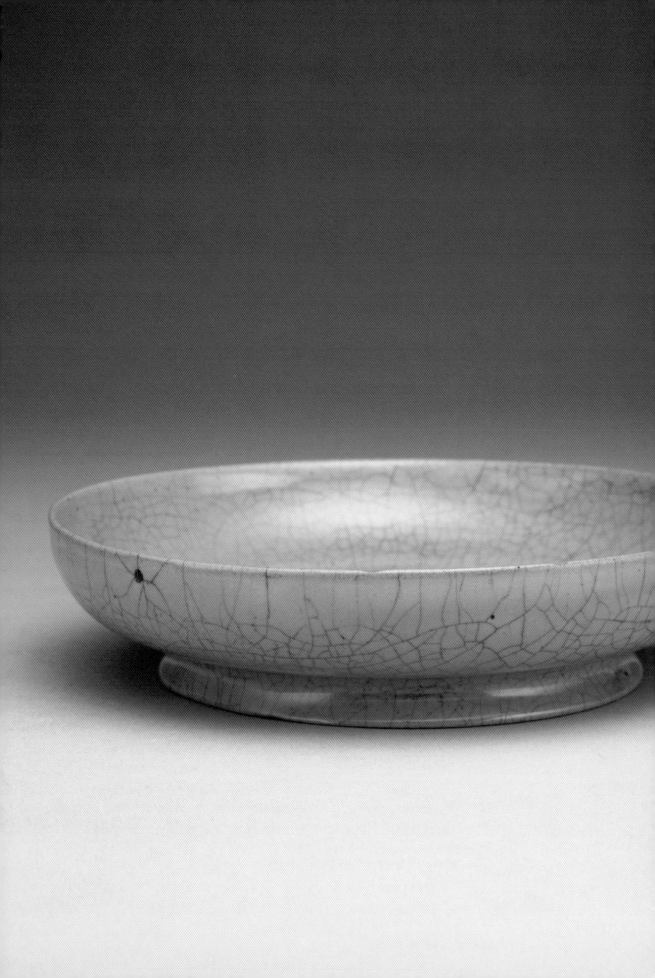

CONTENTS

On facing page
Fig. 5 Ru-Ware Celadon Plate
(see page 37)

CHAPTER I
FROM EARTHENWARE TO PORCELAIN

Pottery is made by shaping clay and firing at a high temperature. The origin of pottery is closely related to agricultural production. The earliest pottery—earthenware—discovered through archeological excavations in China survives from the cultures of the neolithic period, such as the earthenware of the Peiligang culture from Xinzheng in Henan Province, from Xianrendong in Wannian, Jiangxi (fig. 6), or from Zengpiyan in Guilin, Guangxi, dating as far back as six to eight thousand years ago.

Porcelain developed out of earthenware. The main differences between the two lie in the materials, firing temperature, and use of glazes. From the appearance of earthenware to the emergence of a primitive form of porcelain in the late Shang dynasty (1600–1046 BC), a period of development took place lasting three to five thousand years. In this gradual process of development, people were constantly experimenting, acquiring experience and improving their techniques; after reaching the highest level in the production of earthenware, they advanced step by step to the initial and then the mature stages of the age of porcelain.

1 The Sublimation of Clay: the Age of Earthenware

In China, the neolithic period was also the time when the culture of earthenware developed and reached its peak. The regional cultures defined by archeologists are based on variations in the earthenware of this period. The earthenwares from the neolithic cultures of each region each have their own distinctive shapes, styles, and forms of decoration. The colored pottery, black pottery, and white pottery which are particularly notable in this period all have clear differences in artistic style.

Neolithic culture in China can be divided into six main regional cultures: Yanliao culture, the cultures of the Central Plains (*zhongyuan*), Shandong, Gansu-Qinghai, Jiangsu-Zhejiang, and of the middle reaches of the Yangtze River. These varying cultures were formed by primitive tribes or clans, and the making of pottery was part of the agricultural life of these tribes. The techniques of making pottery at this time mainly consisted of the following elements:

Raw materials. Pottery was mostly made from yellow, red, or black clay which had been naturally washed by river water and left to settle, while some cooking vessels also included sand or gravel, powdered lime, ground rice-straw, broken pottery, or other ingredients used to improve the heat resistance of the vessel's body, so that it would not crack

Fig. 6 Earthenware Pot
Neolithic period
Height 18 cm, rim diameter 20 cm
National Museum of China
About ten thousand years old, this is the earliest earthenware vessel so far found in China.

at high temperatures. The ingredients of the clay affected the thickness and color of the vessel; the iron oxide content was particularly important for the color. The raw material of the white pottery characteristic of the Dawenkou and Longshan cultures was already very similar to the kaolin used for making porcelain, while the iron oxide content was far lower than that of other types of pottery, so that when fired at a high temperature it turned white. The emergence and spread of white pottery was an important stage in the transition from earthenware to porcelain.

Techniques for forming the vessels. At this period the techniques for forming earthenware vessels consisted of both hand-shaping and turning on a wheel. Hand-shaping was more common in the early stages of earthenware development. For example, wide-mouthed bowls, jars, and cylindrical jars (*guan*) which bear clear marks of hand-shaping also tend to be uneven in thickness and not entirely symmetrical. In addition, some zoomorphic pieces, such as pottery owls, bird-shaped flasks, and other earthenware sculptures, were also hand-shaped. Wheel-turned vessels could include those built up from strips of clay by coiling or those cast in molds and then finished by turning, or could be entirely wheel-thrown. Vessels made by coiling were produced by forming the clay into strips and then building these up layer by layer according to the desired shape and size; they were then smoothed on both inside and outside. Molded vessels could be made with either an internal or an external mold. Generally speaking, bowls, jars, basins and other vessels with a wide mouth and ring foot would be shaped with an internal mold. A slow wheel was used for hand-shaping and finishing of earthenware vessels. In the technique of throwing on a fast wheel, the rapid turning of the wheel makes it possible to draw up the clay and form it into the desired shape. The technique of wheel-throwing not

only increased the speed and reduced the cost of production; it also gave the vessels a more regular shape and even thickness. In later times it became the most important technique for the shaping of porcelain vessels.

Decoration. The decoration of earthenware vessels includes both additional work on the surface of the vessel and decorative patterns. When the surface of the half-dried or "leather-hard" vessel has been polished, it comes out of the firing process very shiny, so the aesthetic quality of a plain vessel can be enhanced by increasing its sheen. A slip, or layer of thinly diluted clay, may be added to the surface of the vessel; variations in the content of the slip will produce different colors when fired. For example, a slip with a high iron oxide content will produce a red color; a kaolin slip with added fluxing agent will produce a white color. In the later manufacture of porcelain, when a slip was added and then glazed and fired, this was to make the surface beautifully shiny, and to disguise any imperfections in the clay body.

The main types of line decoration include: (1) string marks, geometric designs, or squares etc. made by impressing or pecking the leather-hard vessel; (2) color painting, done with natural mineral pigments on the polished dried clay before firing so that the color would be permanent, the three main colors being red, black, and white; (3) added relief decoration formed by attaching strips of clay to the body in simple patterns, which also had the effect of strengthening the walls of the vessel; (4) piercing, usually on the foot of the vessel (or the stem of a high-stemmed stand), in square, round, or triangular shapes.

The kiln. More than one hundred kilns of the neolithic period have been discovered by Chinese archeologists, mostly in the Yellow River valley. Judging by the vessels excavated so far, the standard of pottery manufacture in the Yellow River valley was clearly superior to the Yangtze valley or the South China region.

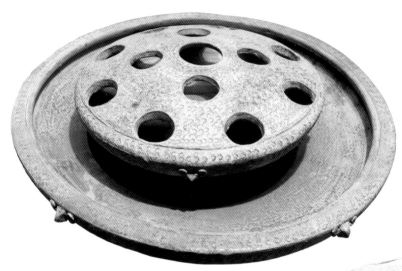

Figs. 7–8 Greenware Proto-Porcelain Wine Warmer

State of Yue, early Warring States period (475–221 BC)
Nanjing Museum

This curiously shaped vessel could be used either to heat or to cool wine by placing charcoal or ice on the tray.

The construction of kilns for the firing of pottery developed continuously, and the firing temperatures achieved gradually increased from 600+ degrees Celsius to 1,100 degrees. The rise in firing temperature was an essential condition for the production of porcelain: for the successful firing of proto-porcelain (known in English as stoneware or in its finer form as porcelanous ware) the kiln temperature must exceed 1,200 degrees, and thus the design of the kiln and control of its temperature are important conditions for the development of porcelain.

2 A New Domestic Favorite: Proto-Porcelain

The transition from pottery to porcelain was a process of development and improvement, and there have always been differing views on the definition of proto-porcelain. In the 1960s, the archeologist An Jinhuai (1921–2001) proposed a broad definition of porcelain, believing that porcelain was anything that fulfilled the following conditions: "The body is made of kaolin, while in some cases it may be tempered with powdered quartz or feldspar; It has a lustrous glaze; It is hard, resistant to heat, and when struck it makes a metallic sound; The body does not absorb water."

The Shang and Zhou (1646–256 BC) dynasties marked the highest development of China's ancient bronze culture, and bronze vessels are the most important and finest vessels of this period. Bronze vessels were used mostly by the nobility as sacrificial or ritual vessels and for music, but lacquer and earthenware vessels played a more important role in everyday life. The emergence and use of proto-porcelain was something quite new in the material culture of the Shang and Zhou periods, especially during the Shang and the Western Zhou (1046–771 BC), when even porcelaneous vessels which now seem very coarse and rough appear only in aristocratic tombs, and then only rarely. Over seven hundred proto-porcelain vessels were excavated in 2004 from an Eastern Zhou (770–256 BC) aristocratic tomb complex of the Yue kingdom at Hongshan on the border between Wuxi and Suzhou municipalities in Jiangsu Province. These were of many different types, covering virtually all the types of bronze ritual and utilitarian vessels (figs. 7 and 8). This could be described as a dream

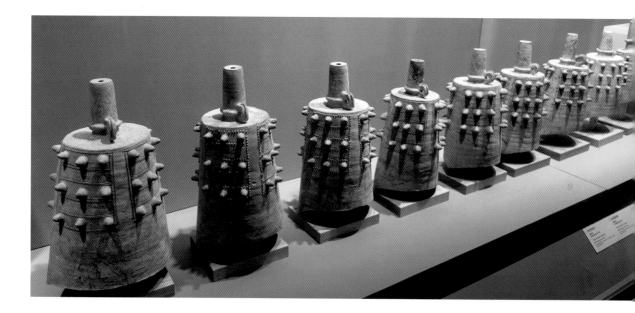

Fig. 9 Set of Bells in Greenware Proto-Porcelain
State of Yue, early Warring States period
Nanjing Museum
This set of bells, imitating bronze, was used in a
burial to show the status of the tomb occupant.

collection of proto-porcelain: its discovery
filled a gap in the history of Chinese
porcelain, and revealed the beginnings of
China's role as the millennia-old land of
porcelain. The date of the Hongshan Yue
tombs is approximately 473–468 BC, at the
height of Yue's power after the defeat of the
state of Wu by King Gou Jian (d. 465 BC).
The occupants of the tombs were aristocrats
below the rank of king or prince. We know
that in the Shang and Zhou ritual system
tombs and their contents were distinguished
by rank, and the bronze ritual vessels buried
with deceased nobles symbolized their
status. However, all the ritual vessels in the
Hongshan Yue tombs are proto-porcelain
greenware, stoneware, and earthenware
made in imitation of bronze ritual vessels
specifically as burial goods, but the groups
of ritual tripods, stem-bowls (or tazze), and
vases and the ensembles of bells (fig. 9),
chimes, and other musical instruments still
follow the grouping of bronze ritual vessels,

clearly being intended as status markers. Such
a large-scale imitation of bronze vessels could
not be achieved without the most advanced
techniques of ceramic manufacture and large-
scale potters' workshops. The discovery
in 2006–2007 of Eastern Zhou kiln sites at
Huoshaoshan, Tingziqiao, and Fengjiashan
in Deqing, Zhejiang Province, revealed the
origin of the greenware from the Hongshan
Yue tombs. In particular, the examples of
greenware bells found at the Tingziqiao
kiln site were proved through materials
analysis and comparison of clay samples to be
identical to the greenware from Hongshan,
so the Tingziqiao kiln was probably a potters'
workshop with the character of an "official
kiln" which specialized in manufacturing
greenware for the aristocracy.

Porcelaneous ware co-existed with
stoneware, glazed pottery, and earthenware
for a very long time. Because of their
differences in quality, they were used as trade
goods and everyday utensils by different
classes in society at different periods. There
is not much information on porcelaneous
ware in the Shang dynasty, and what there
is has come from aristocratic tombs and city
sites. It was in the Western Zhou period that

proto-porcelain greenware appeared in large quantities. In the Spring and Autumn (770–476 BC) and Warring States (475–221 BC) periods, there is a trend in the development of proto-porcelain greenware in which it diminishes in the north and expands in the south. The Jiangsu-Zhejiang region then becomes the most advanced center of proto-porcelain production based in the Dongtiao Creek valley near Deqing, where the scale of production and quality of manufacture both increased by leaps and bounds, laying the foundation for the later rise and development of the Yue kilns. By the time of the Warring States period, the manufacture of pottery in China had already seen several thousand years of development, and the techniques of throwing and shaping were fully mature. Much is now known about Warring States greenware, but the quality of the products is uneven, though a few high-quality greenwares (fig. 10) can stand comparison with the mature greenware of the Eastern Han (25–220).

Fig. 10 Greenware Proto-Porcelain Wine-Jug with Overhead Handle in the Form of a Dragon

Warring States period
Height 18 cm, mouth diameter 7 cm
National Museum of China

The form of this vessel, made in imitation of bronze, was widespread in the south. Ceramic wine-jugs of this type were made as grave goods.

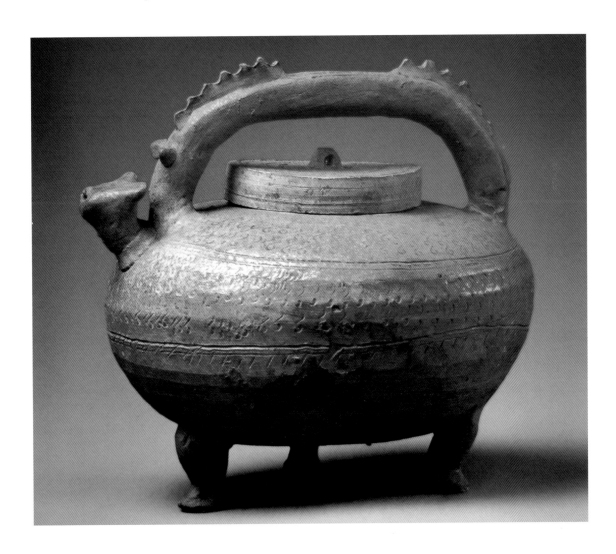

3 Maturity in Potting and Glazing: the Spread of Greenware

In the course of the military disturbances during the transition from the Warring States to the Qin dynasty (221–206 BC), the manufacture of proto-porcelain gradually declined; during the period up to the emergence of mature porcelain in the late Eastern Han, the Qin and Han (206 BC–AD 220) dynasties saw an unprecedented development in pottery production. Everyone is familiar with the amazing Terracotta Warriors from the tomb of the First Emperor of Qin (Qin Shihuang, 259–210 BC), which are remarkable for their vast quantity, life-size scale, and range of postures and costumes. The production of these massive pottery sculptures required the mobilization of a nation-wide effort, representing the high point of pottery craftsmanship in the Qin dynasty.

After the middle of the Western Han (206 BC–AD 25), a type of pottery decorated with a lustrous lead glaze began to appear. The addition of lead to the glaze in this type of pottery as a fluxing agent is one of the outstanding achievements of Han pottery manufacture. The addition of a lead flux to the glaze reduces its melting point so that successful firing can take place at 700 to 800 degrees Celsius; at the same time it increases the luster of the glaze, meaning that added copper or iron pigments can produce beautiful greens, yellows, and browns. In practice, green glazes with a fine, jade-like sheen were the most widely used. The emergence of lead-glazed pottery was probably connected with the demand for ritual vessels imitating bronze-ware, since the lead glaze could disguise the coarse quality of pottery and make it look more like the bronzes on which it was modelled. After the earliest appearance of lead-glazed pottery in the Guanzhong

region, it spread throughout the country and became the most widely used form of burial goods. Types include tripods, flasks, models of granaries, stoves, watch-towers, courtyards, etc. The large-scale production of lead-glazed pottery gave craftsmen plenty of experience in the use of glazes, and their technique became ever more refined. As the selection and use of materials, the forming of the clay body, and the glazing techniques began to be successfully combined, rapid advances in ceramic technology took place, leading to the birth of mature porcelain.

In the Eastern Han period, the production of proto-porcelain greenware was concentrated in the regions of Ningbo, Shangyu, and Yongjia in Zhejiang and Yixing in Jiangsu. There was a particularly large number of kilns in Shangyu, which was the main center of production. In the late Eastern Han, it was in this region too that mature porcelain greenware began to appear. In addition to the correct selection of materials, the successful firing of mature porcelain was dependent on an increase in kiln temperatures. The long "dragon kiln," which was already known in the Warring States period, was in extensive use in Zhejiang by the late Eastern Han, and the structure of kilns had been improved. Initially, these lengthy kilns were built on the slopes of hillsides, using the angle of the slope to ensure a difference in height between the front and back of the kiln. The fire chamber also acted as a chimney, and the plentiful supply of oxygen enabled the firing temperature to exceed 1,200 degrees Celsius. The extended length of the kiln enlarged its capacity, so that production was also greatly increased. At the same time, experience taught the craftsmen how to achieve the desired color and quality of glaze by adjusting the timing of oxidization, reduction, and cooling during the firing process through controlling the kiln temperature. This produced jade-

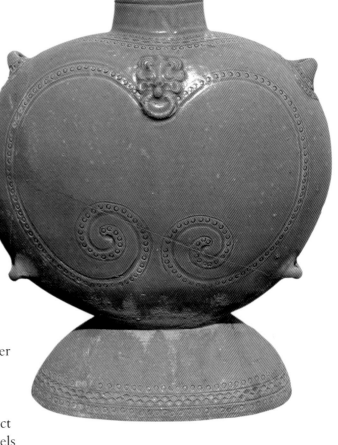

Fig. 11 Greenware Pilgrim Flask
State of Wu, Three Kingdoms period (220–280)
Height 26.2 cm, mouth diameter 6.3 cm
Oriental Metropolitan Museum, Nanjing

A typical wine vessel of the time. Wine drinking was a feature of life in the Three Kingdoms state of Wu, and once greenware became widespread, porcelain wine-vessels became an everyday item in aristocratic life. The majority came from the Yue, Ou, and Deqing kilns in Zhejiang and the Yixing kilns in Jiangsu.

green glazes without running or crackles, and with firm adhesion of glaze to body, the hallmarks of mature porcelain. The successful firing of mature porcelain greenware in the Eastern Han marks another major advance in the quality of Chinese ceramics. The remarkable development in ceramics which followed in many regions gradually developed into an important aspect of the commodity economy; porcelain vessels became one of the most widely used products in the daily life of ordinary Chinese people, a situation which has continued to the present day.

During the Western and Eastern Jin (265–420) and Northern and Southern Dynasties (420–589), many kilns producing greenwares appeared in southerly regions such as Hubei, Jiangxi, and Fujian provinces, forming the southern porcelain production area headed by the Yue kilns. Because of the long-lasting military disturbances and instability in more northerly regions, the manufacture of greenwares did not start until the later part of the Northern Wei dynasty (386–557), and very few kilns have been discovered there.

As a result of the political upheavals during the Jin and frequent wars in the north, large numbers of aristocrats and officials moved south, bringing advanced culture and production techniques with them. In the more politically stable Jiangsu and Zhejiang regions,

the development of agriculture and handicrafts enhanced economic prosperity. With this security, aristocratic demand for the utensils of daily life meant that porcelain manufacture flourished. A substantial network of porcelain kilns was established throughout the Ningbo and Shaoxing regions of Zhejiang, later known as the Yue kilns. These kilns were the largest in scale and the most widely influential in China during the Six Dynasties period (222–589). The Yue kilns of the Western Jin (265–316) were concentrated in the area of Shaoxing and Shangyu: in Shangyu alone there were sixty or seventy kilns. During the Eastern Jin (317–420) and Southern Dynasties (420–589) the sites of the Yue kilns were mostly distributed around Shaoxing, Shangyu, Zhuji, Xiaoshan, Yuyao, Cixi, Yinxian, and Linhai. The products of these numerous and widespread kilns were all similar in style. During the late Southern Dynasties, as tombs became less richly furnished, there was a great reduction in the manufacture of ceramic grave

goods, and the number and scale of kilns began to decline.

Our understanding of the products of the Yue kilns comes not just from analysis of sherds excavated at the sites of known Yue kilns but also from the large quantity of actual examples of porcelain vessels discovered in Six Dynasties tombs. Since the 1950s, a large number of high-quality Yue greenware porcelain vessels have been excavated from many large- and medium-sized tombs. These Yue greenwares, showing a complete range of types and a high level of quality, are representative of the products of the Yue kilns during the Six Dynasties, and provide us with a good understanding of the nature of Yue ware at the time. Although these vessels all ended up as grave goods, they can still be divided into two types: utilitarian vessels and vessels made specifically as grave goods. Common types of utilitarian vessels include bowls, plates, dishes, jars, tall wide-shouldered jars (*guan*), brush-washers, basins, dish-mouthed vases, *zun* jars, flat-sided flasks ("pilgrim flasks") (see fig. 11 on page 15), eared cups, cups, saucers (fig. 12), *lei* wine-vessels, incense-burners (fig. 13), spittoons (leys jars), boxes, ink-slabs, water basins, lamps, candlesticks, and water-droppers. These vessels pertain to all aspects of living, such as food and drink, the study, washing, lighting, etc., showing the importance of porcelain in daily life. The category of specific grave goods includes figurines, funerary urns, and models of stoves, wells, chicken-coops, pig-styes, winnowing baskets, grain-storage jars, etc., forming a three-dimensional scene of the high standard of living and the manorial economy experienced by the tomb occupant in life.

While the southern ceramic industry's prosperity spread out like ripples in a pond, those ripples did not reach the north, probably as a result of the north-south political division from the Wei and Jin onwards and the frequent wars and economic disruption in the north. Our knowledge of northern greenwares comes mostly from porcelain vessels excavated from tombs. Comparison of vessels discovered in the north with those from the south shows great differences between the two. Items from the north which are definitely not imports from the south have bodies varying from coarse to fine, of a greyish-white clay, and overall showing less refinement than the products of the Yue kilns in the south. The glaze is generally greenish-yellow or bluish-green, with some brown or black pieces. The surface of the glaze is usually crazed, and the outside of the vessel is usually only half-glazed. Since not many kiln sites from the Northern Dynasties period (439–581) have yet been discovered in the north, it is not possible to assign each excavated vessel to a particular kiln, even though we can be confident that they were made in the north.

Fig. 12 Greenware Cup and Saucer
Southern Dynasties
Height 9.9 cm, diameter of saucer 16 cm, rim diameter of cup 12.1 cm
National Museum of China

Vessel for tea-drinking. The custom of tea-drinking began in the Han dynasty in south China, and was widespread from the Eastern and Western Jin dynasties onward. Tea-ware, which became more and more sophisticated, was mostly made of porcelain.

Fig. 13 Greenware Incense-Burner
Western Jin
Height 19.5 cm, diameter of stand 17.7 cm
National Museum of China

Beginning in the Warring States period, perfumed incense was habitually burned in aristocratic households. Once porcelain had become commonplace, porcelain incense–burners became very widespread and took many forms, being used not only for their primary purpose but also for decoration.

4 Expressions of Faith: Religious Porcelains

After the introduction of Buddhism to China, its influence on culture during the Han and Jin and the Northern and Southern Dynasties was of profound significance. From the emergence and spread of Buddhist elements in the Eastern Han and Three Kingdoms (220–280) period to the consolidation of the doctrine by the great monk Fa Xian (ca. 337–ca. 422) in the Eastern Jin, the introduction, establishment, and absorption of Buddhism into China was a process lasting several centuries. In the immediate aftermath of its introduction, Buddhism was amalgamated with the indigenous folk beliefs in spirits and with religious Daoism; it became a means for people to express their hopes and wishes, and in the case of some types of porcelain objects particularly associated with religious belief which became widespread during this period, a number of images symbolizing spirits, Buddhist deities, and Daoist concepts might appear on a single vessel, forming a concrete representation of the co-existence at this time of Buddhism with other spiritual beliefs.

The funerary urn (see fig. 14 on page 18) was a type of vessel commonly found in the lower reaches of the Yangtze during the Han and Jin dynasties. Its characteristic feature is that above the shoulders of the urn several levels of relief decoration are applied, while there are also figures in prominent relief on

Most of the kiln sites discovered so far date to the late Northern Qi (550–577), and they are mainly concentrated in southern Hebei and northern Henan and in the area of Zibo, Qufu, Zaozhuang, and Xuzhou in Shandong. But the porcelain industry in the north had one significant achievement: it was there that white porcelain was first manufactured. The emergence of white porcelain was a major event in the history of Chinese porcelain, since it not only set the direction for the later development of the porcelain industry, but also provided the basis for painted porcelain. The earliest white porcelain vessels yet discovered are the bowls, cups, three-lugged jars, four-lugged jars, long-necked bottles and other items excavated from the tomb of the great general Fan Cui (548–575) in Anyang, Henan, which is dated to 575, during the Northern Qi. Although these vessels, with their "white" being a blue-tinged muddy cream, are far below the standard of modern white porcelain, their arrival on the scene is of far-reaching significance.

the shoulders, so that there are two distinct registers of decoration. On the upper register, four miniature urns or pavilions are applied, one on each of the four sides of the central structure, and these are surrounded by figurines of Daoist or Buddhist deities, birds, beasts, musicians, acrobats, etc. Lower down, where the neck and belly of the vessel join, figures of animals or people are generally applied. Ever since people became aware of these strangely configured vessels, they have been the subject of research by specialists and scholars. They first appeared in the Ningbo-Shaoxing area and were generally present in lineage tombs, displayed alongside storage

and sacrificial vessels, so they are categorized as specialized grave goods. The figurines of entertainers and musicians, barbarians, birds, Buddhas, immortals, mythical beasts, and animals reflect the conditions of society at the time as well as concepts of the soul and burial customs; they appear to have evolved from a burial item with the function of storing grain to a votive vessel intended to assist the passage of the soul to immortality. These urns have mainly been unearthed in the area of the Yangtze River's middle and lower reaches, and were mostly made in the Yue kilns. Nothing similar has so far been found in the north.

Lotus jars (figs. 15 and 16) are a type of porcelain greenware peculiar to the Northern and Southern Dynasties period, and widespread in both the north and the south. They are quite large, about 40–85 cm tall, with their outside surface decorated with complex relief patterns of lotus petals facing both up and down, as well as designs of apsaras (Buddhist "angels"), beaded roundels, coiling dragons, etc. Eighteen lotus jars are currently known in the collections of museums around the world, all with a green glaze, some tending towards yellow. Scholars have established that kilns in the north and south were equally able to produce these lotus jars.

The appearance of greenware lotus jars indicates that the craft of porcelain had

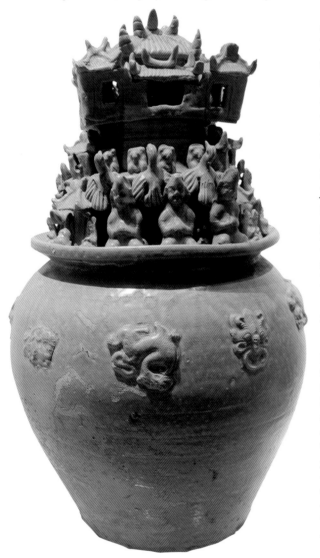

Fig. 14 Greenware Funerary Urn
Western Jin (297)
Height 39 cm
Nanjing Museum

On this funerary vessel, the shoulder is decorated with roundels of dragons and other magical beasts. The upper part is in three registers: the lower register has figures of barbarians sitting in a circle under a watchtower extending to the middle register, which has figures of flying birds, dogs, etc. The upper register is in the form of a square building. The complex craftsmanship and decoration are of the highest quality.

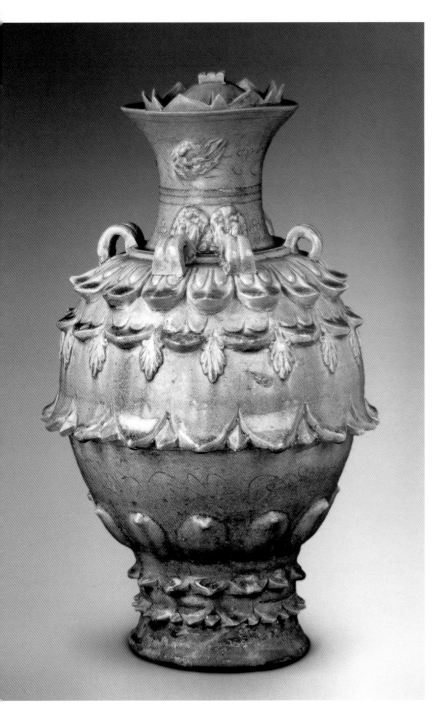

Figs. 15–16 Greenware Lotus Jar
Southern Dynasties
Height 49.5 cm, rim diameter
16.6 cm, foot diameter 16.3 cm
National Museum of China

The surface of this substantial vessel, used in religious ritual, is decorated with Buddhist imagery such as lotus petals, Buddha figures, and flying apsaras (see detail below).

because of the appeal of Buddhism as a source of comfort in troubled times, the religion spread rapidly. Buddhist monasteries and temples were founded all through the Northern Qi and the Southern Dynasties. By the time of the Southern Liang (502–557) there were as many as two thousand monasteries, and Xiao Yan, Emperor Wu of Liang (464–549), established Buddhism as the state religion. In 1972 a pair of lotus jars, one 85 cm tall and one 79 cm tall, were excavated from a large tomb of the Southern Liang at Lingshan near Nanjing. These are the largest and finest pieces of Six Dynasties greenware ever discovered in China and have become known there as the "kings of greenware"; they demonstrate the dominant position of Buddhism during the Southern Liang.

reached an unprecedented level, as well as demonstrating the profound influence of Buddhist belief on everyday life. The lotus, regarded as the sacred flower of Buddhism, is a symbol of the religion. After the introduction of Buddhism to China in the Han dynasty, China underwent almost four hundred years of conflict, war, division, and reunion; with the support of its rulers, and

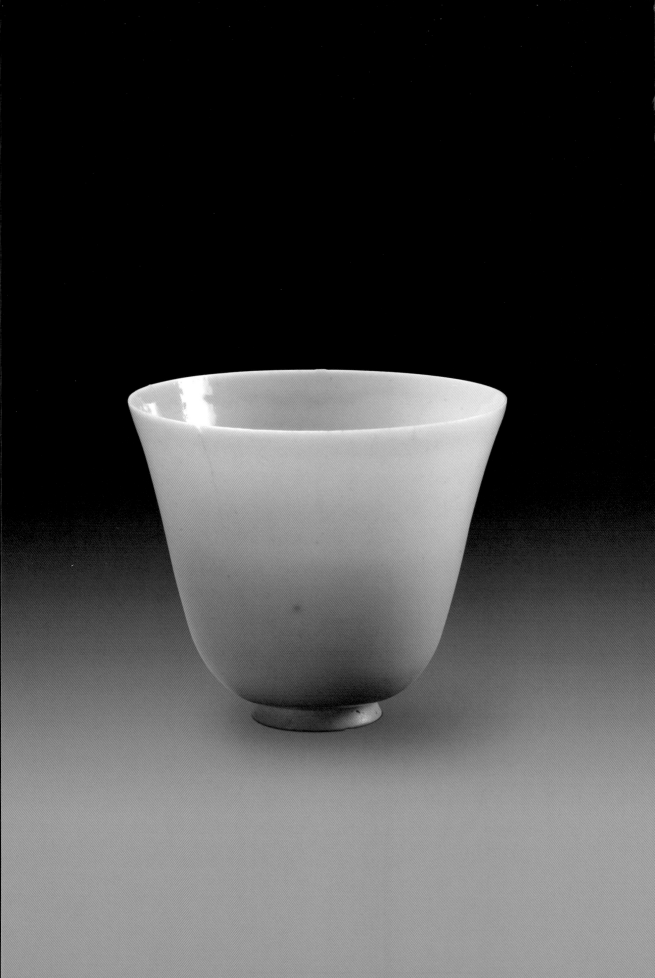

CHAPTER II

THE AGE OF CELADON AND WHITE-WARE

After several centuries during which the Yue kilns of Zhejiang were the leading producers of celadon (also known in English as "greenware") in the south, a new situation developed in the Tang dynasty, known in the world of Chinese porcelain as "Celadon in the south and white-ware in the north." This indicates that the southern kilns continued to produce large quantities of celadon, among which the *mise* porcelain from the Yue kilns of Zhejiang became the most prestigious type of southern celadon. In the north, meanwhile, large-scale production of white-ware began, with the Xing kilns of Hebei becoming the typical makers of white-ware. Thus white-ware began to threaten the dominant position of celadon. At the same time, the rise of the Changsha kilns in Hunan led to the first steps in the development of colored porcelain ware.

1 Like Silver, Like Snow: the Rise of White-Ware

The Sui dynasty (581–618), which succeeded in reuniting China, even though it lasted

for a mere 38 years, was founded by Yang Jian, Emperor Wen of Sui (541–604), on the power base of the Northern Zhou dynasty (557–581). The establishment of a unified government enabled trade between north and south to proceed smoothly and actively, and one of the products which began to flow between north and south was porcelain. Thus, the development of the porcelain industry in north and south gradually evened out, promoting the rapid rise of the northern porcelain industry. The quality of northern celadon showed continuous improvement, with a reduction in the coarseness of the body and the uneven thickness of the glaze.

It was during the Sui dynasty that production of white-ware began to increase and develop. Nine white-ware vessels excavated from the tomb of Fan Cui of the Northern Qi, in the region of Anyang, Henan Province, are considered to be the earliest surviving examples of white-ware. Although the kilns which produced them have not been identified, most scholars believe they were probably produced in either the Xiangzhou kilns of Anyang or the Gongxian kilns, also in Henan Province. During the Northern Qi, these two kiln-sites mainly produced celadon, with a small proportion of white-ware. Few kiln complexes producing white-ware during the Sui dynasty have yet been discovered, and Sui white-ware is mainly known from vessels excavated from Sui-era tombs.

The increasing production of white-

Fig. 17 Translucent Xing-Ware White-Glazed Cup
Sui dynasty
Height 6.9 cm, rim diameter 8.3 cm, foot diameter 3 cm
Shaanxi Archeological Research Institute
With an extremely thin body and a glossy white glaze, this is an excellent example of fine Xing white-ware of the Sui dynasty.

ware in the Sui dynasty laid the foundation for the flourishing of white-ware during the Tang dynasty (618–907). Sui white-ware has a relatively white body, with a blue-ish tinge to the white glaze. The application of a slip to the body allowed a transformation in the quality of the porcelain. Glaze was applied to both the interior and the exterior of small vessels such as bowls and cups, while on large vessels such as pots and vases the glaze generally did not reach to the bottom of the vessel. On most vessels which appear to have a ring foot, this is in fact false, and the base is slightly concave, and unglazed. The main kiln sites producing white-ware were at Xiangzhou in Anyang (Henan), Xingtai in Hebei, and Xingyang in Henan; the finest-quality white-ware has come from the excavations at the Xing kiln complex in Xingtai.

The Xing kiln complex is situated in the area of Neiqiu County and Qicun, Lincheng County, within the Municipality of Xingtai in Hebei. The earliest documentary records of these kilns occur in the Tang dynasty. The *Six Administrative Codes of the Great Tang Dynasty* (*Da Tang Liudian*, 738) records that Xing wares were presented to the Tang imperial palace as tribute items. The great tea expert Lu Yu (733–ca. 804), in his *Classic of Tea* (*Cha Jing*, 780), comments from the perspective of a tea enthusiast on the porcelain of his time that "Xing ware is like silver, Yue ware is like jade"; the comparison he makes between the two suggests that by his time Xing ware porcelain had already reached the level of Yue ware.

The Xing kilns began operations at

the end of the Northern Dynasties or the beginning of the Sui, mainly producing celadon. The transition from Sui to early Tang was also a transition from celadon to white-ware, with most white-ware being quite coarse, interspersed with a small quantity of fine pieces. Among five white-ware vessels excavated from the tomb of Su Tongshi in Xi'an (Shaanxi Province), datable to 608, a white-ware cup (see fig. 17 on page 20) is fully glazed inside and out with a fine glossy glaze. It is remarkable for the fact that the wall of the cup is only 1 mm at its thinnest and formed almost entirely of glaze rather than body; it is almost translucent. This remarkably fine vessel, provisionally attributed to the Xing kilns, shows that by the mid-Sui period this northern kiln complex had experienced a rapid development in production technique, leading to a drastic improvement in the quality of white-ware.

The early and mid-Tang periods were the high point of the Xing kilns. The Tang dynasty's stable economy, technical progress, and flourishing culture all contributed to advances and innovations in ceramic

Fig. 18 White-Glazed Leys Jar
Tang dynasty
Height 16.5 cm
National Museum of China

Leys jars were used by the aristocracy like present-day spittoons, for spitting out the water with which they rinsed their mouths.

Fig. 19 White-Glazed Ewer with *Ying* Mark

Tang dynasty
Height 16.2 cm
Xi'an Museum, Shaanxi Province

The character *ying* is engraved on the base of this high-quality vessel, but the true significance of the *ying* mark is still unknown.

technology. As a result of the improvements in the quality of white-ware products, it seems that people came to prefer white-ware to celadon, while the preferences of the court guided the fashion choices of the wealthy, and the increase in social demand promoted the production of high-quality white-ware from the Xing kilns. The situation of "Celadon in the south and white-ware in the north" continued almost throughout the Tang dynasty. The great majority of fine examples of Xing white-ware come from tombs of the northern aristocracy, while most of the vessels excavated from tombs in the south are still celadon wares. As a result of social instability during the late Tang to the Five Dynasties (907–960), the supply of high-quality raw materials almost dried up, and the Xing kilns began to decline, producing only coarse wares. Once the Ding kilns came to prominence in the Song dynasty (960–1279), the great kiln complex of the Tang, the Xing kilns, fell into obscurity.

The clay used for the bodies of Xing kiln white-ware is pale, fine, and strong, the glaze rich and creamy; a slip is applied between body and glaze. The body is quite sturdy, the glaze quite thick, and it may extend to the base or not, depending on type. Vessels with a flat base are not fully glazed, the technique of dipping the body into the glaze being employed. Xing white-wares are plain and refined, with no decoration.

Xing white-ware of the Tang dynasty can be divided into three classes: fine white-ware, regular white-ware, and coarse white-ware.

Fine white-ware, which was for the use of the court and the aristocracy, was of the highest quality among the Xing white-wares and was produced in the smallest quantities. It employed the most carefully prepared porcelain clay and the most refined potting and firing techniques throughout. It was usually fired in saggars, one piece per saggar, so that each piece was kept separate, in order to ensure high quality and a good success rate in firing. The most common types of fine white-ware vessels include bowls, ewers, stem-cups, jars, flasks in the shape of leather bottles (leather-flask ewers), boxes, spittoons, and figures of horses and riders. They have been most commonly found during excavations of Tang palaces, temples, and aristocratic tombs in the region of Xi'an in Shaanxi Province. Examples of fine Xing white-ware include the white-ware bowls, boxes, plates, and ewers found at the site of the Taiye Pool in the Tang-dynasty Daming Palace; the white-ware jars with *ying* and *hanlin* marks from the site of the Daming Palace; the white-glazed bowl and vase from the crypt of the Famen Temple in Xi'an; the large white-ware bowl with *ying* mark from the Tang-dynasty Ximing Temple in Xi'an; and the white-glazed leys jar excavated in Shanxian, Henan Province (fig. 18). The porcelain vessels with *ying* and *hanlin* marks (fig. 19) are particularly notable examples of fine Xing white-ware. There is a variety of

views among scholars as to the meaning of the *ying* (meaning "surplus") mark. Some believe that they are tribute items presented to the "Great Surplus Treasury" (*daying ku*) of the palace. The Great Surplus Treasury was established around 745 to store precious and unusual items and any surplus from the payment of taxes. The contents of the Treasury were used by the emperor to entertain his intimates and to bestow as gifts. Another view is that the *ying* mark is the name of a workshop or a trade-mark. So the precise meaning of the *ying* mark remains a mystery. At present the general view of the *hanlin* mark is that vessels with this mark were for the use of the Hanlin Academy, established by the Tang Emperor Xuanzong (685–762, r. 712–756) in 713, so such vessels cannot have been made earlier than this date. In the late Tang, fine white-ware was more widely used. A white-glazed handled cup (fig. 20) from a Tang tomb at Kuishan, near Xuzhou in Jiangsu Province, closely copies the form of gold or silver cups, with a regular shape, thin body, and pure-colored glaze; it is an outstanding product of the late-Tang Xing kilns.

Regular white-ware was generally used by the official and merchant classes. It is somewhat coarser than the fine white-ware, with a slightly thicker body of a grey-white color. The glaze is evenly colored but tinged with yellow. Vessels are fully glazed on the inside, while on the outside the glaze may extend to the base or only halfway down. Most have a slip, and were fired stacked in saggars.

Coarse white-ware was produced by the Xing kilns for the use of ordinary people. It is rather crudely made. The body clay is not so dense and contains impurities, its color is yellowish, a slip is applied, it is usually half-glazed, and the color of the glaze is uneven. The vessels are of types which would be used by ordinary people in daily life, the majority

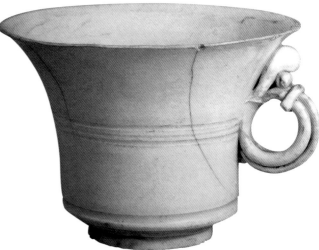

Fig. 20 White-Glazed Handled Cup
Tang dynasty
Height 8 cm, rim diameter 11 cm
Xuzhou Museum, Jiangsu Province

This shape imitates gold and silver cups from Central Asia, showing the profound influence of foreign cultures on the innovations in shapes of Tang-dynasty Chinese porcelain vessels.

(Illustration from: *Complete Collection of Chinese Ceramics* [Zhongguo taoci quanji], Shanghai: Shanghai People's Fine Arts Publishing House [Shanghai renmin meishu chubanshe], 2000.)

being small bowls with flat bases for everyday use. The bases usually retain spur-marks; since coarse white-ware was intended to be of low quality, saggars were not often used for firing it, and instead it was stacked directly in the kiln.

The Tang dynasty was a period of great openness: commercial activity along the Silk Road brought influences from foreign cultures which had a direct impact on all aspects of life. The Xing kiln complex, as a site of craft production which had grown up and flourished in the Tang dynasty, responded to the demands of the times by adopting foreign cultural influences and developing them in innovative ways. Items typical of non-Han-Chinese ethnic groups and pieces imitating the shapes of gold and silver vessels started to appear, such as flasks in the shape of leather bottles, flat "pilgrim flasks" with

carrying lugs, phoenix-head ewers (fig. 21), bowls with foliated rims, plates, saucers, double-lugged cups, stem-cups, or long-necked bottles. To take phoenix-head ewers as an example, these porcelain vessels whose shapes originated from west Asian metalwork were known as "barbarian bottles"; similar vessels could often be seen hanging from the backs of camels in merchant caravans on the Tang-dynasty Silk Road. Once they reached China, they were imitated in Tang *sancai* (three-colored) ware and porcelain, while also incorporating elements of Chinese traditional culture, forming a fine example of the integration of Chinese and western cultures.

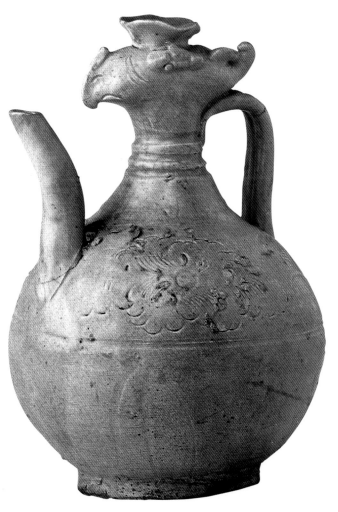

2 *Mise* Porcelain, an Advanced Form of Celadon

In the wind and dew of mid-autumn, the Yue kilns are opened:
They have stolen the blue-green of the mountain peaks for themselves.
Towards midnight they will brim with ambrosial condensation,
Looking like wine-cups left over from Ji Kang's drinking bouts.[1]

This poem on *"Mise* Cups of Yue" by the Tang poet Lu Guimeng (d. 881) posed a question to readers over the last thousand years: what was *mise* ("secret color," sometimes rendered as *bise*) porcelain? Although there were numerous excavations of kilns in Zhejiang's Yue kiln-complex in which increasing quantities of Yue celadon were recovered, no one was able to identify what kind of Yue porcelain was referred to as *mise*. The answer to this age-old riddle only began to emerge on the excavation of the Tang-dynasty crypt below the Famen Temple in Shaanxi in 1987.

The Famen Temple was founded during the Han; its original name was the King Asoka Temple, and it was not named Famen Temple (Dharma Gate Temple) until the Sui dynasty. An inscription dated to the thirteenth year (778) of the Dali reign-period of Emperor Dai of Tang (727–779, r. 762–779) records that by this time the temple had become the imperial temple of

1 Translator's note: Ji Kang (223–262, or 224–263) was a writer and musician, one of the Seven Sages of the Bamboo Grove, and a famous drinker.

Fig. 21 Celadon Phoenix-Head Ewer
Tang dynasty
Height 18.7 cm, mouth diameter 1 cm, foot diameter 7.6 cm
National Museum of China
The vessel shape imitates Central Asian ewers, showing the intermingling of Chinese and western cultures.

the Li family (the ruling house of Tang). Despite successive changes of name through the dynasties, the temple remained in use until recent times. When its pagoda finally collapsed in 1981, its site was cleared and excavations began. In 1987, the Tang-dynasty crypt in the foundations of the pagoda produced thirteen pieces of celadon ware, including a bowl (fig. 22), plate, water-sprinkle (fig. 23), dishes, and other items, along with a written record entitled *Account of Clothing and Objects* naming these thirteen pieces as "*mise* porcelain." This early and specific instance of surviving objects together with a written record, unveiling the historical mystery of *mise* porcelain, caused a sensation among ceramics experts. The list of items in the *Account of Clothing and Objects* dated to the fourteenth year of the Xiantong reign-period (874) and Lu Guimeng's poem on "*Mise* Cups of Yue" form the earliest documentary references to the term *mise*.

The discovery of actual *mise* pieces immediately attracted the attention of ceramics scholars, and many articles on the subject were published, with various different explanations of what was meant by *mise* porcelain. This group of *mise* ware excavated from the Famen Temple consisted of tribute to the imperial household and was of the highest quality, but the color of the glaze varied between blueish-green, yellowish-green, and greyish-blue, so the earlier idea that *mise* (*mi*-colored) referred to a specific glaze

color seemed untenable. Scholars are still at variance on the precise meaning of *mise*: some hold that *mise* porcelain was a particular type of high-quality ware from the Yue kilns on which the color of the glaze was blue-green with a tinge of light green, distinct from the usual Yue porcelain on which the glaze is blue-green with a tinge of yellow, while others think that the word *mi* should be understood as *mi* meaning secret (normally written with a different character) and that it is related to the Tantric beliefs held at the time, which would explain why it occurs only in the record of offerings to the Famen Temple. Still others believe that *mise* is simply a literary expression of admiration at the color of the celadon glaze, a sort of nickname for fine-quality Yue celadon. Despite all the different explanations of the term *mise*, there is no doubt that *mise* porcelain refers to high-quality porcelain sent as tribute to the imperial family and their aristocratic connections.

The high point of *mise* porcelain production was in the state of Wu-Yue (893–978) during the Five Dynasties period; in the reign of its second ruler, Qian Yuanguan (887–941), more than two hundred pieces of *mise* porcelain were sent as tribute to the Later Tang (923–936) court, and more than fifty pieces of *mise* ware (fig. 24) were buried with Qian and his principal wife née Ma. During the reign of Qian Hongchu

Fig. 22 Yue-Ware Bowl with *Mise* Glaze

Tang dynasty
Height 7.1 cm, rim diameter 25 cm
National Museum of China

Vessels with *mise* glaze were a high-quality product of the Yue celadon kilns in the Tang dynasty. They were used by the aristocracy, and very few survive.

Fig. 23 Yue-Ware Eight-Lobed Water-Sprinkler with *Mise* Glaze

Tang dynasty
Height 21.5 cm, mouth diameter 2.2 cm
Famen Temple Museum, Shaanxi Province

Water-sprinklers are used in Buddhist ritual. The offerings from the crypt of the Famen Temple are of very high quality and were probably donated by the imperial family.

Fig. 24 Yue-Ware Melon-Shaped Covered Jar with *Mise* Glaze

Five Dynasties
Height (with lid) 11.1 cm, mouth diameter 4.5 cm, foot diameter 6.4 cm
Lin'an Museum, Zhejiang Province

This jar was excavated from the Kangling tomb of the principal wife, née Ma, of Qian Yuanguan, the second ruler of the state of Wu-Yue in the Five Dynasties period. The body is fine and dense, the glaze color even and glossy; it is a finely made piece with an elegant shape.

(929–988, r. 948–978) at the end of the Wu-Yue state, which overlapped for eighteen years with the newly-established Northern Song dynasty (960–1127), Wu-Yue sent more than 140,000 pieces of porcelain with gold and silver ornamentation as tribute to the Song court. The Yue celadon pieces excavated from the tomb of Empress Yuande (943–977), the wife of Emperor Taizong of Song (939–997, r. 976–997), provide an example of the Yue ware produced at this time. Their refined manufacture, crystalline glaze, and the flowing lines of their incised decoration show that by this time *mise* porcelain had reached a peak of excellence in clarity and color.

3 Changsha Ware: Naturally Poetic

When you were born, I was not yet born;
When I was born, you were already old.
You regret that I was born too late;
I regret that you were born too soon.

This verse expressing with deep feeling the relationship between two people of different ages, written directly on porcelain, is not a piece of modern romanticism: it appears on a jug of Changsha-ware celadon from the Tang dynasty (fig. 25). Writing verses with pigment on the body of a vessel is the most distinctive form of decoration practiced in the Changsha kiln complex in Tang times. The poems which appear on the several hundred examples of these Changsha wares which have been discovered so far are mostly popular rhymes which circulated in urban society as a direct expression of ordinary people's feelings.

The Changsha kiln complex was in operation from the Tang to the Five Dynasties period, having developed on the basis of the earlier Yuezhou kilns, and was situated on the banks of the Xiang River in Tongguan Township, Wangcheng County, in Hunan Province, so it is sometimes referred to as the Tongguan kiln complex and its products as Tongguan wares. The rise of the Changsha kiln complex coincided with the high point of Tang economic and cultural development. The changes in people's outlook on life and in aesthetics resulting from trading activity along the Silk Road, with the consequent intermingling of Chinese and western cultures and the strong influence exerted by west Asian civilizations on the culture of China's central plains, were expressed in many different media: there was a greater preference for bright colors and elaborate styles in painting and handicrafts. In ceramics, the rapid rise of Tang *sancai* ware in the Chang'an and Luoyang regions is an instance

of a change in fashion appearing first in the dynastic capitals. It was against this historical background that the rise of the Changsha kiln complex took place, and so the style of Changsha wares, being utilitarian, fashionable products aimed at satisfying the requirements of ordinary people, incorporates many elements derived from Tang *sancai*, west Asian art, and Buddhist art.

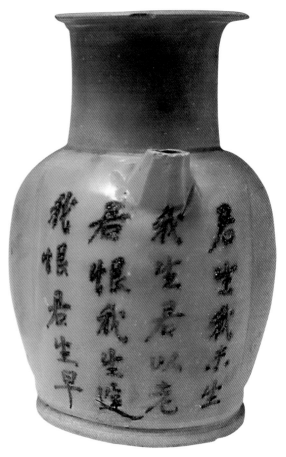

Fig. 25 Changsha-Ware Celadon Jug with Inscribed Verse

Tang dynasty
Height 17.6 cm, mouth diameter 8.9 cm, foot diameter 9.6 cm
Changsha Museum, Hunan Province

This type of jug was widely used at all levels of society in the Tang dynasty to hold hot water for making tea. A verse of poetry is inscribed in brown pigment on the belly of the jug.

(Illustration from: Changsha Ware Editorial Committee ed., *Works in Changsha Ware* [Changsha yao zuopin], Changsha: Hunan Fine Arts Publishing House [Hunan meishu chubanshe], 2005.)

As Changsha-ware porcelain was mostly for popular use, the porcelain clay is not carefully prepared, and the body material is rather coarse, with a greyish-white or light brown color; the walls vary in thickness, and there is a tendency to imitate the effect of metalwork, for example with ridged lids and bases. As regards glaze color, in the early period Changsha ware continued the characteristics of Yuezhou ware, producing celadon glazes. Towards the end of the Tang dynasty, after the rebellion of the Tang generals An Lushan (703–757) and Shi Siming (703–761)—a historical event known as the "An-Shi Rebellion" (755–763)—the Changsha kiln complex began to fire glazes in which celadon was streaked with brown, green, or red, or white glazes streaked with red or green: the Changsha kilns were therefore the first in China to produce colored porcelain. The successful firing of copper-red glaze at high temperatures was one of Changsha's greatest contributions to the development of Chinese porcelain. During excavations at the Changsha kiln complex in 1983, archeologists discovered four ewers with everted rims with a white glaze streaked with red, and two misfired red-glazed pieces, all dated to the mid- to late Tang, showing that Changsha kilns had already mastered the technology required to use copper as pigment in high-fired copper-red glazes. The types of vessels produced at Changsha were mostly utilitarian items, such as jugs, bowls, jars, brush-washers, boxes, vases, plates and dishes, water-droppers, lamps, candlesticks, shallow bowls, cups and saucers, lids, basins, incense-burners, pillows, spittoons, paper-weights, brush-rests, and so on, as well as a few human and animal figurines.

The most characteristic forms of decoration on Changsha ware are overglaze

Fig. 26 Changsha-Ware Yellow-Glazed Jug with Floral Sprigs
Tang dynasty
Height 23.9 cm, mouth diameter 10.5 cm
National Museum of China
The sprigged date-palm decoration below the lugs on this jug shows that it was intended for export.

painting in color and molded appliqué ("sprigged") decoration (fig. 26). Tang *sancai* ware had become widespread as a result of the vogue for elaborate burial offerings in north-central China during the Tang dynasty, and although *sancai* was glazed earthenware rather than porcelain, the techniques of brightly-colored glazing opened the way for multi-colored glazes, and were soon adopted at Changsha for the production of porcelain, thus making Changsha the first

kiln complex in the Tang dynasty to produce overglaze-painted porcelain on a large scale, and a pioneer in colored porcelain ware. The most frequently used colors in overglaze-painted Changsha ware are brown, green, and blue; brown spots and brown birds and plants, freely and sketchily drawn, are the most common form of decoration. The most distinctive type of decoration on Changsha ware is the use of verses, generally written in running or regular script, also very free in manner. They tend to be written on the inner base of dishes or bowls, or on the lower part of the outside of vases and ewers, and include poems, songs, proverbs, and mottoes; more than two hundred such pieces have been discovered so far. For example, there is a pentasyllabic verse describing the emotions of the exiled lady Wang Zhaojun in the well-known legend (fig. 27):

> As I depart, the mountain pass is far behind,
> I travel on, deep into a barbarian land,
> Had I foreseen the bitterness of this day,
> I would have given a generous sum to the court
> painter[1].

A heptasyllabic quatrain expresses romantic longings:

> Blouse and gauze skirt red as the sun;
> One can gaze at the flowers all day and never
> grow tired of spring.
> But when she sits at the dressing-table re-
> applying lipstick,
> Where is her young man? How frustrated she
> feels!

These verses and others like them, together with mottoes such as "Benevolence, righteousness, ritual, wisdom, and trustworthiness," all appear on Tang-dynasty Changsha porcelain pieces. Such popular verses, with their simple expression and

Fig. 27 Changsha-Ware Green-Glazed Jug with Inscribed Verse
Tang dynasty
Height 19 cm, mouth diameter 9.5 cm
National Museum of China

The many verses rich in feeling inscribed on Changsha-ware porcelain help to fill in the gaps in our knowledge of Tang folk poetry.

sincere feeling, seldom if ever appear in literary sources; they provide a reflection of the everyday life of ordinary people in the Tang, and also show the extent to which the poetic culture for which the dynasty is famous had penetrated into the lower levels of society.

Another decorative technique distinctive to Changsha ware is the use of molded appliqué or sprigged decoration, in which each decorative element is individually molded and then applied to the partially dried body. Usually brown pigment is added to make the decoration stand out, before the

1 Translator's note: When the beautiful Wang Zhaojun entered the Han emperor's harem, she failed to bribe the court painter, who painted a portrait showing her as ugly. The emperor therefore ignored her, until the chief of the barbarian Xiongnu asked to marry a Han princess, whereupon Zhaojun was sent away to be his bride.

glaze is applied and the piece is fired. Some experts believe that this type of decoration is modelled on the gilt or engraved decoration of gold and silver vessels; the patterns often include flowers, birds, pairs of fish, lions, pagodas, non-Chinese dancers and musicians, warriors, Bodhisattvas, landscapes and so on, usually in a west Asian style or with Buddhist elements. Research by Li Jianmao, a porcelain specialist at the Hunan Provincial Museum, has demonstrated that Changsha ware shows the influence of metalwork from the Persian Sassanid Empire and from Sogdiana; decorative motifs such as beading, geometric shapes, pairs of birds or beasts, deer, and lions are often found on Persian textiles, while pairs of fish, children with lotuses, pagodas, Bodhisattvas, and the "eight treasures" (conch, endless knot, paired fish, lotus, parasol, vase, wheel, and banner) are all common Buddhist symbols. One reason for the imitation of metalwork and the use of west Asian designs in Changsha ware is the great Tang interest in the exotic "Western regions" while another is the fact that much of Changsha's production was intended for export.

In the late 1990s, fishermen from the Indonesian island of Belitung, between Sumatra and Borneo, would often bring up pieces of porcelain when fishing in the seas to the northwest of the island. When the German manager of a local cement factory heard his workmen talking about this, he took diving equipment and went with some workmen to investigate the area supposed to conceal "treasure"; there they discovered an ancient sunken ship. Starting in September 1998, an almost year-long salvage operation was undertaken, recovering 67,000 valuable objects of all kinds, including gold, silver, copper, iron, ceramic, ivory, wood, stone, glass, and aromatics. The ship was given the name the Batu Hitam, meaning Black Rock in Indonesian. One of the salvaged porcelain

pieces bore the inscription "16th day of the 7th month of the 2nd year of Baoli," equivalent to the year of 826, and from this, together with other evidence, the ship could be dated to the first half of the 9th century and thus the Tang dynasty. The Batu Hitam itself survived almost intact; it had no iron nails and the planking was sewn together with rope. From its structure it could be identified as a typical Arabian sewn ship, known as a dhow, while the entire cargo consisted of Chinese products, of which the great majority were porcelain pieces, to the number of about 60,000, including over 56,500 items of Changsha colored porcelain, more than two hundred Yue celadons, more than three hundred Xing white-wares, three pieces of Tang-dynasty blue-and-white and almost two hundred white-glazed porcelains with green pigment from Gongxian, and other products from kilns in Guangdong. The huge quantity of Changsha porcelains included about 50,000 bowls, forming the largest single category among the cargo; this indicates that Changsha ware was the main type of export porcelain at this period.

The Changsha kilns have a crucial position in the history of Chinese porcelain. This was the first kiln complex in China to produce colored porcelain and the first to create high-fired copper-red glazes, while its products were the earliest export porcelains to combine motifs from both Chinese and western cultures. As a typical non-imperial or unofficial kiln complex, there is no documentary historical record of it, but it was precisely because there were no restrictions on it, as a producer of utilitarian porcelain, that Changsha ware was able to achieve its casual, poetic, and natural character. It forms a sharp contrast to the intensely refined character of high-quality porcelain, and provides an excellent model for contemporary potters in their pursuit of a relaxed, Zen-inspired beauty.

CHAPTER III

SONG PORCELAIN: EXPRESSION THROUGH FORM AND GLAZE COLOR

In 960, a general of the Later Zhou dynasty (951–960) named Zhao Kuangyin (927–976) started a rebellion which led to his being crowned Emperor. He named his dynasty the Song, and established his capital, known as the Eastern Capital (Dongjing) in the location of present-day Kaifeng in Henan Province. His dynasty is known to history as the Northern Song. The establishment of this dynasty put an end to the divisions of the Five Dynasties and Ten Kingdoms period (902–979) and achieved the partial reunification of China. Those powers which held out against the Song comprised the Khitan Liao (916–1125) to the north-east, the Tangut Xixia (1038–1127) to the north-west, and Tibet and Dali to the south-west. The Song dynasty, although it fought several border wars with the Liao and Xixia, sustained a long period of peaceful and stable development.

The Song dynasty normalized the employment of highly educated men (literati) as government officials, creating a society in which military power was subordinate to civilian rule. Economic policies in the early Song encouraged the expansion of handicrafts and the commodity economy in tandem with population growth, and many densely populated urban centers with an active mercantile economy grew up throughout the country. The Eastern Capital was the largest center of trade, with a population as high as one million. The well-known painting *Along the River at the Qingming Festival* (*Qingming Shanghe Tu*) by the Northern Song painter Zhang Zeduan (11th–12th century) realistically depicts a bustling scene of commercial activity along the banks of the Bian River as it flows through the capital. Many important changes took place during this time in people's habits of life, interests, and pursuit of fashion. The adoption of new forms of furniture such as chairs changed the Chinese people's traditional custom of sitting on mats on the ground. A demand for objects to be displayed as part of interior décor stimulated the production of decorative porcelain wares. The examination system as the route for literati to become officials promoted the concept of book-learning being the way to success in society at large. Ornaments and items of use for the studios of the literati became an important category of porcelain products. The rise of tea-drinking and tea connoisseurship led to an expansion in the demand and desire for tea-related porcelain items.

Fig. 28 Yaozhou-Ware Celadon *Meiping* Vase with Carved Peony Decoration
Song dynasty
Height 24.2 cm, mouth diameter 5 cm, foot diameter 6.5 cm
National Museum of China

Such vessels for storing wine were widespread in the Song dynasty. The celadon glaze and engraving technique of Yaozhou ware both originated from the Yue kilns in the south, but later became the dominant form of celadon ware, so that Yaozhou became the leading celadon kiln in the north.

There are two outstanding characteristics of Song dynasty porcelain: one is an unprecedented expansion in the porcelain industry, leading to the existence of many famous kilns and famous products; the other is a new approach in the aesthetics of ceramics, with an emphasis in porcelain on the quality of glaze color, stressing a restrained and elegant simplicity, "like a lotus rising from the water," which would provide a rational sense of calm, restraint, and completeness. At the same time there was a preference for archaism in form. These characteristics are strong evidence of the spiritual aims of China's traditional culture and of the archaistic aesthetic which were widespread at this time.

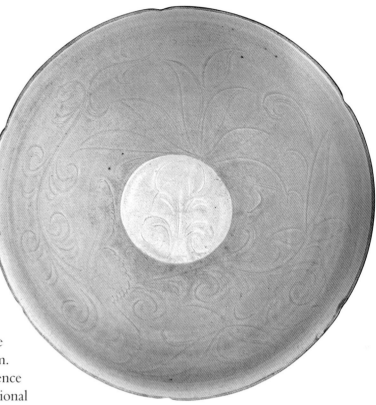

Fig. 29 Ding-Ware White-Glazed Bowl with Incised Pattern of Daylilies

Song dynasty
Height 6.1 cm, rim diameter 21.4 cm, foot diameter 6.6 cm
National Museum of China

In the Song dynasty, the Ding kilns were outstanding for their white-glazed porcelain. In the early period, most floral decoration was incised, while later it was mostly molded.

1 The Five Great Kiln Complexes: the Most Admired Porcelains

In the Xuande reign-period (1426–1435) of the Ming dynasty (1368–1644), the *Catalogue of Ceremonial Vessels of the Xuande Reign* was compiled on imperial orders by the Minister of Rites Lü Zhen (1365–1426) and others. In it they wrote: "In the Inner Treasury are stored vessels from the Chai, Ru, Guan, Ge, Jun, and Ding kilns, the styles of which are classical and elegant." The five kiln sites (Ge, Ru, Ding, Guan and Jun kilns) mentioned together here were regarded by later connoisseurs as the "five great kilns."

The Ding Kilns
The Ding kiln complex is located in present-day Jianci and East and West Yanshan villages in Quyang, Hebei Province. In the Song dynasty Quyang was part of Ding prefecture,

and porcelain from the kilns of Quyang was sold throughout this prefecture, so it became known as "Ding prefecture porcelain." The Ding kilns began operating in the Tang dynasty, making white porcelain in imitation of that from the celebrated Xing kilns. By the Song dynasty, the Ding kilns had taken over from the Xing kilns, its products with their refined and elegant molded decoration being regarded as treasures of the potter's art. In the Northern Song period, the Ding kilns mostly produced white porcelain with carved, incised, or impressed decoration under the white glaze. Carved and incised decoration was produced with metal or bamboo engraving tools on the unglazed and unfired

body, producing precise, powerful designs with the effect of relief carving, inspired by the technique of the Yue kilns (fig. 29). In the early Northern Song, these are usually relief-effect floral designs such as lotus petals or chrysanthemum scrolls, later accompanied by combed wave patterns. In the mid-Northern Song molded designs start to appear (fig. 30), made by putting the wet clay over a convex earthenware patterned mold, pressing it down to form the pattern, and shaping the body by hand. These molded patterns always appear on the interior of the bowl or dish; the lines are clear and precise, evenly arranged in symmetrical patterns. They are often composed of floral scrolls or sprays. These are the most characteristic type of white porcelain from the Ding kilns. The most commonly used designs include waves, fish, birds, and dragons and phoenixes, as well as peonies, lotuses, day-lilies, chrysanthemums, and other floral patterns, with a few designs showing children at play.

The Ding kilns discovered the technique of rim-down firing. In this technique bowls and dishes were placed in the kiln for firing stacked rim-down on stepped supports within a cylindrical saggar. This naturally increased the production of porcelain items while reducing costs, thus making the products more competitive in the market. However, this practice meant that the lip of each dish or bowl was in direct contact with the support, and therefore the lip had to be unglazed, exposing the body: this was known as a "rough mouth" (*mangkou*) or bare rim. Ding porcelains fired in this way with unglazed rims were already in evidence in the Five Dynasties period, and in the early Northern Song such items, with an exposed rim 2–4 mm wide, became numerous. For aesthetic reasons, some of these bare-rimmed items were edged in gold, silver, copper, or other metals, producing a special type of metal-rimmed white porcelain. White Ding ware was particularly favored by the court and was ordered to be presented as tribute, but later it was felt that the bare rim was not pleasing, and the court turned its attention to blue Ru ware. In 1969, construction work in Ding County led to the discovery of the foundations of two Northern Song pagodas, those of the Jingzhi Monastery

Fig. 30 Ding-Ware White-Glazed Plate with Molded Chrysanthemum Petals
Song dynasty
Height 1.8 cm, rim diameter 11.5 cm
Haidian Museum, Beijing

The design of mandarin ducks in a lotus pond on the inner base and the chrysanthemum petal effect on the cavetto was produced with a bowl mold. The unglazed rim indicates that the bowl was fired using the inverted or rim-down technique.

(Illustration from: Haidian Museum ed., *Masterworks of Haidian Cultural Relics* [Haidian wenwu jingxuan ji], Beijing: Cultural Relics Press [Wenwu chubanshe], 2014.)

and Jingzhong Temple; excavations unearthed a treasure trove of objects, of which 170 were porcelain items, all Ding ware, including bowls, plates, cups, dishes, saucers, brush-washers, bottles, incense-burners, boxes, jars, and kundika water-sprinklers. The two pagodas were constructed respectively in 977 and 995. These hoards form the most numerous, largest in scale, and best preserved group of early Northern Song Ding ware yet excavated, and show that by the early part of the dynasty, Ding white-ware was already of the highest quality, much valued by the court and the elite.

A category of Ding vessels have the characters *guan* (官, official) or *xinguan* (新官, new official) inscribed on their base; more than 140 items of this type have been discovered. The majority of scholars believe these *guan* porcelains indicate that they were specially ordered by the elite or for export. In addition, some Ding-ware pieces have been excavated bearing inscriptions with the names of government offices such as the "Food Service" (*shangshi ju*), "Palace Medical Service" (*shangyao ju*), or "Fifth Princely Establishment" (*wu wangfu*); these were items specially ordered during the late Northern Song by offices within the imperial palace or by the princely establishments. Other items inscribed with the names of specific palace buildings such as *fenghua*, *juxiu*, or *deshou* were evidently for use within the palace. Ding white-ware represents the highest quality of white porcelain in the Song dynasty. Although the Ding kilns produced a certain amount of tribute porcelains, the kilns themselves were not government-owned but primarily manufactured porcelain for popular use. Remarkable for their plentiful supply, high quality, and aesthetic appeal during the Northern Song, they were extremely influential throughout the north, and were also in great demand as export wares. This is why the Ding kilns are regarded as one of the "five great kilns" of the Song dynasty.

The Ru Kilns

Porcelain from the Ru kilns is well known both from documentary evidence of its exclusive use by the Northern Song court and because it was collected by the Qing imperial family. Less than a hundred complete pieces of Ru ware now survive, mostly in the Beijing and Taibei Palace Museums, with some also in the National Museum of China, the Shanghai Museum, the Percival David Foundation in London, and a few in collections in the USA and Japan. Their status as imperial pieces and their rarity make them extremely valuable, indeed the most valuable of all types of porcelain from the "five great kilns" of the Song.

The administrative center of Song-

Fig. 31 Ru-Ware Celadon Lotus-Flower Incense-Burner

Northern Song dynasty
Height 14.7 cm, rim diameter 14.8 cm
Henan Provincial Institute of Cultural Heritage and Archaeology

This fragmentary piece was excavated at the site of the Ru kilns. No vessels similar to this one have been found among surviving pieces. This is the main body of the incense-burner, but there should also have been a lid for it to be used as a perfume disperser. It is beautifully formed, and was probably used in the imperial palace.

dynasty Ru prefecture was at present-day Linru County (redesignated as Ruzhou Municipality in 1989) in Henan Province. In the Northern Song period, there were about a dozen kilns producing celadon porcelain here. The Qingliangsi kiln was situated in Qingliangsi Village, Daying Township, 20 km west of the county town of Baofeng, Henan. Several thousand sherds of Ru ware have been excavated here, from which it was possible to piece together more than twenty complete items. A major excavation was undertaken in June 2000, which unearthed the central zone of the Ru kiln complex, and unveiled much new information about the Ru kilns. Not only were examples of sherds similar to all the surviving Ru wares discovered, but also some types of vessels not known among the surviving pieces, such as a lotus-flower incense-burner (fig. 31) or lotus-leaf cup. Furthermore, some items decorated with patterns were found, a type unknown among the surviving pieces; the most common was a lotus pattern, and there were also items in the shape of birds or dragons, which are extremely rare.

The body of Ru ware is hard and fine, of an ashen color; the glaze is lustrous, and includes powdered agate. Glaze colors include eggshell white, azure, pea-green, and blue-grey; the most highly valued are azure and sky-blue. Pieces are mostly individually fired and fully glazed, with only very small spur-marks on the base, usually three on small pieces and five or six on larger ones. The majority of pieces are plates or dishes; there are also some bowls, brush-washers, tripod goblets, vases, *zun* jars, four-footed basins, etc.

The Taibei Palace Museum has twenty-three Ru-ware pieces, the largest number in a single collection. These are all from the Qing imperial collection, and thirteen of them bear poems penned by the Qianlong Emperor (1711–1799, r. 1735–1796) on their bases. An example is a celadon Ru-ware plate, which has a fully-glazed base with five spur-marks within which is inscribed a poem written by the emperor in 1772 (fig. 32; see fig. 2 on pages 2 and 3 and fig. 5 on page 6). Evidently this rather insignificant little porcelain dish was one of the Qianlong Emperor's favorite

Fig. 32 Ru-Ware Celadon Plate
Northern Song dynasty
Height 3.7 cm, rim diameter 15.7 cm
Palace Museum, Taibei

During the Song dynasty, Ru ware was already regarded as high-quality porcelain, and the Ru ware in the Qing imperial collection was particularly admired by the Qianlong Emperor. This piece is entirely covered in a sky-blue glaze; the inscription engraved on the base is a verse of appreciation written by Qianlong.

antiques, which indicates how greatly Ru ware was prized. Four oval celadon narcissus bowls in the Taibei Palace Museum collection are outstanding examples of surviving Ru ware, with a glistening sheen; of these, three bear inscriptions of poems by the Qianlong Emperor on their bases. Sherds of similar items, as well as oval spurred stands (kiln-stilts), have been discovered at the site of the Qingliangsi kiln. A Ru-ware celadon plate in the collection of the National Museum of China (fig. 33) is a domestic item showing obvious signs of use. The Percival David Foundation owns a Ru-ware long-necked bottle with a celadon glaze, which is currently the only known complete example of an elongated Ru-ware vessel.

The Ru kilns are the most highly regarded of the five great kilns, and the high value attached to their imperial wares stimulated the vogue for imitation Ru ware in the Ming and Qing (1644–1911) dynasties.

The Guan Kilns

The site of the Guan (or "official") kilns from the Northern Song is still undiscovered by archeologists, but the discovery of the Jiaotanxia and Laohudong kilns in Hangzhou, Zhejiang Province, has thrown light on the Guan kilns of the Southern Song (1127–1279), another of the "five great kilns."

During the reign of Emperor Qinzong of the Song (1100–1156, r. 1126–1127), in 1127, the army of the Jurchen Jin dynasty (1115–1234) captured Bianliang (present-day Kaifeng, in Henan), the capital of the Northern Song, and captured both Emperor Huizong (1082–1135, r. 1100–1125) and Emperor Qinzong, spelling the end of the Northern Song dynasty. The Song fled south to Lin'an (present-day Hangzhou), where Qinzong's younger brother Zhao Gou was enthroned, becoming Emperor Gaozong of Song (1107–1187, r. 1127–1162). The Southern Song lasted 153 years, and despite their struggles with the Jin and then the Mongols, there was continued development in the economy, culture, art, and education, while the center of porcelain manufacture also gravitated southwards. Documentary records show that after the Song removal to Hangzhou the Guan kilns

Fig. 33 Ru-Ware Celadon Plate
Northern Song dynasty
Height 8.8 cm, rim diameter 16.4 cm
National Museum of China

Ru ware, regarded during the Song dynasty as high-quality porcelain, was very costly. Complete Ru-ware plates like the one illustrated survive in very small numbers, and mostly come from the Qing imperial collection. Complete Ru-ware vessels sell for astronomical prices at auction.

were re-established in order to supply the court with sacrificial vessels, interior décor, vessels for food and drink, and gifts to be bestowed on those favored by the emperor. In accordance with previous practice, the kilns were established within the Palace Maintenance Office and were known as Inner or Palace Kilns; later a second official kiln was established at Jiaotanxia. These two kiln sites, recorded in historical documents, were for a long time the goals of archeological searches.

The Laohudong kiln-site between two hills in Hangzhou, Fenghuangshan and Jiuhuashan, was accidentally discovered in 1996 when it was exposed by erosion following a rainstorm. In the following years, three archeological excavations took place on this site, where the Southern Song stratum revealed a large number of black clay vessel bodies. During examination of this material in 2006, the words "Palace Maintenance Office Kiln" (*xiuneisi yao*) were found to be stamped on part of a potter's wheel, thus finally confirming the status of the Laohudong kilns and explaining the term "Inner Kiln" (*nei yao*), known from documentary records as a term for Southern Song official kilns, as short for "Palace (or Inner) Maintenance Office Kiln."

Raw material for the clay used in the Laohudong kiln was taken directly from the nearby hillsides. Because it contained purple clay, and had a high iron oxide content, its color became quite dark after high-temperature firing, usually giving a dark grey, light grey, or grey-black effect. On some rims and feet the exposed clay showed a purplish-black color, giving rise to the expression "purple mouth and iron foot." The glaze formed a rather thick layer, and was generally a greyish-green, though occasionally powder-blue or pale yellow. The main types of vessels are bowls, plates, dishes, brush-washers, cups, saucers, chopstick rests, shallow bowls, jars, boxes, basins, vases, ewers, incense-burners, *zun* jars, and high-stemmed beakers. Of

these, some shallow round brush-washers, mallet vases, tripod incense-burners, and sets of round boxes are almost identical to Ru-ware vessels. The Laohudong kiln took the form of a dragon kiln, thus basically forming a continuation of Ru-ware techniques, but they were more carefully constructed. The decoration of Laohudong products was simplified: most pieces aimed to please the eye through the glaze color alone, and thus the thick glaze itself became the decoration.

The Jiaotanxia kiln was the second official kiln to be established under the Southern Song; it was situated at the western foot of Wuguishan in the Shangcheng district of Hangzhou, two kilometers from the Southern Song palace complex to the north-east. It was established in about 1143–1179, when Southern Song power had gradually stabilized and the imperial palace required ever more porcelain wares. The Jiaotanxia kiln used a technique of multiple firings of the unglazed body followed by multiple applications of glaze to produce celadons with a thin body and thick glaze, bringing the quality of celadon to a new level.

Products of the Jiaotanxia kiln have a very fine body, with the clay formed from porcelain stone tempered with a small quantity of purple clay, having a high alumina and iron oxide content. A higher alumina content helps to prevent distortion during firing, allowing for thinner walls, while a high iron oxide content gives a dark grey or black color to the clay which enhances the jade-like effect of the glaze. Smaller vessels such as bowls, plates, dishes, or cups usually have a thin body, while larger vessels such as high-stemmed beakers, incense-burners, ewers, or bottles have a relatively thick body. The three main glaze colors are powder-blue, greyish-green, and pale yellow, of which powder-blue is the finest. The Jiaotanxia kiln produced a complete range of vessel types in order to satisfy the requirements of the palace.

They usually have a plain glaze; if decorated, the main techniques are incision, molding, sprigging, and carving. The most common patterns are floral, such as lotus-flowers, peonies, or banana leaves; animal, such as dragons, phoenixes, or animal masks; and archaistic motifs such as string pattern, simple and complex key-frets, or bosses.

Most surviving Guan ware comes from the Qing imperial collection and is now held in the Taibei Palace Museum (which has approximately 107 pieces, with about twenty bearing poems by the Qianlong Emperor) and the Beijing Palace Museum (approximately 27 pieces). In addition, there are a few pieces in the collections of the National Museum of China (fig. 34), the Shanghai Museum, the Tianjin Art Museum, the British Museum, the Percival David Foundation of Chinese Art, the Victoria and Albert Museum, the Musée Guimet, the Cleveland Museum of Art, the Boston Museum of Fine Arts, the Asian Art Museum of San Francisco, the Tokyo National Museum, and the Museum of Oriental Ceramics in Osaka. A Southern Song Guan-ware celadon vase with pierced lugs in the National Museum of China, made in imitation of a bronze flask with pierced handles, has a crackled glaze with a warm and lustrous color: this is a classic piece of Guan ware.

Fig. 34 Guan-Ware Celadon Vase with Pierced Lugs
Southern Song dynasty
Height 22.8 cm, mouth diameter 8.3 cm, foot diameter 9.6 cm
National Museum of China

This vase made in imitation of Shang-dynasty bronzes was used as a ceremonial vessel. Many pieces of porcelain imitating antique forms were produced as a result of antiquarianism in the early Southern Song.

The Jun Kilns

The Jun kilns were situated in the district of Shenhou Township, Yuzhou Municipality, Henan. Jun ware porcelain (categorized as stoneware in English) is renowned for its attractive "kiln-transmuted" (*yaobian*; purple-blue streaked) glaze and lustrous cream glaze. The innovation of a high-fired copper-red glaze was an important contribution to the development of Chinese porcelain. The pigment for this glaze is copper oxide, which produces a red color when fired at

Fig. 35 Jun-Ware Leys Jar with Rose-Purple Glaze

Northern Song dynasty
Height 22.7 cm, mouth diameter 23.4 cm
National Museum of China

The glaze on this piece, with its many variations in color, is very attractive. The glaze on Jun ware is opaque, and the glaze layer is relatively thick. At high temperatures the glaze becomes very fluid, and no vessels have exactly similar glaze colors.

high temperature in the kiln: the streaks of red on the blue ground of the glaze look like sunset clouds in a blue sky. Glaze colors such as rose purple, crab-apple red, egg-plant purple, or chicken-blood red developed subsequently, and were unmatched by other kilns: they formed a style and achievement exclusive to the Jun kilns. Surviving Jun ware in the collections of the Beijing and Taibei Palace Museums includes many characteristic decorative pieces such as archaistic *zun* jars, flowerpots with descriptive labels incised on the base, "drum-nail" brush-washers, and quadrilobed basins; the National Museum of China holds a Jun-ware leys jar (fig. 35) with a deep rose-purple glaze of a pure, even color with a purple tinge, which is a typical example of a Jun-ware domestic item.

Two archeological excavations of the Jun kiln-site took place in 1975 and 2001, through which the strata and layout of the site became clearer. The central part of the early Jun kiln-site was the Liujiamen kiln, which had a very high standard of craftsmanship; types of products include bowls, plates, brush-washers, boxes, basins, ewers, jars, bottles, incense-burners, lids, and pillows. Among these, the handled brush-washers, chrysanthemum plates, flat-rimmed dishes, and lidded boxes all imitate the shapes of gold and silver metal ware, forms which were favored in the Northern Song. The glaze is usually fine and lustrous, mainly azure in

color, though a few light green, white, or red and purple streaked Jun wares are known, with glaze applied to the middle of the base. The most characteristic firing techniques are rim-down firing, firing fully glazed on kiln-stilts, and "thick glazing," i.e. the application of multiple layers of glaze to a pre-fired body.

Ever since the early days of the kilns, Jun ware has been much favored for its remarkably beautiful colors and the variety of its glazes; it was imitated by the imperial kilns throughout the Yuan (1279–1368), Ming, and Qing dynasties. The thick glazing technique in which several layers of glaze are applied to a pre-fired body, peculiar to Jun ware, formed a layer of glaze with the texture of opaque glass, which coupled with its attractive and naturally commingled colors produced the unique character of Jun ware. In the 18th and 19th centuries, during the European attempts to understand and reproduce porcelain wares, the successful imitation of Jun-ware glazing techniques was an important step towards European porcelain manufacture.

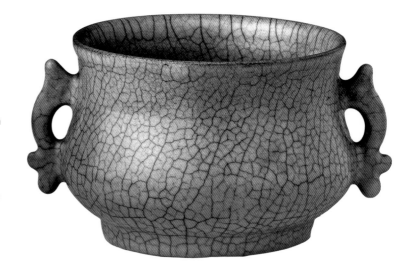

Fig. 36 Ge-Ware Incense-Burner in the Form of a *Gui* Vessel

Song dynasty
Height 8.8 cm, mouth diameter 11.9 cm
National Museum of China

Ritual vessels made in the shape of ancient bronze *gui* vessels all show the most characteristic feature of Ge ware, namely the crackle effect on the surface of the glaze forming a network of so-called "golden threads and iron wires."

The Ge Kilns

Even though the Ge kilns are considered to be one of the "five great kilns," their location and nature remain questions to be answered by ceramics experts. Most of what is known about them comes from documentary records.

At present our understanding of Ge wares comes from surviving pieces in collections, of which the majority are in the Beijing Palace Museum, the Taibei Palace Museum, the National Museum of China (fig. 36), the Shanghai Museum, and some overseas collections. The most notable characteristic of surviving Ge wares is their crackled glaze, in which the crackles form a network traditionally compared to "golden threads and iron wires"; that is to say, thicker black lines are interwoven with thinner, finer red or yellow lines. The origin of this crackled glaze lies in faults in the firing process, but the unique aesthetic effects deriving from such "faults" encouraged people to start

deliberately aiming for these results, so that they became able to control the technique for producing crackled glazes. The bodies of Ge wares are mostly of a purplish-black or brownish-yellow color; on the rim of the vessel, where the body color shows through the thinner glaze, it appears tan in color, and on the unglazed foot it appears iron black, giving the typical so-called "purple mouth and iron foot" characteristic. The surface of the glaze has an oily gloss, with many variations in color, including beige, powder-blue, and cream.

Where was the site of the Ge kilns? This is a mystery that has long intrigued ceramic experts. Although several kiln-sites producing items similar to Ge ware have

Fig. 37 Longquan Celadon Plate with Foliated Rim

Southern Song dynasty
Height 2.4 cm, rim diameter 17 cm
Zhejiang Provincial Institute of Cultural Relics and Archaeology

This piece excavated from a kiln site is closest to the characteristics of Ge ware described in documentary sources.

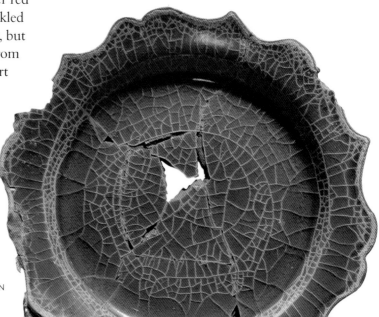

been discovered, comparison with surviving Ge ware pieces have not been conclusive. A type of crackle-glazed porcelain with a black body and celadon glaze has recently been discovered at the site of the Wayaolu kiln in Xiaomei Township, Longquan, Zhejiang Province, in which the white crackle lines seem more like the descriptions of "hundreds of broken slopes" and "shattering" appearing in the documentary records (fig. 37). Dr. Shen Yueming, a specialist from the Archeological Research Institute of Zhejiang Province in charge of the Longquan kiln-site excavations, believes that the Wayaolu kiln in Xiaomei Township may well be the Ge kiln-site referred to in historical documents.

Investigation and controversy over the site of the Ge kilns may continue, but ever since connoisseurs became aware of the unique style and aesthetic effect of Ge ware it has been greatly admired: it was imitated throughout the Yuan, Ming, and Qing dynasties, with particularly fine examples of imitation Ge ware surviving from the Ming Chenghua (1465–1487) and Qing Qianlong (1736–1795) reign-periods.

2 The Blooming of a Hundred Flowers: Regional Porcelains

The Song dynasty was a particularly active period in the development of Chinese porcelain: the sites of Song-dynasty porcelain kilns have been discovered in as many as 130 counties and municipalities nationwide, and the production of porcelain in the Song can be described as "flourishing throughout the land, with each region having its own characteristics." These can be divided accordingly into the categories of whiteware (principally Ding ware), greenware (principally Yaozhou and Longquan ware), whiteware with black decoration (Cizhou ware), streaked glazes (Jun ware), and the blue-white known as *qingbai* (Jingdezhen), with each type having one main kiln-site. The most admired products would be imitated at surrounding kilns, so the number of kilns producing these porcelain wares would increase, and the kilns themselves would be enlarged, forming a kiln-complex with particular regional characteristics. Examples of such kiln-complexes are set out below.

The Longquan Kilns

The location of the Longquan kiln-site was within Longquan County in Zhejiang Province; it was a new celadon-producing site which had developed in the Song dynasty on the basis of the old Yue kiln-site. It is a good example of the combination of the northern and southern celadon traditions. Longquan ware (sometimes referred to as "southern celadon") was one of the most famous types of porcelain in the Song, Yuan, and Ming dynasties, with a slightly different style in each period.

The Longquan kiln-complex was formed of a number of kilns centered on one major kiln. Longquan ware had a finely-colored glaze. In addition to popular and export production, some tribute pieces were also produced for use in the imperial palace. Longquan ware was already being produced in large quantities by the mid-Northern Song period. The glaze was thin and of a light blue-green color. During the Southern Song, the bodies of Longquan wares grew thinner, while the glaze became thicker through the technique of multiple applications, and new colors such as powder-blue and "plum green" were developed. The glaze had a soft gloss like fine jade. Vessel shapes also became more varied.

The Beijing Palace Museum has the largest number of examples of Longquan porcelain, with over 800 pieces from the Song, Yuan, and Ming dynasties. The original

Qing palace collection held more than 160 pieces, including 25 from the Song dynasty; these were mainly used as decorative pieces displayed in the Cuiyun Lodge of the Chonghua Palace, the Yangxing Hall, Yangxin Hall, and Yuqing Palace. Particularly typical products of the Song-dynasty Longquan kilns are a multiple-spouted jar, an incense-burner in the shape of a *li* tripod cauldron (fig. 38), a vase with pierced lugs, a tripod incense-burner, and a vase in the shape of the ritual jade vessel known as a *cong*. More common domestic items include food-vessels such as bowls and plates; wine-vessels such as bottles, wine-jugs, cups, and saucers; tea-vessels such as teapots, cups, saucers, and leys jars; and items for the studio such as flower-vases (fig. 39), water basins, brush-pots, ink-slabs, and water-droppers.

Sculptural Longquan porcelains first appeared in small numbers during the Southern Song, and became more numerous during the Yuan and Ming. Many religious figurines were produced, such as those of the Bodhisattva Guanyin, Maitreya Buddha (the "Laughing Buddha"), Sakyamuni, and the Dark Warrior God of the North. Some particularly characteristic Southern-Song Longquan figurines were excavated in 1960 at the site of the main Longquan kiln: these are three of the "Eight Immortals," namely He Xiangu, Han Zhongli, and Han Xiangzi. The figures are lively and realistic, with the fluid, billowing lines of their clothing, and a glossy, crackled celadon glaze. The faces and hands are unglazed, and the exposed body clay has fired to a reddish-brown, giving a sharp contrast between the colors of skin and clothing, a very life-like and captivating technique. By the time of the Yuan dynasty, this so-called "exposed body" technique had come to be used on vessels such as bowls, plates, and vases, and is one of the peculiarities of Yuan-dynasty Longquan ware.

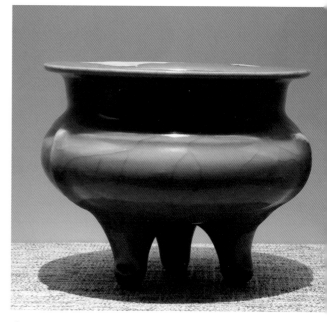

Fig. 38 Longquan Celadon Incense-Burner in the Shape of a *Li* Tripod Cauldron
Southern Song dynasty
Height 12 cm, rim diameter 14.5 cm
Zhejiang Provincial Institute of Cultural Relics and Archaeology
This incense-burner imitates the shape of an ancient bronze vessel type.

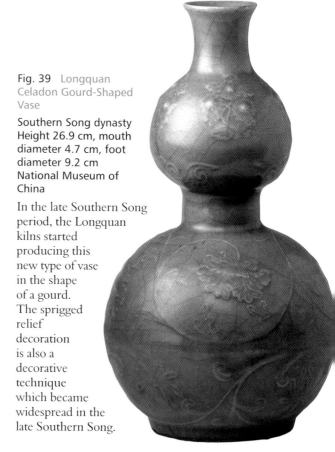

Fig. 39 Longquan Celadon Gourd-Shaped Vase

Southern Song dynasty
Height 26.9 cm, mouth diameter 4.7 cm, foot diameter 9.2 cm
National Museum of China

In the late Southern Song period, the Longquan kilns started producing this new type of vase in the shape of a gourd. The sprigged relief decoration is also a decorative technique which became widespread in the late Southern Song.

The Yaozhou Kilns

The Yaozhou kiln-site was in Tongchuan Municipality, about 70 kilometers north of Xi'an in Shaanxi Province. The complex, centered around Huangbao Township, had seven individual kilns. The site started operations during the Tang dynasty and began to flourish in the Five Dynasties period, while the Song dynasty marked the height of its success.

Most of the production of Song Yaozhou ware took place in three kilns, located at Huangbao, Yuhuagong, and Lidipo. As production increased and there was a sharp rise in demand for fuel, the Yaozhou kilns started substituting coal for firewood; they were the first to fire porcelain using coal as fuel. Yaozhou greenware was already dominant in northern China by the Five Dynasties period, equivalent in importance to Yue ware in the south. After the establishment of the Song dynasty, the porcelain industry in the north overtook that in the south, and production of Yaozhou greenware constantly expanded, while technical advances also took place, so that Yaozhou became the most prominent producer of greenware at that time, and other kilns in the area all modelled their products on Yaozhou ware; thus a whole network of kilns producing Yaozhou-type wares developed in north China. The Linru, Yiyang, Baofeng, and Xin'an Chengguan kilns in Henan, as well as the export ware centers of Xicun in Guangzhou and Yongfu in Guangxi, all made products imitating Yaozhou ware. Since this greenware could be sold more cheaply in its local area because of reduced transport costs, it was quite competitive.

The Yaozhou kilns of the Song dynasty mainly produced porcelain with green, black, or dark brown glazes. The green glaze is most typical of the local style and is the highest in quality. The main vessel types include bowls, plates, bottles, jars, incense-burners, ewers, boxes, censers, and shallow bowls. The body clay is dense, hard, and greyish-white. The glaze color is pure and glossy like jade, with a glass-like texture. The thick, shiny "olive green" glaze has a slight touch of yellow. The most common form of decoration is incised floral patterns, with an incising technique which was second to none at the time. Each line of the pattern is created with the use of both the edge and the flat of the burin, while the round tip of the burin gives a line which is both sharp and fluid. Where the burin has been pressed deeply into the clay, the pooled glaze shows a darker color. Both the overall design and the individual lines give an impression of power and rhythm. Because of high demand for Yaozhou ware from the mid-Song onwards, molded decoration became the main technique used for common vessels such as bowls and plates. Frequently occurring designs include peonies or chrysanthemums in either scrolls or sprays, waves, lotus flowers, and children at play.

Much Song Yaozhou ware has been excavated from tombs or kiln-sites. The earliest group to be discovered was from a cache at the Song-dynasty Yaozhou kiln at Binxian in Shaanxi, which was exposed as a result of a landslide. This comprised more than one hundred fine pieces of Yaozhou ware, including a tripod covered jar of a simple shape, decorated in an extravagantly carved floral pattern with fluid lines, a beautiful piece. As a result of tomb robbery at the family burial ground of the Northern-Song epigrapher and Neo-Confucian philosopher Lü Dalin (1040–1092) at Lantian, Shaanxi Province, the archeological authorities undertook an emergency excavation in 2007–2010, in which more than six hundred relics were discovered, among which most of the utilitarian porcelain vessels were of Yaozhou greenware. Examples include a *meiping*

vase with carved peony decoration, which is similar in quality to the *meiping* vase, also with carved peony decoration, in the collection of the National Museum of China (see fig. 28 on page 32), an incised lidded bowl, and a spittoon with incised peony decoration; all were of refined craftsmanship, with distinctive shapes and a fine, glossy glaze, showing the high standards achieved in Northern-Song Yaozhou ware.

The Cizhou Kilns

The largest group of unofficial (non-imperial) kilns in north China, with its main kilns at Guantai and Pengcheng townships in Cixian (previously named Cizhou), Hebei Province, is known as the Cizhou kiln-complex. Its most typical products are porcelains (stonewares) with black decoration on a white ground. Similar products for popular use were made at numerous unofficial kilns throughout Hebei, Henan, and Shanxi provinces, such as the Hebi, Bacun (Yuxian), and Quhe (Dengfeng) kilns in Henan, and the Jiexiu kiln in Shanxi.

The Guantai kiln-site in Cixian, discovered in the 1950s, is the most typical of the Cizhou kiln-complex. It began operating in the early years of the Northern Song, or perhaps even slightly earlier, and operated until the very end of the Yuan dynasty or beginning of the Ming. In the early Northern Song, it produced white-ware and black ware influenced by Ding ware. During the Song, the Cizhou kiln-complex began using coal as fuel, using both firewood and coal at the same time, and the color of the fine body gradually became a paler grey or off-white. The main shapes include bowls, plates, shallow bowls, incense-burners, jars, water-droppers, boxes, pillows (see fig. 4 on page 4), and *meiping* vases. Styles of decoration include floral designs on a dotted ("ring-matted") ground, black designs on a white ground, and molded floral designs. The main designs are semicircular sprays of flowers, cloud-shaped sprays of flowers, chrysanthemum petals, chrysanthemum scrolls, and intertwined creepers. "Partridge feathers," "oil spot," and "hare's fur" were popular types of glazes for black ware.

It was during the Song dynasty that the styles of Cizhou ware were formed, especially its unique black on white decoration, which combined traditional Chinese painting and calligraphy with the potter's craft. There were several types of black on white decoration: one uses the sgraffito technique, in which a white slip is applied between body and glaze, black pigment is applied all over the white slip, a sharp bamboo tool is used to incise the outline of a pattern, and then the black pigment outside the outline is scraped away, exposing the white slip; this is known as black-decorated sgraffito. Another technique, known as white-ground painted and incised decoration, involves painting the decoration on the white slip with a brush, and then using a sharp bamboo tool to draw incised lines around the outlines of details such as flower petals, leaves and stems, or the feathers of birds or scales of fish. A third type, known as white-ground black painting, involves drawing or writing directly on the slip with a brush: this is the most typical form of black on white decoration. Using a brush and pigment to paint directly on the vessel is a manifestation on porcelain wares of the technique of Chinese painting, with designs in a natural, free, and bold style. This laid the foundation for the painting style of Yuan and Ming blue-and-white wares.

The Jingdezhen Kilns

The manufacture of porcelain at Jingdezhen (in Jiangxi Province) began in the Tang dynasty, but no kiln-sites dating back to the Tang have yet been discovered there. Jingdezhen began to produce *qingbai* ware in the early Northern Song, but the color

Fig. 40 *Qingbai*-Glazed Ewer Set from Jingdezhen

Southern Song dynasty
Overall height 23.9 cm
National Museum of China

This is a set comprising wine-ewer and wine-warming bowl of a type widespread in the Song dynasty. Jingdezhen became famous in the Song for producing *qingbai*-glazed porcelain, at a time when the Jingdezhen porcelain industry was gradually rising to prominence.

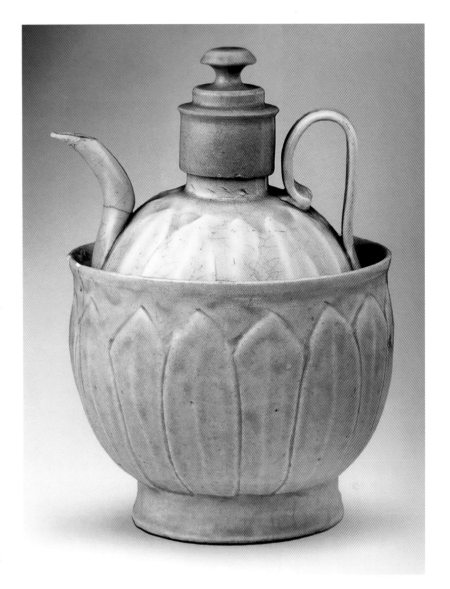

tended to be yellowish and the quality of the glaze was rather poor. Glaze was not applied to the base of the pieces. By the mid- to late Northern Song, the bodies of Jingdezhen *qingbai* wares had become thin and very dense, the glaze had a glossy sheen, with hints of blue-green in the white, and a delightful blue-green where the glaze pooled, and with a high gloss and translucence, so it was also known as "shadow blue" (*yingqing*). The color of *qingbai* ware varies between blue-green and white; the white has a greener tinge than Song white porcelain, but it is quite glossy. However, compared to greenware, it is much whiter, the glaze layer is thinner, and it has a more glassy texture. During the Chunhua reign-period (990–994), it was already being stockpiled for use in the palace. Prior to the Song, Jingdezhen had been known by several different names: Xinping, Taoyang, and Changnan commanderies. During the

Jingde reign-period (1004–1007) of Emperor Zhenzong (968–1022, r. 997–1022), *qingbai* ware produced here became outstanding in quality and was praised by the emperor himself, so it became famous throughout the empire; it gradually became known as Jingde porcelain, and the place-name Jingdezhen (Jingde Commandery) has been used ever since for China's premier site of pottery and porcelain manufacture.

During the Song, *qingbai* ware was produced at more than one hundred sites within Jingdezhen such as Hutian,

Yangmeiling, and Shihuangwan, as well as at other locations including Ji'an and Nanfeng in Jiangxi, and sites in Zhejiang, Guangxi, Anhui, Fujian, and Guangdong provinces. Thus there was a whole network of kilns producing *qingbai* ware, centered on Jingdezhen itself, which had widespread influence among the population; the highest quality was produced at the Hutian kiln in Jingcheng Village about 4 km south-east of present-day Jingdezhen Municipality. *Qingbai* ware was produced at Jingdezhen in a wide variety of shapes, such as ewers with warming basins (see fig. 40 on page 47), Guanyin figurines, pillows, incense-burners, vases, shallow bowls, brush-washers, spittoons, censers, boxes, jars, ewers, plates, bowls, dishes, water-droppers, water basins, and toys. Early Song *qingbai* ware is usually plain and undecorated, relying for its appeal on its pure, clean glaze; somewhat later, incised decoration became widespread, usually with designs of flowers, human figures, children at play, fish among waves, or clouds.

The Jian Kilns

Jian ware is a well known type of black-glazed porcelain from the Song; the kiln-sites were in the region of Houjing and Chizhong

villages in Shuiji Township, Jianyang County, Fujian Province. Among a large number of kilns producing black-glazed porcelain, Jian-ware kilns were noted for their unique style of black-glazed vessels such as bowls and cups.

Jian-ware black-glazed porcelain started to appear in the Northern Song period, while the Southern Song was its most productive time. The main type of black-glazed vessels are bowls of four different forms, namely bowls with straight rims, shallow bowls with flared rims, bowls with turned-in rims, and cup-shaped bowls with everted rims. The shallow bowls with flared rims and the bowls with turned-in rims, known as "Jian cups" (fig. 41), which were used for tea-drinking, were the most popular forms of Jian ware. The bodies of black-glazed Jian ware tended to be quite thick; their colors varied between blackish-grey, dark grey, and light grey. Glaze colors included deep black, blue-black, dark blue, dark green, and dark brown. Glaze was usually applied by dipping, so the glaze never reached the bottom of the vessel. Special glaze effects resulting from glaze transmutation in firing, such as hare's fur, oil spot, partridge feathers, and tortoiseshell markings, produced a dazzling effect in

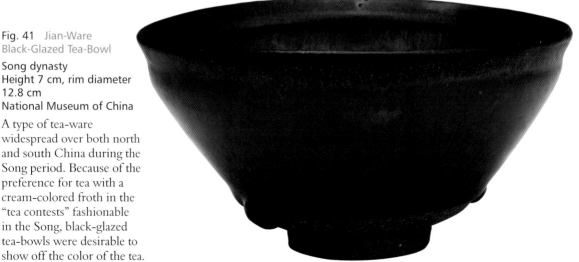

Fig. 41 Jian-Ware Black-Glazed Tea-Bowl

Song dynasty
Height 7 cm, rim diameter 12.8 cm
National Museum of China

A type of tea-ware widespread over both north and south China during the Song period. Because of the preference for tea with a cream-colored froth in the "tea contests" fashionable in the Song, black-glazed tea-bowls were desirable to show off the color of the tea.

sunlight and were highly decorative; these were regarded as prized objects.

The Jian kilns were unofficial, southern kilns; the bodies were quite thick, and the reason that these black-glazed bowls were so popular in the Southern Song period is connected to the Song-dynasty passion for tea. People did not simply drink tea during the Song, they also held "tea contests." There was a very lively tea culture in the imperial palace in the early Northern Song, and at the great feasts given by the emperor for his senior officials in spring and autumn, tea ceremonies were always held. The emperor often awarded tribute tea as prizes, or bestowed it as gifts to officials, monks, or commoners. When scholar-officials or literati assembled, a tea ceremony often formed part of the occasion, and they would enjoy themselves tasting and assessing tea, painting, and writing poems. These customs were adopted by lower ranks in society, and tea-drinking became a fashionable social activity rather than just a part of everyday life, extending into every corner of society.

"Tea contests" were also known as "tea tasting" or "tea testing." Tea in the Song dynasty was powdered, that is to say a cake of half-fermented tea-leaves was ground into powder; when boiling water was added to the powdered tea, a layer of bubbles would form on the surface. Because the color of the tea itself was white, contrasting black-glazed teacups were the most suitable for use in tea contests, but apart from their dark color, another reason for the enthusiasm for Jian tea-wares was their thickness, which meant that the tea stayed hot for longer. Among samples recovered from the Jian-ware kiln-sites, some teacups have inscriptions engraved on their bases such as "imperial offering" or "presented teacup," proving that Jian ware really was sent as tribute to the palace, so that although they were unofficial kilns, they did produce imperial wares.

3 Nostalgia for the Past: Archaistic Styles in Song Porcelain

Many Song-dynasty porcelain pieces imitate ritual vessels of the Shang and Zhou dynasties made of bronze (see fig. 34 on page 40, fig. 36 on page 42 and fig. 38 on page 44) or jade, and this became an important aspect of Song culture. Ritual, with its implication of social order, lies at the heart of Confucianism. The ritual system was from earliest times one of the most fundamental means of ensuring social order. Ritual vessels were utensils used by the Shang and Zhou aristocracy to carry out rites related to such activities as sacrifices, burials, official appointments, military campaigns, banquets, marriages, and coming of age ceremonies. The arrangements of bronze vessels represented the different ranks of feudal society, thus consolidating adherence to the ritual system.

In the early Northern Song, there was an attempt to revive the "rites of the three ancient dynasties" in sacrifices at the ancestral temple of the imperial family. The Northern-Song scholar Nie Chongyi (dates unknown) composed an *Illustrated Account of the Three Rites* in response to this need, and this can be regarded as heralding the Song vogue for archaism in arts and crafts. Emperor Huizong himself gave the order for the compilation of the *Illustrated Catalogue of Antiquities of the Xuanhe Reign* (*Xuanhe Bogu Tu*), giving a strong stimulus to the fashion for archaism.

Another reason for the rise of antiquarianism was the dominance of Neo-Confucianism which blended traditional Confucian doctrine with aspects of Buddhist and Daoist beliefs in the Song. The literati had a high status in Song society, and the literati class gradually evolved a particular, stylized way of life in order to demonstrate their own superiority. Their preferences and aesthetic standards shaped the fashions of

their age, and they became the promoters of the fashion for archaism. In the décor of Song literati's studios, flower vases became indispensable items, and vases in archaizing shapes became an adaptation to everyday life of such ritual vessels. This mood of nostalgia for an idealized past not only affected the literati's aesthetic appreciation of objects, but also had a profound influence at this time on the design and production of porcelain items. The vogue for archaistic porcelain endured right into the Ming and Qing dynasties.

4 Ethnic Identity: Porcelain of the Liao, Xixia, and Jin

Liao (907–1125). The regime established by the nomadic Khitan people in the north shared a border with the Northern Song in the region of Hebei and Shanxi. After establishing the Liao dynasty, the Khitan gradually turned to a more settled way of life, and the production of pottery and porcelain developed as one of their handicrafts. Two types of porcelain have been excavated within the territory of the Liao. One type is the numerous items produced by kilns within the Liao borders under the influence of porcelain-making in the central plains of China; the other is products of the Song kilns, much less numerous but of finer quality, demonstrating the commercial and cultural interchange between Liao and Song.

Porcelain kilns first appeared in Liao territory sometime during the Huitong reign-period (938–947) of Emperor Taizong of Liao (902–947, r. 927–947) or the reign of Emperor Shizong (917–951, r. 947–951). The earliest craftsmen had been captured as prisoners of war from Dingzhou and Cizhou, which were not far from the Liao border. Seven porcelain kilns within Liao territory have so far been discovered, at the Liao Upper Capital, Nanshan, and Baiyingele in Lindong (in present-day Bairin, Inner Mongolia), at Gangwa in Chifeng (Inner Mongolia), at Gangguantun in Liaoyang (Liaoning Province), at Longquanwu in Beijing, and at Qingci in Datong (Shanxi Province). The largest of these, the Gangwa kiln at Chifeng, is believed to have been the official kiln of the Liao dynasty; white porcelain was being produced here early in the Liao, at the same time as earthenware with black decoration on a white glaze, tea-dust green glaze, three-colored glaze and plain glaze. The white porcelain products were mainly cups, bowls (fig. 42), plates, dishes, ewers, and jars, while the glazed earthenware pieces were usually plates, dishes, cockscomb ewers (fig. 43), and phoenix-head bottles.

From the point of view of shapes, Liao porcelains can be divided into two broad categories. One comprises the traditional shapes of vessels from the Chinese central plains, such as *meiping* vases, plates, bowls,

Fig. 42 *White-Glazed Stem-Bowl*
Liao dynasty
Height 6.8 cm, rim diameter 10 cm, foot diameter 4.4 cm
Haidian Museum, Beijing

White porcelain of the Liao was less refined than in north-central China, and the application of the glaze on both the inside and the outside of this bowl is patchy.

(Illustration from: Haidian Museum ed., *Masterworks of Haidian Cultural Relics* [Haidian wenwu jingxuan ji], Beijing: Cultural Relics Press [Wenwu chubanshe], 2014.)

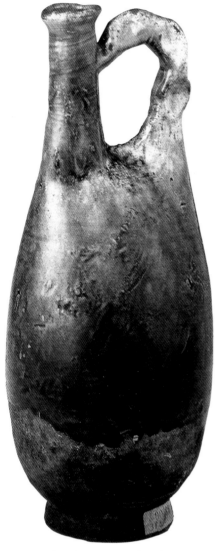

Fig. 43 Green-Glazed Cockscomb Ewer
Liao dynasty
Height 52 cm, mouth diameter 11.6 cm
National Museum of China

This was a common vessel shape in the Liao dynasty, originating from the leather water bottles used by the Khitan people. Ceramic cockscomb ewers went through a gradual process of development from a close imitation of the shape of leather water bottles to a simplified version.

Yu (9th–10th century), dated to 942, in the Ar Khorchin Banner of Inner Mongolia, is the earliest known tomb of the Liao era; a cockscomb ewer and flask with pierced carrying lugs excavated from this tomb are extremely fine, and were fired in a local kiln.

The decoration of Liao porcelain is similar to that of central plains, and includes carved, incised, sprigged, and molded patterns as well as the use of colored glazes. There is also a small quantity of vessels decorated with carved glaze (in which the pattern is carved into the unfired glaze), with a sgraffito pattern incised in the slip, or with black glaze applied to the ground around the pattern. Designs favored by the Khitan included tree peonies and herbaceous peonies, as well as lotuses, chrysanthemums, scrollwork, waves, clouds, fish, or butterflies. Preferred glaze colors were yellow, green, red, white, and black. The colors of Liao three-colored (*sancai*) ware, unlike the Tang yellow, green, and red *sancai*, are usually yellow, green, and white, thus forming their own unique style of three-colored ware.

In the mid- to late Liao, tea-wares such as saucers, conical cups, teapots, and warming basins, and other utilitarian vessels such as censers and cosmetic boxes remained the same as those used within north-central China, suggesting that the Khitan aristocracy wished to imitate the Song way of life. A refined lifestyle involving such luxuries as tea-tasting and the burning of perfume were gradually replacing the traditional life on horseback and the consumption of mare's milk, marking the sinicization of the Khitan people.

dishes, warming jugs, warming basins, round boxes, pillows, water-droppers, spittoons, saucers, cups, and jars, while the other consists of vessels in the Khitan ethnic style, some introduced from the Chinese central plains or from central and western Asia and adapted by Liao craftsmen in accordance with Khitan preferences, such as cockscomb ewers, flasks with dished mouths and pierced carrying lugs, phoenix-head bottles, chicken-leg vases, and elongated four-lobed dishes. Cockscomb ewers, also known as stirrup or leather-flask ewers, are the most characteristically Khitan porcelain type; their shape is a direct copy of the leather water bottles attached to the saddles of the nomadic Khitan people, and the early examples retain the shape and features of the leather containers. The tomb of Yelü

Xixia (1038–1227). The Tangut people who established the Xixia kingdom were a branch of the larger Qiang ethnic group. They originally lived in what is now Qinghai in north-west China, but later gradually moved eastwards to present-day Ningxia and Gansu. In 1038 the Tangut leader Yuanhao (1003–1048, r. 1038–1048) founded the Xixia state and declared himself emperor. The Xixia ceramic industry developed only after the foundation of the state. A number of porcelain kiln-sites have been discovered within its borders, such as at Ciyaobao and Huiminxiang in Ningwu, Chaqikou in Helan County, and Gangcijing in Yinchuan (all in Ningxia), and at Guchengxiang, Wuwei, in Gansu. The earliest, and the site with the greatest variety of porcelain types, is that of Ciyaobao in Ningwu (known as the Ningwu kiln-site). Xixia ceramics excavated and collected include utilitarian vessels such as bowls, dishes, stem-bowls, pilgrim flasks, bottles, jars, and wine-cups, studio items such as ink-slabs and water-droppers, entertainment items such as chess (*go*) pieces and

parts for musical instruments, and building materials such as tiles, roof decorations, eaves-tiles, as well as figurines, religious items, and kiln furniture. These pieces vary between coarse and fine; as regards glazing, the most common glazes are white and black (or dark brown). As regards decoration, the most common techniques are carving and sgraffito, while the designs are usually peonies, lotuses, or animals; the designs may be placed within a frame painted on the vessel.

The firing of Xixia ceramics was heavily influenced by the techniques used in the northern Chinese kilns such as Ding

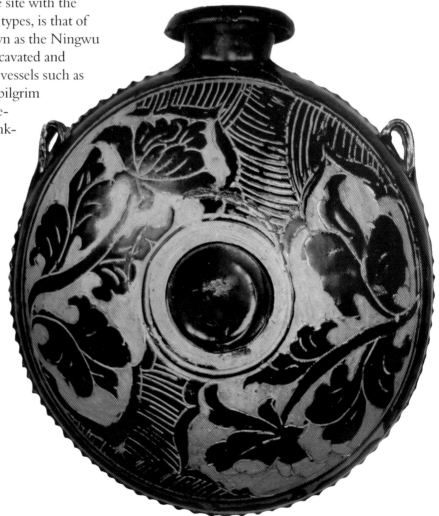

Fig. 44 Four-Lugged Pilgrim Flask with Sgraffito Decoration in Brown Glaze

Xixia
Height 33.3 cm, mouth diameter 9 cm, belly diameter 32 cm
National Museum of China

This is one of the finest surviving Xixia porcelain pilgrim flasks. The brown-glaze sgraffito decoration of two peony sprays on the front of the belly is a typical Xixia decorative type. The back has a round ring-foot, and the sides have a pattern of broken lines imitating the seams on a leather bottle.

and Cizhou, but in glaze colors, body composition, and firing technique they fell well below the standard of Song or Liao wares. Alongside imitation of the shapes and decoration of north-central Chinese porcelain, the Xixia wares also developed an ethnic identity of their own. The pilgrim flasks are the most obvious examples of this tendency (fig. 44). The Tangut people were fond of using such flasks to hold water, milk, or wine. They were round in profile, with flat sides, and two or four lugs on each curved side through which a cord could be run for carrying or hanging. Some of these flasks also have a ring foot on each of the flat sides; that on the back is to ensure stability when the flask is laid flat, while that on the front is partly for balance and partly to strengthen the vessel body. This shape appears to have evolved from the leather flasks used by the nomads to hold water, as it is particularly suited to carrying on horse- or camel-back.

Another peculiarity of Xixia ceramics is the large quantity of glazed earthenware construction materials and parts (fig. 45). The tomb platforms at the site of the Xixia royal tombs at Yinchuan in Ningxia may look like simple mounds of earth, but the sherds of glazed tiles to be found there show that they originally held splendid buildings with elaborate eaves tiled in bright colors.

Fig. 45 Green-Glazed Roof Finial
Xixia
Height 152 cm, width 92 cm, depth 32 cm
National Museum of China

This roof finial represents a *chiwen*, a magical beast from ancient Chinese mythology. These finials were usually placed facing each other at either end of the roof-ridge on a building, to guard the building. The size was proportional to the size of the building, so the massive size of this *chiwen* shows that the palace which it adorned was a very large one.

Fig. 46 Ding-Ware White-Glazed Bowl

Jin dynasty
Height 11 cm, rim diameter 26.2 cm, foot diameter 12 cm
National Museum of China

This piece was for use by commoners, and the quality is not equal to that of Ding ware in the Northern Song period. When the Jurchens who established the Jin dynasty drove the Song out of north China, the Ding kilns also came under Jin control. Having suffered damage in the course of war, it was only in the later part of the Jin that the Ding kilns became active again.

Jin (1115–1234). The Jin state was established in the north and north-east of what is now Chinese territory by the Jurchen people. At Huining Prefecture (present-day Echeng District in Heilongjiang) in 1115, Wanyan Aguda (1068–1123, r. 1115–1123), leader of the Jurchen Wanyan or Wanggiyan clan, having rebelled against the Liao, declared himself emperor of the Great Jin dynasty. In 1127, the Jin army attacked the Song Eastern Capital (present-day Kaifeng in Henan) and took prisoner the Song Emperor Huizong and his son, who on Huizong's abdication became Emperor Qinzong, as well as more than three thousand members of the imperial family, palace women, and court officials. The Northern Song collapsed, and Emperor Huizong's ninth son Zhao Gou, Prince of Kang (Song Emperor Gaozong), took the throne in Yingtian Prefecture (now Shangqiu in Henan), which became the Southern Capital. Subsequently the court moved to Lin'an (Hangzhou), and the dynasty became known as the Southern Song. For the next century or more, China's territory was divided between the Jin in the north and the Southern Song in the south.

After the establishment of the Jin state, the ceramic industry became one of its most highly developed crafts. There are two distinct periods of Jin ceramic production; the boundary between the two is conventionally set at 1153, when Wanyan Liang, Prince of Hailing (1122–1161), moved the capital to Yanjing (the "Central Metropolis" of Jin, present-day Beijing). Ceramics produced in the north-east before the move to Yanjing belong to the earlier period, while the later period refers to ceramics produced after the move in the region "within the Passes" (Guannei), that is to say, within north China itself.

The early-period Jin kilns located in the north-east developed on the basis of the Liao-dynasty kilns. These Jin north-eastern porcelain kilns may be represented by Daguantun in Fushun and Gangguantun in Liaoyang (both in Liaoning Province). The great majority of their products were coarse everyday wares, with glaze colors including black, white, dark-brown, and tea-green; the glaze is opaque and the body rough. The most common shapes are plates, bowls, dishes, bottles, jars, and ewers.

The later-period Jin ceramic industry in the Guannei region generally represents a revival and development of the Northern Song kilns. The best-known Northern Song kilns in the north, producing Ding, Cizhou, Yaozhou, and Jun wares, had all come under

Jin control. Dated porcelain items discovered so far in Jin tombs start from 1161, in the reign of Emperor Shizong of Jin (1123–1189, r. 1161–1189), showing that by this time these well-known Song kilns had already recovered their position. The majority of porcelain pieces excavated from Jin tombs or kiln-sites are Ding ware (fig. 46); very few pieces of southern manufacture have been found in the territory administered by the Jin. Ding ware also predominates in finds from tombs and kiln-sites in the territory controlled by the Southern Song. These Ding-ware pieces, transported far to the south through trade between the Song and Jin, are concentrated in areas on the Song-Jin border such as Jiangsu, Zhejiang, and Sichuan, in the Southern Song heartlands, and in the more economically developed cities.

Jun ware. The place-name Junzhou (Jun Prefecture) first appears in the Jin dynasty, from which some scholars have concluded that Jun ware also began in the Jin. Current research suggests, however, that the production of Jin-dynasty Jun ware began at the very end of the Northern Song period in unofficial kilns imitating Ru ware; after the Song fled south, the official Ru kilns ceased production while the unofficial kilns continued to operate, eventually becoming the main producers of celadon in north China under the Jin. As they became more successful they developed the unique style of Jun ware, which was one of the most influential types of ceramic in

the north in the later part of the Jin dynasty.

Among Jun ware excavated from Jin tombs and kiln-sites, the most common forms are bowls, plates, dishes, and long-necked bottles (fig. 47), with fine, dense bodies but rather irregular shapes. The glossy, crackled glaze is usually azure or sky-blue, and shows that the craftsmen had a firm grasp of techniques for mixing pigments. Some glazes have streaks of red or purple like the petals of a rose or the clouds in a sunset; the complex and gorgeous colors show great variety. A few Jun-ware pieces have also been excavated from sites within Southern Song territory, mainly from the Southern Song kiln-site at Fengjiaba in Lüeyang, Shaanxi, the site of the east pagoda of the Tang-dynasty Guoning Temple in Ningbo, Zhejiang, and the remains of a Tang- and Song-dynasty barbican or subsidiary city-wall, also in Ningbo. They date from the mid- to late Southern Song to the early Yuan dynasty, and bowls are the only form; they have a thick layer of glaze, which varies between sky-blue and azure.

Fig. 47 Jun-Ware Long-Necked Bottle
Jin dynasty
Height 28.8 cm, mouth diameter 5 cm, foot diameter 7 cm
Haidian Museum, Beijing

Jun ware is famous for its beautiful kiln-transmuted glazes, said to be "one color on entering the kiln and ten thousand shades on emerging." The Jun-ware bottle in the illustration, with its evenly-colored pale azure glaze, is a rather early example; the color like that of hazy moonlight is very attractive.

(Illustration from: Haidian Museum ed., *Masterworks of Haidian Cultural Relics* [Haidian wenwu jingxuan ji], Beijing: Cultural Relics Press [Wenwu chubanshe], 2014.)

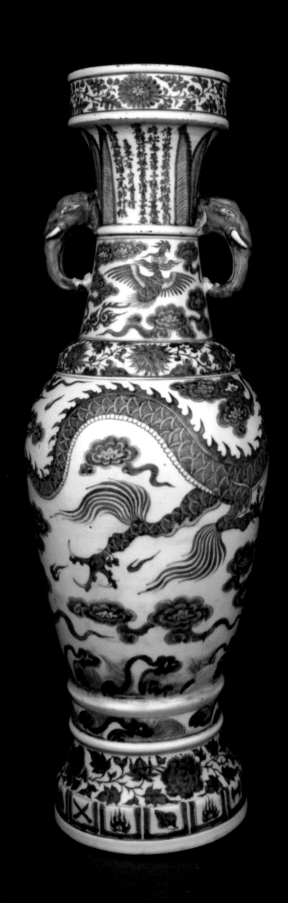

CHAPTER IV
YUAN PORCELAIN: APPRECIATION OF BLUE AND WHITE

Mongol rule over China, in the form of the Yuan dynasty, lasted for less than a century, but had a profound influence on China's government, economy, and culture. Under the Yuan, Neo-Confucianism was subordinated to government power, becoming a pragmatic set of guidelines applied nationally, and gradually transforming itself into a dogma controlling ideology and behavior. Yuan concepts of social status placed the literati at a low level, thus destroying the elegant lifestyle adopted by the scholar-official elite at least from Song times. The importance placed on such aspects of the economy as agriculture, handicrafts, and overseas trade meant, as far as porcelain manufacture was concerned, that on the one hand various kilns such as those producing Cizhou, Longquan, Jun, and Dehua wares continued the production practices of the previous dynasty, while on the other hand methods of production gradually took shape which aimed to supply the specific needs of the government or of particular regions. For example, the government established the Fuliang Porcelain Bureau at Jingdezhen to be in charge of the manufacture of porcelain items, with a monopoly on the firing of porcelain utensils for official government use; this spurred the rapid development of the Jingdezhen porcelain industry, leading to the production of innovations such as the high-fired "egg-white" glaze, underglaze blue decoration, underglaze red, and blue glaze, so that porcelain manufacture became more refined, delicate, and complex. Jingdezhen slowly became the center of porcelain production for the entire country, while kilns which had produced fine porcelain all over China reduced in number, with the great majority of kilns producing coarse porcelain for everyday use. Thus there was a sharp division into the two extremes of fine and coarse, complex and simple.

Figs. 48–49 Vase with Elephant-Ear-Shaped Handles and Pattern of Dragons amid Clouds in Underglaze Blue

Yuan dynasty
Height 63.3 cm, mouth diameter 14.3 cm, foot diameter 17.5 cm
Percival David Foundation, London

The illustration shows one of a pair of very substantial vases. The neck bears an inscription of about sixty characters, which clearly records that the pair were made in the 11th year of the Zhizheng reign-period of the Yuan dynasty (1351). This pair of vases is the only known example in the world of Yuan blue-and-white porcelain with an inscription giving a precise date.

1 The Fuliang Porcelain Bureau: the Rise of Jingdezhen

During the Yuan dynasty Jingdezhen continued the Song manufacture of *qingbai* ware, while the government established the Fuliang Porcelain Bureau there to be in charge of supervising the manufacture of porcelain for official use and of distributing important raw materials. This secured Jingdezhen's position as the center of porcelain manufacture. The number of artisan kilns increased rapidly; production and sales were highly successful. A figurine of a seated Guanyin can serve as a representative example of Yuan-dynasty *qingbai* ware (fig. 50). The glaze of Yuan *qingbai* is slightly bluer than that of Song *qingbai*, and thick-bodied wares are more numerous than thin-bodied. Modern scientific analysis shows that the sodium oxide and potassium oxide content of Southern Song *qingbai* glaze is fairly low, and the glaze is less viscous than in the Yuan, so the glaze is more translucent, with a glassier surface texture, while the surface of Yuan *qingbai* glaze is smooth but opaque. This is a result of a change in the composition of the glaze from a calcareous glaze to a more alkaline calcium glaze. Moreover, the body of Yuan porcelain was composed of two ingredients, porcelain stone and kaolin; this was an innovative technique in Yuan-dynasty porcelain manufacture at Jingdezhen, which meant that the bodies were both harder and stronger, and did not easily warp in firing.

In the Yuan, Jingdezhen gradually took over as the center of Chinese porcelain manufacture, while the kiln workshops also slowly collected within the township itself rather than on its outskirts. The variety of types of porcelain also represented a sharp change from the situation in the Southern Song where *qingbai* was absolutely dominant. Now new types of porcelain ware were created, such as egg-white glaze, underglaze blue, underglaze

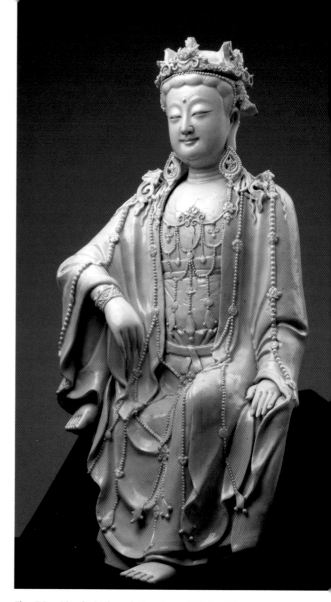

Fig. 50 *Qingbai*-Glazed Figurine of Water-Moon Guanyin from Jingdezhen

Yuan dynasty
Overall height 65 cm
Capital Museum, Beijing

The craftsmanship of this Guanyin figurine is very fine. Her posture is elegant and relaxed, her facial expression compassionate and gentle, gazing serenely down on all sentient beings, with her smile showing a hint of sadness. This is a very fine example of Yuan-dynasty *qingbai*-glazed porcelain sculpture from Jingdezhen.

(Illustration from: Capital Museum ed., *Masterpieces from the Capital Museum* [Shoudu bowuguan zhenpin jicui], Beijing: Social Science Academic Press [Shehui kexue wenxian chubanshe], 2019.)

red, underglaze blue and red, overglaze painting, decoration reserved in white on a blue background, and high-fired blue glazes. This laid the foundation for subsequent achievements in porcelain production.

2 Veneration of White: "Egg-White Glazed" Porcelain

Egg-white glaze was a type of high-fired porcelain glaze first developed at Jingdezhen in the Yuan, and one of its most numerous types of product. The name derives from the similarity of the color, an opaque white with a slight blue-green tinge, to that of a goose egg. The egg-white glaze is even and does not crackle nor easily vitrify. Egg-white glazed wares usually have molded decoration, which because of the opacity of the glaze does not stand out clearly. Some pieces have molded characters incorporated in the decoration, such as "Grand Celebration," "Cabinet Office," "Jade," "Good fortune," or "Emoluments." Comparison with written records shows that "Grand Celebration" (*taixi*) refers to the Office of Imperial Ancestral Worship (*taixi zongsi yuan*), which was in charge of sacrifices to deceased emperors and empresses; "Cabinet Office" (*shufu*) refers to the Bureau of Military Affairs, which in the Yuan was the central government agency in charge of military activities; "Jade" (*yu*) refers to the Bureau of Imperial Ritual (*yuchen yuan*), the office supervising sacrificial ritual in the early Yuan, in charge of musicians, worship, and sacrificial offerings. Evidently the egg-white glazed porcelain vessels with these inscriptions were made on the orders of government offices, and the decorative designs were probably also supplied by the government.

Since the most numerous of these inscriptions found in early archeological excavations were the "Shufu" type, these porcelain wares are referred to by scholars as "Shufu porcelain" or "Shufu ware." They have been found in Jiangxi, Anhui, Jininglu in Inner Mongolia, and the site of the Mongol capital Dadu (now Beijing). 109 pieces of Shufu porcelain were discovered in 1984 at the site of a Yuan-dynasty cache in Shexian, Anhui, stored in a large, 48 cm tall, round earthenware pot. There are very few examples of surviving or newly excavated Shufu vessels, so this discovery of over one hundred pieces caused a sensation in the world of ceramics. The group consists only of bowls and plates, 31 bowls with angled sides (so-called "bent waist" type) and impressed decoration, and 78 plates with impressed decoration, all with a glistening egg-white glaze and peony-scroll designs, with the characters *shu* and *fu* set opposite each other among the flowers. 32 of the vessels have the character *chun* written in ink on the base; research has shown that during the Zhiyuan reign-period (1335–1340) of the Yuan dynasty, a local man named Hong Chun acted as Vice-Magistrate or Assistant Magistrate of Shexian and subsequently became Magistrate of Yushan and then Dongyang. Both Yushan and Shexian border on Jingdezhen, so it would be very easy to place an order there. This also shows that Shufu ware was not just for the use of the Bureau of Military Affairs in the central government, but could also be used at lower levels of government or even by commoners. Among the Yuan export porcelain recovered from a sunken ship off Sinan in South Korea, there were also some pieces inscribed with *shufu*, but these commercial pieces made in imitation of Shufu wares and exported in large numbers were rather coarse in quality and evidently quite cheap. Vessels marked *shufu* are mostly small plates and bowls (see fig. 51 on page 60), with the "bent-waist" bowls being the most typical. They all have molded decoration on the interior, with the most common subjects being lotus or chrysanthemum scrolls; dragon and phoenix patterns appear only on high-quality pieces.

In 1999, more than 240 examples of early-Yuan egg-white glazed Shufu wares were discovered on the site of the Liujiawu kiln in Jingdezhen, of which 95% were stem-cups, some having a molded design of imperial five-clawed dragons, so they were of high

quality. They were carefully made, with very fine rims and a dense body of pure white; the glaze color was a bright pure white. The Liujiawu kiln must have been one of the kilns supplying the imperial household with egg-white glazed porcelain.

The fondness of the Yuan governing elite for the egg-white glaze must have been related to a preference in Mongol culture for the color white (which in Han-Chinese culture is inauspicious). In the Yuan palace, white clothes were always worn on ceremonial occasions, and horses in the imperial herd were all greys, while among hunting hawks the white gyrfalcon was the most prized, so it was natural that the elite should favor white-glazed porcelain. It is also claimed that the Mongol preference for white is related to their custom of drinking mare's milk, and indeed the color of egg-white glaze is very close to that of mare's milk, being creamy, thick, and opaque. The most frequently seen egg-white glazed wares are bowls, plates, and stem-cups, but there are also other shapes such as spouted bowls (pouring bowls), bottles, ewers, cup-stands, lamps, jars, pillows, and figurines.

Fig. 51 Egg-White Glazed Plate with *Shufu* Mark

Yuan dynasty
Height 4.3 cm, rim diameter 13.3 cm, foot diameter 4.5 cm
National Museum of China

The body of this plate is quite thick and hard, of a pure white color; the white of the glaze has a blue-green tinge. The interior of the plate has a molded floral pattern. Porcelain with the *shufu* mark was mostly for official use.

3 Brilliant Blues: Underglaze Blue Decorated Porcelain

Yuan underglaze blue (or blue-and-white) porcelain has made its mark in the world of antique collection through the high prices it achieves at auction, though during the Yuan dynasty it was regarded as commercial ware destined for export or for ordinary use in the domestic market. Because of its attractive decorative patterns and because it survives in relatively low numbers, it is a great favorite with contemporary collectors.

Underglaze blue decoration is made by

painting on the leather-hard body with a cobalt oxide pigment and then adding a layer of transparent glassy glaze; a single firing at a high temperature results in a porcelain vessel with the painted decoration under the glaze. Blue-and-white porcelain first appeared during the Tang dynasty, but was very rare: the few surviving examples include three blue-and-white plates recovered from the famous Tang-dynasty wreck of the Batu Hitam, and a blue-and-white stupa-shaped urn showing polo players, excavated from a Tang-dynasty tomb in Zhengzhou, Henan. The designs on these pieces are simple and freely drawn; they were all produced by the Tang kilns at Gongxian in Henan, which were the main producers of Tang *sancai* wares. The sudden appearance of large numbers of blue-and-white wares in the Yuan dynasty is related to trade demand from the Middle East at that time. Lapis lazuli blue had long been a favored color for decoration in the Islamic world, and cobalt had a long history of use there as a colorant for earthenware. In the 9th and 10th centuries, white-glazed earthen ware with blue decoration started to appear in the region of Persia and Mesopotamia, and these patterns were painted using cobalt pigment. The cobalt pigment used for Yuan underglaze blue was known in China as "Sumali blue," a term which some scholars think came from Persia (now Iran) and others from Central Asia.

Yuan underglaze blue ware was somewhat neglected by scholars in China before the 1980s, since very little had been excavated, and it was often thought to date from the early Ming. What first drew scholars' attention was a pair of underglaze blue vases with elephant-shaped handles, decorated with a cloud and dragon pattern, known as the "David vases," from the Percival David Foundation in London (see figs. 48 and 49 on pages 56 and 57). In a space reserved among the banana-leaf decoration on the neck is an inscription of sixty-odd characters which

makes it absolutely clear that these porcelain vases were made in 1351 (the 11th year of the Zhizheng reign-period of the Yuan dynasty) specifically to be dedicated to Marshal Hu Jingyi in the Xingyuan Ancestral Hall. It has been established that the Xingyuan Ancestral Hall was the main hall of the Lingshun Temple at Wuyuan in Jiangxi, and that the deity concerned was a god of wealth who was worshipped by local believers as the "God of Five Manifestations." The donor Zhang Wenjin was a merchant from Yushan County near Jingdezhen, which shows that in the Yuan dynasty underglaze blue decorated porcelain was available as a commodity which could be ordered by commoners. Once these dated Yuan vases became known, they established a benchmark for Yuan underglaze blue, and Chinese scholars began to recognize that some blue-and-white vessels excavated from early Ming tombs actually belonged to the Yuan dynasty; one example is a *meiping* vase in the Nanjing Municipal Museum with an underglaze blue design showing the semi-historical tale of "Xiao He pursuing Han Xin through the night," which was excavated in 1950 from the tomb of Mu Ying at Jiangning, in Jiangsu Province, dated to 1392 (the 25th year of the first Ming emperor's reign). Mu Ying (1344–1392) was an adopted son of Zhu Yuanzhang (1328–1398, r. 1368–1398), the first Ming emperor. Mu Ying was ennobled as Marquis of Xiping and then Prince of Qianning, and acted as military commander of Yunnan, from where his body was returned to the capital Nanjing for burial; his burial place became known as the General's Hill. This vase was at first attributed to the Hongwu reign-period (1368–1398), but with greater understanding of Yuan blue-and-white ware it was then recognized as a Yuan piece. This is a very fine piece, whose very full decoration in several registers is highly typical of Yuan-dynasty underglaze blue. The ring of inverted lotus-petal panels on the shoulder,

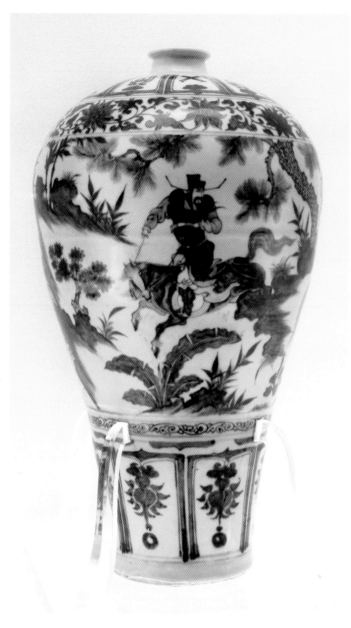

Fig. 52 *Meiping* Vase with Underglaze Blue Design of "Xiao He Pursuing Han Xin by Night"

Yuan dynasty
Height 44.1 cm, mouth diameter 5.1 cm, foot diameter 13 cm
Nanjing Municipal Museum

Meiping vases could be used either for wine storage or as flower vases. In addition to the main painted scene, this vase has five bands of decoration in a well-balanced arrangement. The white glaze is pure and glossy, the blue pigment rich and elegant. The vase would be a worthy centerpiece in any room. The story of "Xiao He pursuing Han Xin by night" comes from an incident in the war between Chu and Han at the end of the Qin dynasty in the 3rd century.

containing Buddhist emblems, is a design peculiar to Yuan underglaze blue (fig. 52). The subject of "Xiao He pursuing Han Xin" depicted on the belly of the vase derives from a story from the war between Chu and Han at the end of the Qin dynasty in the late 3rd century BC. The brilliant military strategist Han Xin (?–ca. 196 BC), having taken the side of Liu Bang (256 or 247–195 BC), who went on to found the Han dynasty, went off in anger at not being given a senior position; Liu Bang's prime minister Xiao He (d. 193), who had an eye for talent, pursued Han Xin through the night in order to bring him back, and persuaded Liu Bang to give him a suitable appointment, in which Han Xin went on to play a vital part in enabling Liu Bang to become emperor. The traditional form of drama known as *zaju*, which had first developed in the late Song, became very popular during the Yuan, and this story provides the basis for the *zaju* play *Xiao He Pursues Han Xin by Night* by the Yuan playwright Jin Renjie (dates unknown). *Zaju* plays were a highly popular and widespread form of entertainment, and were also published in popular illustrated editions, whose woodblock prints often provided inspiration for scenes from popular dramas as decoration on porcelain vessels.

The vessels which are decorated with such dramatic figure scenes in underglaze blue are usually rather large, such as large *guan* jars, *meiping* vases, or pear-shaped bottle vases (fig. 53). The large jars are mostly about 25–30 cm high, the *meiping* vases about 40 cm high, and the bottle vases about 30 cm high. Surviving examples of such underglaze blue pieces include a large jar in a British private

collection with a scene of the legendary
political theorist Guiguzi descending the
mountain, a lidded jar in the Idemitsu
Museum of Arts in Tokyo with a design of
Wang Zhaojun leaving China to marry the
Xiongnu chief, a covered *meiping* vase in the
Boston Museum of Fine Arts showing Liu Bei
(161–223) visiting Zhuge Liang's (181–234)
thatched hut, a pear-shaped bottle vase in the
Hunan Provincial Museum showing the Qin-
dynasty general Meng Tian, and a *meiping*
vase in Hubei Provincial Museum (fig. 54)
depicting the "four loves": the calligrapher
Wang Xizhi's (321–379) love of orchids, the
poet Tao Yuanming's (ca. 370–427) love of
chrysanthemums, the hermit Lin Bu's (967–
1029) love of plum-blossom and cranes, and
the philosopher Zhou Dunyi's (1017–1073)
love of lotuses. Apart from figure scenes from
drama, decoration on this type of large vessel
often consists of cloud and dragon patterns,

Fig. 53 Pear-Shaped Bottle Vase with Design of Dragons amid Clouds in Underglaze Blue
Yuan dynasty
Height 29.8 cm, mouth diameter 8.4 cm, foot diameter 9.9 cm
National Museum of China

The design on this vase is freely drawn, the dragon image lively and expressive. Pear-shaped bottle vases were wine containers or flower vases and were in wide use during the Song and Yuan periods.

Fig. 54 *Meiping* Vase with Design of the "Four Loves" in Underglaze Blue
Yuan dynasty
Height 38.7 cm, mouth diameter 6.4 cm, base diameter 13 cm
Hubei Provincial Museum

Images of the "four loves"—the calligrapher Wang Xizhi's love of orchids, the poet Tao Yuanming's love of chrysanthemums, the hermit Lin Bu's love of plum-blossom and cranes, and the philosopher Zhou Dunyi's love of lotuses—are depicted in four foliated panels on the belly of the vase.

(Illustration from: Hubei Provincial Museum ed., *Highlights of Cultural Relics Excavated in Hubei* [Hubei chutu wenwu jingcui], Beijing: Cultural Relics Press [Wenwu chubanshe], 2006.)

floral scrolls, phoenixes and birds, fish among waterweeds, lotus ponds with ducks (fig. 55), and so on. The Yuan dynasty painter Ke Jiusi (1290–1343) added a note to his set of poems *Fifteen Palace Songs* indicating that in the Tianli reign-period imperial robes were often decorated with such scenes of lotus ponds. Tianli (1328–1330) was one of the reign-periods of Tugh Temür (1304–1332), otherwise known as the Yuan Emperor Wenzong. If these designs of lotus ponds which appeared on the emperor's robes also appeared on porcelain vessels, that shows that elite fashions had already spread to decorative objects.

Underglaze blue decoration was also used in the Yuan on smaller items, such as plates, bowls, saucers, stem-cups, boxes, spouted bowls, and jugs used in everyday life, or ritual vessels such as incense-burners or altar-vases. The most characteristic pieces are stem-cups (fig. 56) and spouted bowls (fig. 57). The main features of stem-cups (*gaozubei* or "high-footed cups"), which are also known in Chinese as handle-cups (*babei*) or stirrup-cups (*mashangbei*), are an everted rim and rounded bowl, supported on a high foot. After the establishment of the Yuan dynasty, the influence of Mongol customs led to great quantity of stem-cups being produced, so

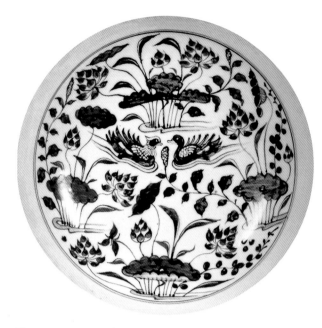

Fig. 55 Lotus-Pond Design in Underglaze Blue
Yuan dynasty
The lotus-pond design is a common form of decoration on Yuan-dynasty handicraft items, and sometimes includes mandarin ducks, geese among reeds, and other creatures.

that they became one of the most popular types of Yuan porcelain. They were used both as wine cups and as sacrificial vessels. The spouted bowl is a water container with a single pouring spout on the rim and a ring-lug under the spout through which a hanging string could be threaded, for convenience in carrying on horseback.

Large Yuan underglaze blue vessels have a thick, heavy body, while small vessels are quite light and thin. The body clay varies widely in quality. The glaze is white with a bluish tinge. Most pieces have unglazed bases, except for pear-shaped bottle vases which usually have glazed bases. The imported "sumali blue" cobalt pigment gives a strong, attractive color, with dark spots where the pigment is particularly thickly applied. The decoration covers most of the surface and gives an effect of depth. The main area of

Fig. 56 Stem-Cup with Phoenix amid Clouds in Underglaze Blue
Yuan dynasty
Height 9.5 cm, rim diameter 9.4 cm, foot diameter 3.4 cm
Archeological Research Institute of Inner Mongolia Autonomous Region
This type of drinking vessel was very common in the Yuan dynasty.

Fig. 57 Spouted Bowl Decorated with Flower Spray in Underglaze Blue
Yuan dynasty
Height 4.6 cm, rim diameter 13 cm, base diameter 8 cm
Anhui Museum

Made in imitation of Mongol metal ware spouted or pouring bowls, this was a type of wine or water vessel which was easy to carry on horseback.

decoration may consist of floral scrolls, dragons and phoenixes, fish, lotus ponds, or figure scenes, while the minor decorative registers often have lotus petals, Buddhist emblems, or scrollwork.

Two hundred-odd complete examples of Yuan underglaze blue vessels have been excavated in China; the most important discoveries include six fine pieces found in a cache at a Yuan-dynasty kiln in Baoding, Hebei Province, in 1964, nineteen pieces among a collection of Yuan porcelain from a cache at a kiln in Gao'an, Jiangxi Province, phoenix-head flasks discovered in Beijing and Xinjiang, and the *meiping* vase discovered in Hubei depicting the "four loves."

There are over three hundred pieces of Yuan underglaze blue porcelain in museums around the world, with 43 in the Topkapi Saray in Istanbul, 28 in the National Museum of Iran, 30 in the Palace Museum in Beijing, and six in the National Museum of China (fig. 58). Japan has about forty, including those in the Tokyo National Museum and the Idemitsu Museum of Arts.

There are at least twenty pieces altogether in the British Museum, Victoria and Albert Museum, Percival David Foundation (on loan to the British Museum), and the Ashmolean Museum in Oxford. There are also some important and fine pieces in museums in France, Holland, and elsewhere, as well as in private European collections. The main museums in the United States with collections of Yuan underglaze blue are the Boston Museum of Fine Arts, the Freer-Sackler in Washington DC, and the Metropolitan Museum of Art in New York; there are also a few pieces in the Cleveland Museum of Art, Harvard's Sackler Museum, and some private collections.

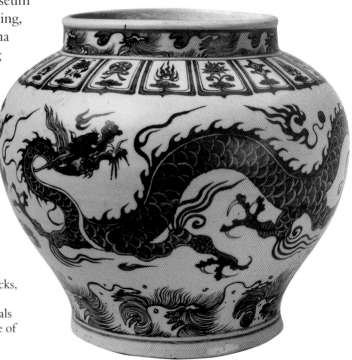

Fig. 58 Jar with Design of Dragons among Clouds in Underglaze Blue
Yuan dynasty
Height 27.9 cm, mouth diameter 20.9 cm, foot diameter 19.8 cm
National Museum of China

This type of jar, with a high shoulder, rounded belly, and wide mouth, is very common in the Yuan dynasty. The subject of the densely composed design is two dragons flying among clouds; the dragons' bodies are long and thin, with small heads and slender necks, a form typical of Yuan-dynasty dragon designs. The shoulder is encircled by inverted lotus petals containing a variety of jeweled pendants, a style of decoration which also began in the Yuan.

4 Harmony in Blue: the First Blue-Glazed Porcelains

Blue-glazed porcelain is made by adding cobalt as a colorant to the glazing material, applying it to the body surface, and firing at a high temperature. The result is a glossy, sapphire-blue glaze surface. This was an innovation of Jingdezhen during the Yuan dynasty. There are different types of blue-glazed ware: blue glaze with reserved white decoration, pure blue glaze, and blue glaze with gilt decoration.

Blue-glazed porcelain requires strict control of the firing temperature. The temperature must be kept between 1,280 and 1,300 degrees Celsius. If the temperature is too high, the glaze will run, so blue-glazed porcelain is particularly hard to fire and has a very high failure rate. The number of surviving pieces from the Yuan dynasty is a mere ten to twenty, and includes *meiping* vases, spouted bowls, tripod goblets (*jue*), small cups, plates, and bowls.

A particularly characteristic form of Yuan blue-glazed porcelain is the *meiping* vase with reserved white dragons; currently there are three known examples, in the Yangzhou Municipal Museum, the Summer Palace (Yiheyuan) in Beijing, and the Musée Guimet in Paris, with the Yangzhou vase being the largest. There are also five known blue-glazed plates with reserved white dragons, in the collections of the Beijing Palace Museum, the Percival David Foundation, the Museum of Oriental Ceramics in Osaka, the Idemitsu Museum of Art, and the National Museum of Iran. The plate in the Palace Museum was part of the collection belonging to the Qing imperial household, and was originally kept in either the Mountain Estate for Escaping

Fig. 59 Plate with Dragon Design Reserved in White in Blue Glaze
Yuan dynasty
Height 1.1 cm, rim diameter 16 cm, foot diameter 14 cm
Palace Museum, Beijing

On a blue-glazed ground, a white dragon writhes with raised head. This technique of reserved white decoration in blue glaze is very difficult to accomplish. The blue glaze is achieved by adding cobalt pigment to the glaze. This requires a large quantity of cobalt, so blue-glazed pieces from the Yuan dynasty are very rare.

the Summer Heat (*Bishu Shanzhuang*) in Chengde or in the imperial palace in Shenyang (fig. 59).

The decoration reserved in white on blue-glazed porcelain was made by carving or impressing the design on the unglazed body and applying a clear glaze to the design and the blue glaze to the remaining surface, and then firing at a high temperature. Techniques for forming the design were engraving, molding, and carving.

The blue-glazed *jue* tripod goblets held in the Hangzhou Historical Museum and the Shexian Museum in Anhui were both excavated at Yuan-dynasty caches and form the only known complete examples of their type. Their shape is an imitation of an ancient bronze vessel type, with three feet,

a round belly, and a boat-shaped mouth with two upright pillars on the rim. The bronze *jue* goblet was a widely used wine vessel in the Shang and Zhou periods, and porcelain reproductions were mostly used as ritual items. Some fragments of this blue-glazed type have been excavated from the Luomaqiao kiln-site in Jingdezhen.

Two very fine porcelain vessels with a blue glaze with gilt decoration were discovered in a cache at a Yuan-dynasty kiln-site in Baoding, Hebei Province, in 1964: one was a bowl and one a spouted bowl. The bowl (fig. 60) is now in the Hebei Museum; it is blue-glazed both outside and in, and the exterior is painted with plum-blossom using the gilt decoration. The spouted bowl has been in the Beijing Palace Museum collection since 1965. Gold-painted decoration on porcelain first appeared in the Tang dynasty, and then sporadically through the Song, Liao, and Jin. The painting is done over the fired glaze, and the piece then requires a second firing, this time at a low temperature. This is a complex process, and the gold pigment easily flakes off in use, so very few examples survive. The decoration on the Yuan pieces excavated from this cache is quite well preserved and still shiny, which is most unusual.

The enthusiasm of the Mongols for the colors blue and white is reflected in both the blue-glazed pieces with reserved white decoration and the underglaze blue pieces. The sober and plain pure blue glaze was more highly regarded, and was used only by the highest ranks in society for domestic and ritual purposes, so it survives in very small numbers. Even in later times, only small quantities of blue-glazed porcelain were produced, and those were mainly for ritual use. After the transmission of porcelain manufacture to Europe, Meissen in Germany and Sèvres in France also produced blue-glazed porcelain with gold decoration as prestige ware for the use of royal households.

5 Glowing Like Sunset Clouds: Underglaze Red Porcelains

Underglaze red is the name for porcelain painted in red under a high-fired glaze, and was another of Jingdezhen's innovations during the Yuan dynasty. The decoration was painted on the leather-hard body with a pigment containing metallic copper as the colorant, and then a layer of clear glaze was applied before a single firing at a high temperature of about 1,250 degrees Celsius in a reducing (low-oxygen) atmosphere. The resulting red design was fresh, bright, and glowing; the warm, fiery-red tone was something quite new in ceramic decoration, and created a new combination of Chinese painting technique with porcelain manufacture.

The first kilns to use an over-glaze copper red pigment were the Changsha kilns in the Tang dynasty, but that was an unintentional outcome of firing in an

Fig. 60 Blue-Glazed Cup with Gilt Design of Plum-Blossom in the Moonlight
Yuan dynasty
Height 4 cm, rim diameter 8.1 cm, base diameter 4 cm
Hebei Museum

The technique of gilding used on this blue-glazed cup, in which an extremely thin layer of gold leaf is applied to the surface, is a decorative technique often used on lacquerware but very seldom seen on porcelain. Such vessels were unusual in the Yuan dynasty.

oxidizing atmosphere, and it was not until the Yuan that true underglaze red porcelain was successfully fired. The successful firing of underglaze red required very specific conditions, not only the correct copper content in the pigment and ingredients in the base glaze, but also a precise control of the firing temperature and atmosphere; it was only when all these conditions came together that a pure underglaze red could be achieved. The slightest inaccuracy meant that the color would come out wrong. Consequently, the production of underglaze red in the Yuan was very low, and there are very few surviving pieces. Moreover, because this technique was still in an early stage of development, control of the color was far from ideal, and it might come out uneven, irregular, or too faint, so there were some constraints on the design, which was usually painted using a wash or highlights on a flat surface, in combination with other decorative techniques such as engraving, impressing, carving, or underglaze blue painting.

An example is the lidded jar with pierced panels decorated in underglaze blue and red excavated from the Yuan cache at Baoding in Hebei (fig. 61): the main decoration is in underglaze blue, with only the flowers on the pierced panels highlighted in underglaze red. On a pear-shaped bottle vase with floral design in underglaze red (fig. 62) from the Capital Museum in Beijing, the color has a blackish tinge, the depth of color is uneven, and the painting is rather slapdash, showing that the underglaze red technique was still in its infancy.

Types of vessels decorated in underglaze red during the Yuan include large *guan* jars, pear-shaped bottle vases, *meiping* vases, grain containers in the shapes of buildings (used

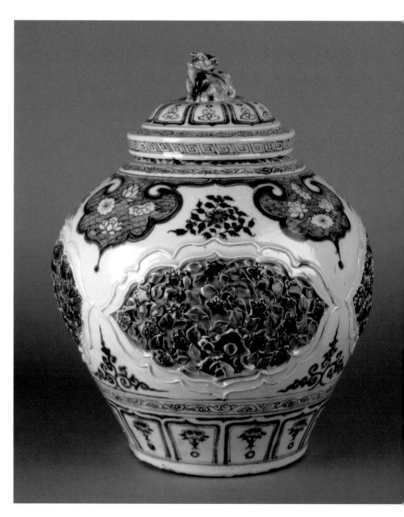

Fig. 61 Large Lidded Jar with Pierced Panels Decorated in Underglaze Blue and Red
Yuan dynasty
Overall height 42.3 cm, mouth diameter 15.3 cm, base diameter 18.7 cm
Hebei Museum

This large jar has a lid with a knop in the shape of a lion. The belly is decorated with pierced openwork floral panels on which the flowers are highlighted in underglaze red. This is an unusual form of decoration for the body of a jar. With its three-dimensionally rendered lion, openwork floral panels, and the harmonizing colors of the underglaze blue and underglaze red, this is a rare and splendid example of Yuan porcelain.

Fig. 62 Pear-Shaped Bottle Vase with Floral Design in Underglaze Red

Yuan dynasty
Height 31.4 cm, mouth diameter 8.4 cm
Capital Museum, Beijing

Excavated from the crypt of the Wayao Pagoda in Fengtai, Beijing, this was evidently donated as a precious offering. Underglaze red decoration was in an early stage of development in the Yuan dynasty; although the color and technique of the painting are rather coarse, underglaze red porcelain of the Yuan is quite a highly-valued type.

(Illustration from: Capital Museum ed., *Exhibition of Masterpieces of Ancient Porcelain Art* [Gudai ciqi yishu jingpin zhan], Beijing: Beijing Publishing House [Beijing chubanshe], 2005.)

6 An Export Best-Seller: Longquan Porcelain

The Longquan kilns were situated mainly on the upper reaches of the Ou River in Zhejiang, and formed an important production center for celadon from the reign of the Song Emperor Shenzong (1048–1085, r. 1067–1085) onwards. In the Southern Song period, Longquan celadon was already famous throughout China, and its bright, glossy powder-blue and plum-green glazes were much admired, even by the imperial household and the aristocracy. Because of increased demand from overseas trade, the scale of production at the Longquan kilns increased during the Yuan, and hundreds of kilns along both banks of the Ou and Songxi rivers produced Longquan ware in unprecedented quantities for both the foreign and domestic markets.

The Longquan kilns were divided into southern and eastern districts, the most important kilns in the southern district being those at Jincun, Xikou, and Dayao, which produced high-quality ware for the upper levels of the aristocracy. The eastern district mainly produced ordinary wares for the use of commoners and export wares. As far as is known from archeological discoveries to date, Longquan celadon was very widely used, throughout all the main regions of the Yuan empire, from Manchuria and present-day Inner Mongolia in the north to Guangdong and the islands of Hainan Province in the south, and from Shandong in the east to Gansu and Ningxia in the west. Archeological excavations well beyond China's borders have shown that Yuan-dynasty Longquan celadon travelled along both the overland Silk Roads and the maritime trading routes, reaching Korea and Japan to the east, South-East Asia to the south, India and Asia Minor to the west.

During the Yuan the main trading ports

as grave goods), double-lugged flat-sided bottles, stem-cups, spouted bowls, plates, bowls, and four-lugged jars, as well as various smaller items. Some fragments of *jue* goblets with unevenly painted underglaze red have been excavated from the Luomaqiao kiln-site at Jingdezhen.

Fig. 63 Longquan Celadon High-Necked "Phoenix-Tail" Vase with Engraved Peony Pattern

Yuan dynasty
Height 45.5 cm, mouth diameter 19.5 cm, base diameter 13 cm
National Museum of China

In the Yuan dynasty the Longquan kilns continued to flourish on a large scale, and were the main producers of export porcelain. The vessel shown in the illustration is one of the larger types from this period.

were Mingzhou (present-day Ningbo in Zhejiang), Hangzhou, Quanzhou, and Guangzhou. In 1976 the wreck of a Yuan-dynasty merchant ship was recovered from the sea off Sinan in South Korea. The 200-tonne vessel was 34 meters long and 11 meters wide. It had set out from Mingzhou and sank off Sinan. More than ten thousand pieces of Longquan celadon were on board the ship, representing the main types of porcelain exported for the maritime trade. Mingzhou, as the port nearest to the Longquan kilns, was the main port for the export of Longquan ware. The Longquan celadon recovered from the Sinan wreck was finely made in a great variety of shapes, including bowls, plates, incense-burners, vases, jars, cups, basins, ewers, water-droppers, and figurines, the most common types being ritual vessels, decorative pieces, and items for the study.

In October 2007, underwater archeologists recovered a cargo of Yuan-dynasty Longquan celadon from the wreck of a ship which sank to the west of Dalian Island, Fujian Province. The main types, among about 603 items, were bowls, large plates, brush-washers, and small jars. Many of the bowls, plates, and brush-washers were warped in some way, and the glaze was generally quite thick. Types of decoration included engraving, molding, and sprigging, with designs such as waves, scrollwork, flowers (lotuses, peonies, chrysanthemum petals), pairs of fish, dragons, cranes and pine-trees, and female figures. This was an ordinary merchant vessel transporting a cargo

of Longquan celadon which hit one of the many hidden rocks which dot the seas to the west of Dalian Island and sank not long after leaving port.

A comparison of the two cargoes shows that both the Sinan and the Dalian Island wrecks occurred in the mid- to late Yuan. Longquan celadon was already being exported in the Northern Song, and the export of Longquan was at its height in the Southern Song to Yuan period. Cargo from known wrecks together with pieces preserved overseas show that Longquan celadon was China's main type of export porcelain during the mid- to late Yuan.

In the early Yuan, Longquan celadon continued the style of the Southern Song. Most pieces are plain and undecorated, though some vessels such as bowls, plates, and brush-washers are engraved with lotus petals on the side of the belly; the lotus petals are quite long and thin, and usually outlined with a single engraved line, with the central spine in relief. On items such as plates and brush-washers the base of the interior may have sprigged decoration of paired fish; incense-burners in the shape of a *li* tripod cauldron have the belly decorated with vertical flanges. In the mid-Yuan, new types such as stem-bowls, jars with lotus-leaf lids, small jars, gall-bladder-shaped vases (with a round belly and long neck), pear-shaped bottle vases, high-necked "phoenix-tail" vases (fig. 63), bottles with paired ring-lugs, incense-burners with the eight trigrams in relief, and basins with everted rims and molded pairs of fish were added to the usual plates and bowls. This represented an obvious increase in the number of vessel types compared to the early Yuan, and the vessels also tended to be quite large. The main form of decoration was various kinds of molding, and the use of molds began to increase; decorative subjects were usually floral, sometimes highlighted with dots of brown pigment. In the late period, there was a significant change in the shapes being produced: bases were usually broad and flat, plates had deeper cavettos and broader lobed rims. The main decorative techniques were engraving and molding. Figurines became more numerous, with many statuettes of divinities such as Guanyin (fig. 64), Maitreya Buddha, Sakyamuni, or the Dark Warrior God of the North; such figurines often had the exposed skin on their face, hands, etc., left unglazed, showing the natural color of the clay.

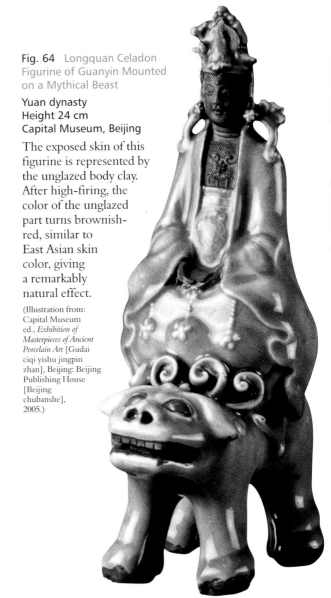

Fig. 64 Longquan Celadon Figurine of Guanyin Mounted on a Mythical Beast

Yuan dynasty
Height 24 cm
Capital Museum, Beijing

The exposed skin of this figurine is represented by the unglazed body clay. After high-firing, the color of the unglazed part turns brownish-red, similar to East Asian skin color, giving a remarkably natural effect.

(Illustration from: Capital Museum ed., *Exhibition of Masterpieces of Ancient Porcelain Art* [Gudai ciqi yishu jingpin zhan], Beijing: Beijing Publishing House [Beijing chubanshe], 2005.)

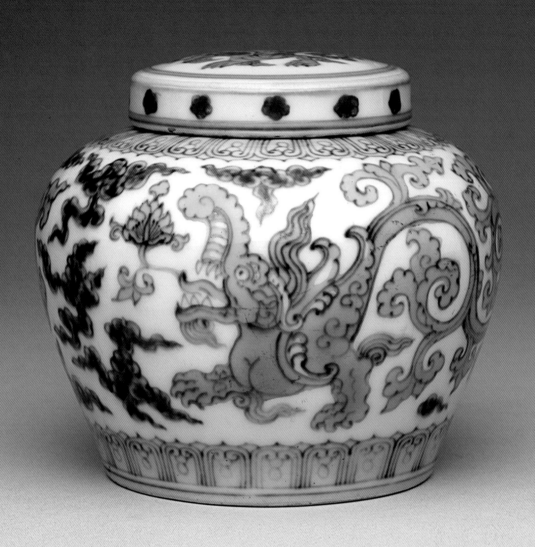

CHAPTER V
OFFICIAL VERSUS UNOFFICIAL: PORCELAIN OF THE MING DYNASTY

In 1368, the Ming dynasty was established by the Grand Progenitor of the Ming, Zhu Yuanzhang. The dynasty, under the rule of seventeen emperors, lasted for 276 years. Porcelain manufacture during the Ming showed huge advances on the base laid down in the Yuan. Jingdezhen became China's main center of porcelain production. The establishment of an imperial porcelain workshop in the early Ming made a distinction between porcelain for imperial and for commoner use, leading to a clear contrast between refined and simple in ceramic art. The underglaze blue porcelain which had been a leading export product during the Yuan now became one of the main items produced for the domestic market, while the Ming porcelain industry also developed many innovative porcelain types such as monochrome glazes, polychrome, and the *doucai* ("fitted colors") technique which combines underglaze blue with overglaze

pigments. Production techniques became ever more skillful, laying the foundation for the heights of technical skill reached during the Qing. The late Ming coincided with the start of the great maritime trading empires, when porcelain products from Jingdezhen were transported by the various East India Companies to Europe, where they had a profound impact on both art and life.

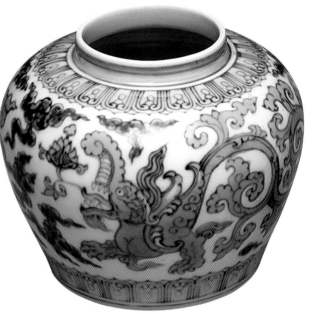

Figs. 65–67 Covered "Heaven Jar" with *Kui* Dragon in Underglaze Blue and *Doucai* Colors

Ming, Chenghua period
Height with lid 11.3 cm, height of jar 10.3 cm, mouth diameter 6.2 cm, base diameter 9 cm
Palace Museum, Taibei

The *doucai* technique involved painting the outlines of the decoration in underglaze blue pigment, and then adding colors over the glaze after high-firing. This covered "heaven jar," so called for the *tian* (heaven) character marked on the base, is typical of *doucai* pieces produced by the official kilns in the Chenghua period.

1 The Imperial Porcelain Workshops

Scholars have shown that during the early Ming reigns of the Hongwu and Yongle (1403–1424) emperors, the porcelain industry of Jingdezhen continued to follow the administrative system of the Yuan, with government kilns continuing production under the old system. At the beginning of the Xuande period, an imperial porcelain workshop was formally established and began production at Jingdezhen, firing porcelain which it supplied to the imperial palace, with officials specially appointed to oversee production. These kilns were commonly referred to as the "official kilns," to distinguish them from kilns operated by commoners. The site of the Ming and Qing imperial porcelain workshops is in the present-day city center of Jingdezhen; the buildings of the workshops during the two dynasties covered an area of approximately 50,000 sq.m.

The section on ceramics in the *Collected Statutes of the Ming Dynasty* (*Da Ming Huidian*), the official compilation which details the administrative system, laws, and regulations of the Ming, records that "In the 26th year of Hongwu (1394)

it was ruled that whenever vessels for use are to be fired, a system for making samples must be established, in order to calculate the manpower and materials required." This shows that, starting in the Hongwu reign-period, vessels to be supplied to the palace had to be fired according to officially provided samples, and that there were decorative patterns whose use was restricted to the official kilns. In the Hongwu reign, porcelains for imperial use included underglaze blue (fig. 68), underglaze red (fig. 69), alum red (also known as iron-red glaze, with an orange tint), and monochrome red and white glazes. Official samples of these types have been

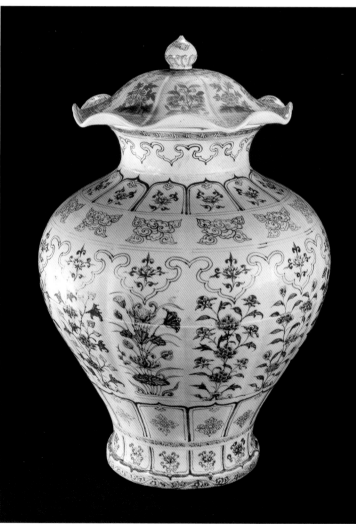

Fig. 68 Lidded Jar Decorated with Floral Sprays in Underglaze Blue
Ming, Hongwu period
Overall height 66 cm, mouth diameter 25.3 cm
Capital Museum, Beijing

This vessel shape is unique in the Hongwu period. The substantial size of the piece means that it was difficult to fire: this is a masterpiece among similar vessels.

(Illustration from: Capital Museum ed., *Masterpieces from the Capital Museum* [Shoudu bowuguan zhenpin jicui], Beijing: Social Science Academic Press [Shehui kexue wenxian chubanshe], 2019.)

Fig. 69 Pear-Shaped Bottle Vase with Chrysanthemum Scrolls in Underglaze Red

Ming, Hongwu period
Height 32.1 cm, mouth diameter 8.3 cm, foot diameter 11.9 cm
National Museum of China

Craftsmanship in the underglaze red technique, invented in the Yuan period, made great advances in the Hongwu period. This piece represents the style at its finest.

discovered at many of the Jingdezhen kiln-sites, showing that at this time vessels from the official kilns were in fact fired at unofficial kilns, but under official supervision. These official supervisors could be either local officials or officials of the Ministry of Works dispatched from the central government.

Demand for porcelain from the official kilns during the Yongle reign mainly came from the need for ritual and sacrificial items for the imperial household, and for diplomatic gifts in relations with Tibet and on the voyages of the admiral Zheng He (1371 or 1375–1433 or 1435) in the South China Seas and Indian Ocean. The shapes and designs of these vessels were dictated by these specific requirements. It was during the Xuande reign that the manufacture of imperial porcelain began to be concentrated within the imperial porcelain workshops; moreover, the words "Made in the Xuande reign of the Great Ming" or "Made in the Xuande reign" were inscribed in underglaze blue on the base of each piece. From this time onwards, the imperial porcelain workshops at Jingdezhen, with their specialist supervisors, became the only kilns in the Raozhou area to fire porcelain for imperial use, and the practice of writing the reign title on the base continued thereafter. During the Xuande reign, Cizhou and Longquan also had imperial workshops making porcelain for official use, producing porcelain decorated in black on a white slip and celadon-glazed porcelain respectively. In the early Ming period, the imperial workshop at Jingdezhen had extremely strict criteria for porcelain from the official kilns: pieces which were incorrectly fired had to be

smashed immediately and buried to prevent them falling into the hands of commoners. In recent years excavations at the site of the imperial kilns at Zhushan in Jingdezhen have revealed a large quantity of fragments of porcelain from the official kilns dating to the Hongwu, Yongle, Xuande, and Chenghua reigns: these are all remnants of pieces which were destroyed because they were not up to standard.

By the Chenghua reign, Jingdezhen was the only remaining imperial porcelain workshop. The government was able to capitalize on its financial and material resources to monopolize the supply of high-quality raw materials and highly skilled craftsmen for the imperial workshop. As a result, the quality of imperial products from Jingdezhen showed a steep rise in the Chenghua period. Underglaze blue and *doucai* porcelain from the Chenghua official kilns became greatly sought after from that time onwards, while they also stimulated improvements in the quality of products from

the unofficial kilns.

There was a clear distinction between the official and unofficial kilns at Jingdezhen. Unofficial kilns were the ceramic workshops operated by commoners; under the influence of the over-all economic environment of the time, their products were mainly aimed at fulfilling the domestic needs of the general population, so their shapes and decorative style accorded with popular taste and were not subject to any particular rules or constraints. They were simple, natural, plain, and bold, showing great variety and individuality. Products of unofficial kilns in the Ming very rarely show a date, and the few that do simply imitate the reign-marks of previous reigns. Consequently, it is very difficult to give accurate dates for porcelain from the unofficial kilns, though approximate dates can be established by using pieces excavated from dated tombs as benchmarks.

As the imperial porcelain workshops were extremely busy during the Jiajing reign (1522–1566), the government permitted the selection of particularly expert unofficial kilns to undertake the firing of porcelain for official use, also making available to them the high-quality raw materials which the official kilns had monopolized. In this way some of the advanced techniques and artistic styles of the official kilns spread to the unofficial kilns, contributing to improvements in their technical skills and aesthetic standards. This laid the foundation for a significant rise in the quality of porcelain from the unofficial kilns by the end of the Ming.

Fig. 70 Bowl with Lotus-Petal Decoration in Underglaze Blue

Ming, Yongle period
Height 10 cm, rim diameter 21.4 cm, foot diameter 7.8 cm
National Museum of China

The decorative pattern of long, thin lotus petals on this piece is a type of decoration very characteristic of the Yongle period.

2 The Peak of Blue-and-White: Porcelain of the Yongle and Xuande Reigns

After the foundation of the Ming dynasty, the underglaze blue porcelain which in the Yuan had been either exported or used by the general population in China now became one of the leading forms of porcelain. Admiral Zheng He's seven overseas voyages during the Yongle and Xuande reigns led to a constant stream of foreign embassies bringing tribute to China, and the porcelain which was bestowed on these embassies in return continued to be composed mainly of underglaze blue ware. There had been no obvious improvement in the firing quality of underglaze blue in the Hongwu period; on many pieces the blue color tended towards grey as a result of failures in the firing process. Underglaze blue porcelain remained the chief product of the official kilns in the Yongle and Xuande reigns, but now there was greater refinement in the body and glazing materials, in the throwing and shaping of the bodies, and in the design and application of the decorative patterns. The quality of these products far surpassed the previous reign; even the unglazed bases of the vessels were pure white, with a smooth texture.

The Yongle and Xuande reigns were in fact a golden age for underglaze blue production

Fig. 71 Ewer with Pattern of Flowers and Fruit in Underglaze Blue

Ming, Yongle period
Height 26.1 cm, mouth diameter 6.4 cm, foot diameter 9.8 cm
National Museum of China

This wine vessel imitates the forms of west Asian metalwork. The underglaze blue decoration is painted with the classic "'sumali' (or 'sumani') blue" pigment, in a brilliant blue with patches of precipitation. Originally it had a lid, now lost.

in China. The cobalt blue pigment known as "sumali blue," imported from Shahr-e Rey in Persia (about 40 km south of present-day Tehran in Iran), produced a color like the blue of lapis lazuli, giving a rich effect but with some fainter areas and darker blue spots of precipitation resulting from the cohesion of cobalt with iron. The lines and washes forming the designs are free and natural; there are fewer registers than in the designs of Yuan underglaze blue, and there is more white, so that the blue and white areas appear evenly balanced. The most frequent designs are floral sprays, floral scrolls, auspicious fruits, dragons among clouds or waves, or rocks with bamboos and banana palms, while border decoration includes key-fret, scrollwork, waves, and lotus petals. There is a wide variety of vessel shapes at this period, especially during the Yongle reign, when forms newly developed to satisfy different requirements far outnumbered those of the previous reign. From the Yongle period onwards, vessels produced by the official kilns of Jingdezhen began to be inscribed with the imperial reign-title, though in the Yongle reign the four-character mark in seal script *Yongle nian zhi* ("made in the Yongle period") is rather rarely used; in the Xuande period it became usual to inscribe the reign-title in regular script on the base of the vessel, either in the four-character form as *Xuande nian zhi* ("made in the Xuande period") or in the six-character form *Da Ming Xuande nian zhi* ("made in the Xuande period of the Great Ming").

In the Yongle period the clay for underglaze blue porcelain was very carefully prepared; the body is light and thin, the shape of the vessel elegant and refined, with fluid lines and careful technique. Large pieces are rather rare. Porcelain from the official kilns was mainly intended to fulfil the following needs:

Rituals and ceremonies, daily use, and display in the imperial household. Commonly seen types are *jue* goblets, incense-burners, candlesticks, bowls (fig. 70), plates, cups, ewers (fig. 71), strainers, *meiping* vases, pear-shaped bottle vases, and jars.

Exchanges with other countries. In the Yongle period there were frequent contacts with the Islamic countries of western Asia, so many vessels adapted to the customs of those countries were produced, with shapes which often imitated western Asian styles of glass or metal ware, but with decorative designs usually in traditional Chinese styles, though occasionally in Central Asian styles.

Fig. 72 Pilgrim Flask with Dragon Reserved in White on Underglaze Blue Waves

Ming, Yongle period
Height 46 cm, mouth diameter 8 cm, foot 15 × 10 cm
National Museum of China

Made as a decorative item in imitation of west Asian glassware. On the underglaze blue ground, the incised dragon is reserved in white, a technique more complex than that of regular underglaze blue painting.

Typical forms are pilgrim flasks (fig. 72), jugs of various types, cylindrical *zun* vases, round-bellied *zun* vases, pen-cases, and basins with everted rims (fig. 73).

Exchanges with Tibet. After the foundation of the Ming, the central government maintained control over Tibet. At the start of his reign, Zhu Yuanzhang sent official envoys to Tibet to contact influential governmental and religious figures there, while leading Tibetan monks and laymen also came to the capital to present tribute and receive imperial gifts. During the Yongle and Xuande reigns, contacts between the two sides became even closer; most of the religious and administrative leaders of Tibet as well as some

Fig. 73 Underglaze Blue Basin with Everted Rim

Ming, Yongle period
Height 15.4 cm, rim diameter 35.1 cm, base diameter 24.5 cm
National Museum of China

This vessel shape, imitating Persian brass basins, which first appears in the Yongle period, is representative of the cultural exchange between China and western Asia in the early Ming.

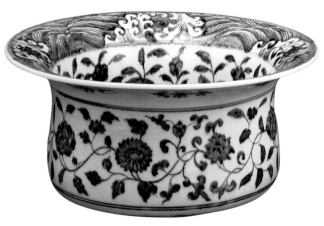

other important monks and laymen were given titles by the Yongle court. Porcelain was a major component of the gifts bestowed on Tibet by Zhu Di (1360–1424, r. 1402–1424), the Yongle Emperor. Many porcelain vessels were designed and decorated to suit the needs of the Tibetans, including pieces intended for use in Tibetan Buddhist ceremonies; examples include monk's cap ewers, water-sprinklers, and underglaze blue ladles with Tibetan inscriptions.

In the Xuande reign, a period of political stability and rapid economic development, the scale of the imperial porcelain workshops at Jingdezhen and their volume of production increased; according to the *Collected Statutes of the Ming Dynasty*, the court ordered 443,500 items of porcelain from Jingdezhen in the year 1433 alone. In order to fulfil such a vast order, the imperial workshops built additional kilns so as to increase the scale of production.

Underglaze blue remained an important type of porcelain during the Xuande reign, and the supply of cobalt which Zheng He had brought back from his voyages made possible the production of a great number of pieces. The technique of firing improved more generally through the Xuande period, and some very challenging large vessels were successfully fired, such as fish-bowls with a diameter of over 50 cm.

Xuande porcelain vessels were formed in a plain and elegant classical style; bodies were thicker and heavier than in the Yongle period, and they were carefully crafted, with a strong underglaze blue using both imported and Chinese cobalt pigment. They represent the highest firing quality in Chinese underglaze blue. The types of vessels remained much the same as in the Yongle period, but the quantity greatly exceeded the previous reign; the main types included bowls, plates, stem-cups, *meiping* vases, "pomegranate" vases (with a round belly, short neck, and foliated rim), square-sectioned facetted vases (fig. 74), lidded stem-bowls, bowls with domed lids, water-sprinklers, monk's cap ewers, globular

Fig. 74 Square-Sectioned Facetted Vase with Design of Convolvulus in Underglaze Blue

Ming, Xuande period
Height 14.1 cm, mouth diameter 5.4 cm, foot diameter 7.4 cm
National Museum of China

This vessel, whose shape imitates west Asian metal ware, is characteristic of the Xuande period.

vases, large jars, candlesticks, and incense-burners. The types and quantity of vessels for domestic use increased, with the appearance of some leisure-related items such as birdseed containers, cricket cages (figs. 75 and 76), and miniature vases. These miniature vases were a new type: although tiny, about 3 cm tall, they were exquisitely made, and formed the models for the porcelain vases with flat sides used as ornaments on the wall by later generations.

The decoration on Xuande underglaze blue was basically the same as that seen in the Yongle period, with the main designs being dragons, phoenixes, flower and fruit scrolls, flower and fruit sprays, rocks with bamboos and banana palms, lotus ponds with fish and waterweed, waves and sea-creatures, Buddhist emblems, and figure scenes. The increased number of figure scenes shows a firmer grasp of the technique of painting with cobalt pigment. The mining and use of cobalt from within China increased the variety of tones in underglaze blue, the somber tone of the deep blue, easily precipitated imported cobalt and the free, light, bright feel of the domestic cobalt combining to give the decorative designs a livelier, bolder touch.

Figs. 75–76 Underglaze Blue Cricket Cage

Ming, Xuande period
Height 9.5 cm, rim diameter 13.5 cm, foot diameter 12 cm
Jingdezhen Institute of Ceramic Archaeology

This type of cricket jar or cage was a leisure item used in the imperial palace for the sport of cricket fighting. The Xuande Emperor was a devotee of cricket fighting, and ordered the palace workshops to make a large number of ceramic cricket cages.

3 The Interregnum: Porcelain in a Time of Instability

Because of political instability during the Zhengtong (1435–1449), Jingtai (1450–1457), and Tianshun (1457–1464) reign-periods, the Jingdezhen porcelain industry suffered an economic downturn. Documentary records show that at the start of his reign, the Zhengtong Emperor, also known as the Emperor Yingzong (1427–1464, r. 1435–1449 and 1457–1464), ordered the Jingdezhen imperial workshops to cease production and the palace and government officials posted there to return to the capital. Throughout the Zhengtong reign-period frequent orders were given to cease or reduce the firing of particular types of porcelain, with severe punishments for anyone who produced them privately. Pieces with the Zhengtong, Jingtai, and Tianshun reign-marks are almost unknown today, and most porcelain items excavated from tombs of this period are the products of unofficial kilns. Not much is known about the porcelain industry during these twenty-nine years, with little to be gleaned from documentary records, so this period is referred to by ceramics scholars as the "Interregnum."

As more experts have begun to take an interest in porcelain of the Interregnum, and examples of Interregnum porcelains have been discovered in recent excavations at the site of the Jingdezhen imperial workshops, some light has been shed on the situation of the porcelain industry in this period. Porcelain manufacture at Jingdezhen did not cease completely during the Zhengtong years, since the government issued an order in 1439 for Raozhou Prefecture (where Jingdezhen was located) to undertake the firing of porcelain for imperial use, and again in 1444 Raozhou was ordered to produce underglaze blue fish-bowls decorated with dragons. A fragmentary dragon fish-bowl excavated from the site of the imperial workshops and a large fish-bowl decorated with underglaze blue dragons and clouds in the Shanghai Museum are almost certainly products of this period.

The majority of Interregnum pieces are in underglaze blue; in addition to relatively common types such as bowls, plates, stem-cups, *meiping* vases (fig. 77), jars, long-necked bottles, and flower-pots, there are also some unusual types such as large fish-bowls with dragon ornament, double-lugged vases, and stands. Apart from underglaze blue pieces, there are also some with underglaze blue and alum red, *doucai*, red and green pigments, monochrome blue glaze, and white glaze.

Fig. 77 *Meiping* Vase with Lion Design in Underglaze Blue

Ming, Zhengtong period
Height 37.8 cm, mouth diameter 5.2 cm, foot diameter 13 cm
National Museum of China

The style is similar to that of the Xuande period, and the workmanship very fine. There is no reign-mark.

Decoration at the beginning of the Interregnum is carefully done and attractive, similar to the style of the Xuande reign, but with no reign-mark; the dragon designs, floral scrolls, and border patterns resemble Xuande types. The main areas of decoration, however, often show rare motifs such as billowing waves, sea-monsters, human figures among clouds, the islands of the immortals, or floral roundels. On porcelains from later in the Interregnum, the patterns are drawn with soft, thin lines, in a style approaching that of the Chenghua period. The over-all characteristic of decoration from the Interregnum is that it shows a transition from the density of Xuande to the openness of Chenghua.

4 The Spirit of Color: *Doucai* and Colored Enamels

The term *doucai*, meaning "fitted colors" or "dove-tailed colors," is a decorative technique combining underglaze blue outlines with painting in overglaze colors. Usually the outline was first painted with cobalt pigment on the leather-hard body, and then a layer of clear glaze was applied and the piece fired at a high temperature (1,300 degrees Celsius); after firing the underglaze outlines were filled in (i.e. "fitted") by painting over the glaze with traditional mineral pigments, followed by a second, final firing at low temperature (800 degrees Celsius). The two firings resulted in bright, attractive colors in a fresh, elegant style, giving a delightful aesthetic impression.

The *doucai* technique first appeared during the Xuande period, developed during Zhengtong, and came to maturity in the Chenghua reign. Chenghua *doucai* porcelains are all small items intended for enjoyment and appreciation, such as cups, vases, bowls, jars, boxes, plates, and dishes. Among existing examples, taller items such as vases are no more than 19 cm high, while the diameter of

cups is about 7–8.5 cm. The most celebrated vessels are the small cups used for drinking wine or tea, decorated with chickens, grape-vines, scholar-recluses, children at play, autumn flowers, chrysanthemums, and so on. *Doucai* chicken cups of the Chenghua period were already the focus of collectors' attention during the Ming dynasty, and in Wanli-era (1573–1620) sources their prices are recorded in the hundreds of thousands of copper coins. At a Sotheby's auction of fine Chinese ceramics and works of art in Hong Kong in April 2014, a Chenghua *doucai* chicken cup from the Meiyintang collection in Switzerland sold for HK$281.24 million, setting a world auction record for Chinese porcelain. Another famous type of vessel from the Chenghua official kilns is the *doucai* "heaven jar" (see figs. 65 to 67 on pages 72 and 73). These are tiny covered jars, so named because of the character "heaven" (*tian*) inscribed in underglaze blue on the base. All these jars are about the same size and shape, and the decoration is arranged in a similar way, with inverted and upright lotus petals on the shoulder and lower part of the belly respectively, while the main decoration on the belly usually consists of dragons and waves, sea-monsters, or lotus scrolls. According to tradition, the Chenghua Emperor (1447–1487, r. 1464–1487) gave these heaven jars to his concubines as containers for tea-leaves or medicines.

The body and glaze of Chenghua *doucai* are fine and pure white, light, thin, and translucent. The cobalt pigment used to draw the underglaze blue outlines was natural cobalt from Leping in Jiangxi, which gave a light, refined color. The overglaze painting was applied as a flat wash, giving a rich color; the most commonly used pigments were bright red and a variety of greens, yellows, and purples, with a purplish-brown being the most highly regarded. On a pair of Chenghua *doucai* cups decorated with fruiting vines in the

Capital Museum in Beijing (fig. 78), the color of the grapes is this purplish-brown which is unique to *doucai* of the Chenghua period.

The designs on Chenghua *doucai* are mostly those seen on objects of daily use, such as human figures, lotuses, chrysanthemums, floral roundels, flower and fruit sprays, birds and flowers, dragons, lotus ponds with mandarin ducks, chickens, butterfly roundels, children at play, or autumn flowers. Because of the small size of the vessels, the designs are often rather sketchy, with an emphasis on liveliness rather than precision. The bases usually bear the mark "Made in the Chenghua period of Great Ming" (*Da Ming Chenghua nian zhi*). Chenghua *doucai* is one of the treasures of Chinese porcelain, aesthetically pleasing and highly collectable.

The most famous monochrome glazes

Fig. 78 *Doucai* Cups with Fruiting Vines
Ming, Chenghua period
Overall height 4.8 cm, rim diameter 7.8 cm
Capital Museum, Beijing

These cups come from the tomb of the grand-daughter of the senior Qing minister Soni (or Sonin, d. 1667). Soni was one of the ministers who contributed to the founding of the Qing dynasty, and was appointed by the Shunzhi Emperor (1638–1661, r. 1643–1661) to be regent for the young Kangxi Emperor (1654–1722, r. 1661–1722). The dark purple color used for the grapes is unique to Chenghua-period *doucai*.

(Illustration from: Capital Museum ed., *Masterpieces from the Capital Museum* [Shoudu bowuguan zhenpin jicui], Beijing: Social Science Academic Press [Shehui kexue wenxian chubanshe], 2019.)

of the Ming dynasty are the red glaze of the Yongle and Xuande reigns and the yellow glaze from the Hongzhi reign (1488–1505).

The Yongle-Xuande red was a high-fired copper-red glaze in which the colorant was copper oxide fired at temperatures above 1,250 degrees Celsius. Since it was mostly used for ceremonial vessels, it is also known as "ceremonial red." Red-glazed porcelain was already being made in the Yuan dynasty, and by the Yongle period Jingdezhen had already mastered the process for achieving the copper-red color. Because the glaze color depended on accurate control of the kiln temperature and the reducing atmosphere, and the glaze had to be applied to a precise thickness, the success rate was quite low and the color was frequently uneven. Only the finest pieces showed a smooth, glossy glaze, even color, and fresh red which was compared to congealed chicken blood; this was referred to as ruby red, and was highly valued. The main types of red-glazed vessels in the Yongle and Xuande periods were plates (figs. 79 and 80), bowls, stem-cups, *meiping* vases, ewers, and monk's cap ewers. The rim, where the glaze was thin, shows a white edge, which is known in Chinese as a "lamp-wick rim." Red-glazed porcelain of the Yongle period bears no reign-mark, but Xuande ware has an underglaze blue reign-mark on the base.

Ming yellow-glazed porcelain had a low-fired lead glaze with iron oxide as the

Figs. 79–80 Red-Glazed Plate
Ming, Yongle period
Height 4.1 cm, rim diameter 18.3 cm, foot diameter 11.1 cm
National Museum of China

Red glaze is difficult to fire. Such Yongle pieces with their bright red glaze are rare and valuable; in the Ming dynasty they were probably used as ceremonial vessels.

colorant, fired at a temperature of 800–900 degrees Celsius. Such pieces first appeared in the Xuande period. Because the glaze was applied by pouring, they are sometimes referred to as "poured yellow." There are two types of Xuande yellow glaze: in one, the yellow glaze is applied over an initial white glaze, and in the other, the glaze is poured directly on to the body. The underside of the foot is always glazed in white, with the reign-mark either written in regular script with underglaze blue or incised. The main forms are either plates or bowls.

Yellow-glazed pieces were produced during the reigns of all Xuande's successors, but the finest examples of yellow glaze come from the Hongzhi period: they have a white, dense body, with an even, shiny glaze, refined

and delicate, with a glossy color comparable to chicken fat, and are regarded as canonical examples of Ming yellow-glazed porcelain. The base is usually white-glazed, with an underglaze blue reign-mark in regular script. The main Hongzhi types are bowls and plates (figs. 81 and 82), with vase types being very unusual.

There were very clear rules about the use of yellow-glazed porcelain in the Ming; according to the *Collected Statutes of the Ming Dynasty*, in 1531 (the 9th year of Jiajing) it was ordered that only yellow-glazed vessels were to be used for sacrifices to the Earth God, because of the cosmological association of the color yellow with earth. Historical records also show that yellow-glazed vessels were reserved for the sole use of the emperor's mother.

Figs. 81–82 Yellow-Glazed Plate
Ming, Hongzhi period
Height 4 cm, rim diameter 18 cm, foot diameter 10.5 cm
National Museum of China

This was a ceremonial vessel. Hongzhi-period yellow-glazed vessels have an oily sheen, which has led to the color being known as "chicken-fat yellow." Vessels of this period represent the summit of achievement in yellow glazing.

5 Underglaze Blue and Polychrome: Porcelains of the Late Ming Jiajing (1522–1566)

During the late Ming from the reign of Jiajing (1522–1566) to Chongzhen (1628–1644), as China's strength gradually declined, great changes took place in the style of porcelain from Jingdezhen. The most widespread types of decoration at this time were painting in underglaze blue and in polychrome, with an increased number of massive pieces such as large fish-bowls, jars, gourd-shaped vases, and plates, and with a coarser quality of manufacture.

In the Jiajing period, underglaze blue decoration was painted using the so-called "Mohammedan blue" pigment, which gives a deep blue color tending towards purple. The Jiajing Emperor (1507–1567, r. 1521–1566) was a believer in Daoism, so the shapes and decoration of porcelain in his time were strongly influenced by Daoist legends and beliefs. There are many gourd-shaped vases (fig. 83), and other common forms are bowls, cups, *meiping* vases, large jars, garlic-bulb-mouthed bottles, ewers, covered boxes, and incense-burners. Shapes were very varied, with complex forms such as square, hexagonal, and octagonal vessels, which were very difficult to make successfully. There was a notable increase in decorative designs expressing wishes for good fortune, long life, and many offspring, such as children at play, the islands of the immortals, red-crowned cranes, or the characters for "good fortune" (*fu*, 福) and "long life" (*shou*, 寿), giving these porcelain pieces a new function as auspicious items. To supply the needs of Daoist worship, many sculptural figures of Daoist deities were created in the Jiajing period, such as the Longevity Star, the Dark Warrior God of the North, Lord Wenchang (a patron of literature, of particular importance to the scholar-official class), the Eight Immortals, and the

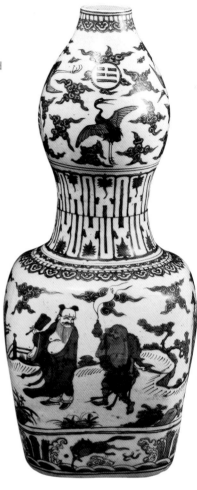

Fig. 83 Gourd-Shaped Vase with Figures of the Eight Immortals in Underglaze Blue

Ming, Jiajing period
Height 58 cm, mouth diameter 6.4 cm, foot diameter 19.2 cm
National Museum of China

The figures of the Eight Immortals depicted on this vase are decorative elements taken from the Daoist religion of which the Jiajing Emperor was a devotee.

Supreme Lord (the legendary founder of Daoism). Such figurines, with their lively appearance and harmonious proportions, are particularly striking.

The Longqing reign (1567–1572) lasted no more than six years, but although the quantity of porcelain produced in the time was small, its quality surpasses that of Jiajing. During the Longqing period, Mohammedan blue continued to be used for underglaze blue painting, but in comparison with Jiajing and the following Wanli reign, the Longqing-era Mohammedan blue is particularly fine, with a rich, bright tone. Longqing vessel types include bowls (figs. 84 and 85), plates, cups, wine-jugs with overhead handles, jars, incense-burners, boxes, and fish-bowls. Because of the large size of these fish-bowls, they were very apt to slump during firing, so the success rate was extremely low, and very few survive. Also, because the reign was so short, there are not many pieces from the official kilns with a Longqing reign-

mark, so these fish-bowls are exceptionally valuable. The most common decorative designs on Longqing underglaze blue pieces are dragons and phoenixes, *lingzhi* fungus scrolls, children at play, flowers and fruit, and floral roundels. Most reign-marks are written slightly differently from earlier marks, using a different word for "made" in "made in the Longqing period of Great Ming" (*Da Ming Longqing nian zao*).

The Longqing Emperor (1537–1572, r. 1566–1572) withdrew the ban on maritime trade, which then rapidly expanded, leading to a great increase in demand for porcelain from the unofficial kilns, which in turn greatly improved their production quality.

The following Wanli reign thus became a time in which the official and unofficial kilns vied for supremacy in craftsmanship. In the early part of the reign, the quantity of production from the official kilns was very high; according to the *Collected Statutes of the*

Ming Dynasty, in 1582 alone, Jiangxi Province provided more than 96,600 porcelain items of all types. Later, however, as the government's financial resources declined, production from the official kilns gradually decreased. In 1608, riots broke out among the ceramic workers at Jingdezhen, who set fire to the imperial workshops there. After this the imperial workshops ceased production, so that in the late Wanli period, most porcelain for official use was in fact fired in unofficial kilns.

The Wanli Emperor (1563–1620, r. 1572–1620) was on the throne for forty-eight years, the longest reign of any Ming emperor, but his reign represented the start of the Ming dynasty's decline and fall. There is a wide gulf between the scale and character of porcelain production at the beginning and end of his reign. Wanli underglaze blue continued the use of Mohammedan blue; in the early period its color is deep and attractive, with a purplish tinge, but in the later period the blue is quite faint, and tends towards a dull grey. The shapes of Wanli porcelain show a greater variety than in previous reigns, with a wide range of all sorts of items for everyday use, for display, and for use in the study. New types appear, such as wall-vases with flat sides to allow hanging, cylindrical vases, small dishes which could be fitted together like a jigsaw to form one large dish, and pots to hold chess or *go* pieces, as well as new products intended

Figs. 84–85 Underglaze Blue Bowl Decorated with Mandarin Ducks in a Lotus Pond

Ming, Longqing period
Height 9.6 cm, rim diameter 20.2 cm, foot diameter 7.4 cm
National Museum of China

The painting of this loosely composed scene is very fine. The Longqing Emperor was on the throne for only a short period, and pieces with his reign-mark such as the one illustrated are rare. The reign-mark on the base, reading *Da Ming Longqing nian zao* ("created in the Longqing period of Great Ming") is slightly different from the marks of other reigns, which use the word "made" (制, *zhi*) rather than "created" (造, *zao*).

for the export market. The official and unofficial kilns were competing for markets, and the kilns were very active; underglaze blue porcelain now became a popular product which was widely used in the everyday life of commoners. Other types of vessel which make frequent appearances at this period are bowls, plates, *meiping* vases, jars with designs incorporating the character for "long life" (*shou*; fig. 86), incense-burners, flower-vases in the shape of ancient bronze beakers (*gu*), and square or round boxes. There is a wide variety of popular designs drawn from traditional symbols of good fortune and success and from vernacular story-telling, including dragons, phoenixes, and other auspicious creatures, flowers and fruits, rocks with pines, plum-trees, and bamboo, the Eight Immortals, the eight Buddhist emblems, narrative figure-scenes, and so on.

The Ming-dynasty polychrome porcelain which began to be made in the Xuande period reached its most outstanding level during the Jiajing and Wanli reigns, when it was produced in large quantities. Jiajing polychrome has long been famous for its rich colors and fine craftsmanship: as the Chinese saying goes, "One hundred pieces of Wanli polychrome are worth less than one piece of Jiajing polychrome." However, the quantity produced in the Wanli reign was greater than that in Jiajing, showing that in the Wanli period polychrome porcelain had reached a wider market.

In visual terms the colors most evident in Jiajing polychrome are red, green, yellow, and blue; the blue appears as underglaze blue, while the other colors all come from low-fired overglaze pigments. Apart from the colors just mentioned, purple, black, and peacock blue also appear. Most Jiajing polychrome wares are large vessels such as jars (fig. 87), plates, and flower-pots, with the main designs being fish among water-plants, dragons and phoenixes, birds and flowers, jeweled pendants, and red-crowned cranes. Because of the high reputation of Jiajing polychrome, it was often imitated in later times.

The patterns and colors of Wanli-period polychrome give a rather dense visual impression, with a crowded layout, and prominent reds, greens, and underglaze blues used equally, with small amounts of black, brownish-purple, and other colors, though the peacock blue of the Jiajing period is rarely seen. Wanli polychromes are usually large pieces, with thick, heavy bodies and rather poor craftsmanship; the decoration is quite careless, loose, and irregular. The workmanship of smaller pieces is finer; common shapes include bowls, plates,

Fig. 86 Jar Decorated with "Long Life" Characters in Underglaze Blue
Ming, Wanli period
Height 49 cm, mouth diameter 22.9 cm, foot diameter 26 cm
National Museum of China

This type of jar entirely covered with scrollwork incorporating the character for "long life" (*shou*) is quite unique to the Wanli period. During this period overseas trade was very active, and some vessels of this type are also known to have been exported.

Fig. 87 Lidded Jar with Polychrome Design of Fish among Water-Plants

Ming, Jiajing period
Overall height 46 cm, mouth diameter 19.8 cm, foot diameter 24.8 cm
National Museum of China

These lidded jars with a polychrome design of fish among water-plants are characteristic of polychrome porcelain from the official kilns of the Jiajing reign. Very few survive, although there are many later imitations.

flower-vases in the shape of ancient bronze beakers, garlic-bulb-mouthed vases (fig. 88), and covered boxes. The decoration is similar to that on underglaze blue porcelain. Many Wanli polychrome pieces were imported to Japan and much admired there; the polychrome of this period had a significant influence on the rise and development of Japanese colored porcelain.

Porcelain produced between 1608 and 1680, when the imperial porcelain workshops were out of action, is described by scholars as "Transitional." As the official kilns ceased production, unofficial kilns became very active and found customers throughout the general population. Decorative designs, reflecting popular ambitions, interests, and

desires, included subjects such as the elegant lifestyle of the literati, narrative scenes derived from vernacular fiction and drama, and auspicious symbols of health, wealth, and happiness. Underglaze blue porcelain remained a mainstream product up to the end of the Ming, mainly using Chinese cobalt mined in Zhejiang Province, with a light, elegant tone and rich depth of color. The main designs are narrative scenes and scenes of landscapes or figures in courtyards and gardens, painted in a style derived from traditional Chinese ink painting. The literati painting style, with its preference for monochrome, became more widely admired in the society, and had a great influence on the decoration of late-Ming "Transitional" underglaze blue porcelain.

Fig. 88 Garlic-Bulb-Mouthed Vase with Polychrome Dragon Decoration

Ming, Wanli period
Height 42.8 cm, mouth diameter 7.2 cm, foot diameter 15.2 cm
National Museum of China

This is a typical piece of Wanli polychrome, with a complex design and even use of color. There are many surviving examples of Wanli polychrome, of which many were exported, some with the reign-mark written in underglaze blue on the rim. Japanese kakiemon porcelain was influenced by this polychrome style.

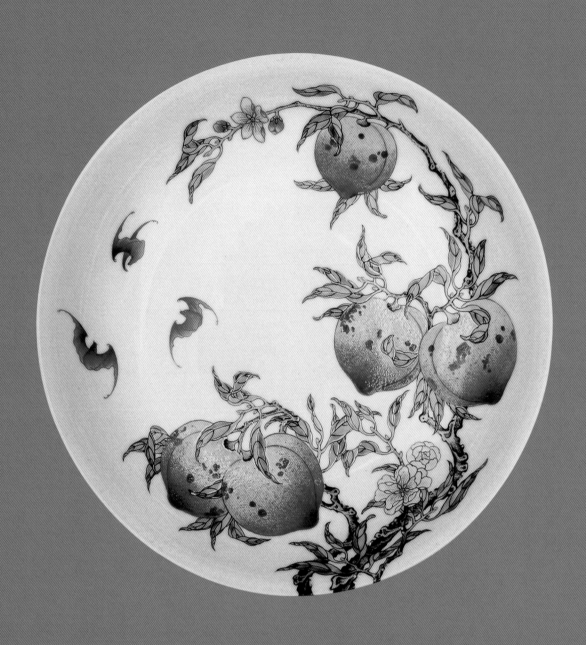

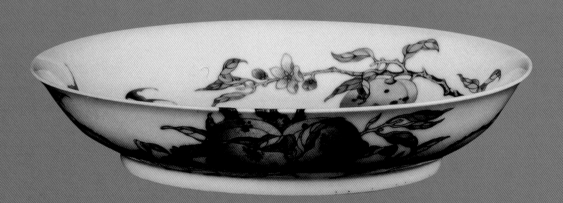

CHAPTER VI
QING PORCELAIN: THE ULTIMATE IN SKILL

From the accession of the Shunzhi Emperor (1638–1661, r. 1643–1661) onwards, the Qing dynasty ruled for almost three centuries. During this period the Qing porcelain industry, while continuing the Ming system of official kilns, advanced it even further. The pursuit of technical mastery for its own sake led to great heights of achievement but ultimately to a loss of aesthetic quality. The successive reigns of the three emperors Kangxi (1654–1722, r. 1661–1722), Yongzheng (1678–1735, r. 1722–1735), and Qianlong, in China's "long eighteenth century," saw the Qing porcelain industry's greatest advances and highest achievements. A wide variety of porcelain was made during the Kangxi period (1662–1722): in addition to underglaze blue, it included polychrome, enamel colors, the high-fired copper-red known in Chinese as "Lang red" and in English by the French term *sang de boeuf*

("bull's blood"), a deeper or brighter copper-red also called *sang de boeuf* in English but "clearing skies red" (*jihong*) in Chinese, monochrome blue, and monochrome yellow glazed pieces. Particularly conspicuous is the underglaze blue with overglaze polychrome decoration. The enamel-painted porcelain made to imperial order was successful from the start, and changed the direction of colored porcelain in China. The Yongzheng period (1723–1735) was especially notable for the official kilns' famille rose (*fencai*) and their reproductions of ancient glazes, while their decoration, in a highly refined and elegant style which successfully combined traditional Chinese *gongbi* (meticulous or realist) painting with porcelain, was greatly admired by later generations.

During Qianlong's reign, when China enjoyed social stability, external influence, and prosperity, the manufacture of porcelain reached unprecedented and stunning heights in variety of types, intricacy of decoration, and brilliance of color. The firing of underglaze blue, famille rose, *doucai*, and enamel colors became ever more skillful. At the same time, many imitations of famous wares of the past or of other types of handicraft products were produced, all reaching an unprecedented level in potting, glazing, and decoration. However, from the Jiaqing (1796–1820) and Daoguang (1821–1850) reigns onwards, porcelain manufacture gradually declined in quality.

Figs. 89–90 Famille Rose Plate with Design of Extended Branch Bearing Eight Peaches
Qing, Yongzheng period
Height 3.4 cm, rim diameter 17 cm, foot diameter 10.8 cm
National Museum of China

In traditional Chinese culture, this design with a combination of bats and peaches symbolizes the wish for a long and happy life.

1 Refined Elegance: Porcelain of the Shunzhi Period

The whole of the socio-economic structure being in a state of collapse at the start of the Qing, it took until about 1653 for production at the imperial porcelain workshops to revive; still, at this time, they were in a very weak state and could do no more than respond to direct imperial orders, and often only with the help of the unofficial kilns. Even so, there was much that they were unable to accomplish, and so porcelain with the Shunzhi reign-mark is rarely seen. During the Shunzhi period (1644–1661), the official and unofficial kilns operated at the same level, with very little difference in quality, and continuing the artistic style of the late Ming. In fact, the shapes, decoration, and other characteristics of porcelain produced in this early period are much the same as the "Transitional" styles of the Tianqi (1621–1627) and Chongzhen periods, the last two Ming reigns. The style of late Shunzhi porcelain, however, is similar to that of early Kangxi, so the Shunzhi reign as a whole marks a turning-point between Ming and Qing porcelain.

Types of Shunzhi porcelain include underglaze blue, and polychrome, dark blue, eggplant purple, and yellow glazes. In the Beijing Palace Museum collection, there are very few pieces with the Shunzhi reign-mark, in fact only eight, all of which have monochrome glazes. The fact that so few pieces survive indicates that output from the official kilns was very low, and mostly consisted of ceremonial vessels with monochrome glazes. The unofficial kilns, on the other hand, manufactured a rich variety of products, which therefore present a clearer picture of the characteristics of this period; the most numerous are underglaze blue and polychrome pieces.

The cobalt pigment used for Shunzhi underglaze blue porcelain was domestic cobalt from Zhejiang Province. Documentary records show that this cobalt mainly came from the Shaoxing and Jinhua regions of Zhejiang. Having been refined and ground, it imparted a bright, pure, clear color to high-quality pieces. The designs give a strong impression of depth and chiaroscuro, with two or three different shades of blue; the underglaze blue decoration of the Kangxi period built on this foundation to develop a more accomplished use of the techniques of Chinese painting. Vessel types are mainly plates, brush-pots, beaker-vases (fig. 91), incense-burners, fish-bowls, tall jars, so-called "ginger jars," and garlic-bulb-mouthed vases. The rims of plates, incense-burners, and cylindrical "rolwagen" vases often have a brown glaze. Common designs include rocks and plants (or birds and flowers), rocks and leafy shrubs, flowers and birds or butterflies, antique flower-vases, landscapes and

Fig. 91 Beaker-Vase with Design of Birds and Flowers in Underglaze Blue

Qing, Shunzhi period
Height 38.6 cm, rim diameter 19 cm, foot diameter 13 cm
Tianjin Museum

The design on this vase, with flowers, birds, banana leaves, bamboo, and rocks, was a very common form of decoration in the Shunzhi period. This type of beaker-vase was used for flower arrangements, frequently used in the Qing dynasty as religious offerings.

Fig. 92 Plate with Design of "Picking the Red Leaf from the Palace Moat"

Qing, Shunzhi period
Height 7.5 cm, rim diameter 35 cm, foot diameter 17 cm
Palace Museum, Beijing

The story of "Picking the red leaf from the palace moat," a love story full of wonderful coincidences, first appears in the Tang dynasty. The color of the underglaze blue painting on this plate is rich, the composition is closely focused on the narrative, and the human figures are full of life.

(Illustration from: Palace Museum ed., *Underglaze Blue Porcelain of the Qing Shunzhi and Kangxi Reigns* (Qing Shunzhi Kangxi chao qinghua ci), Beijing: Forbidden City Publishing House [Zijincheng chubanshe], 2005.)

buildings, and so on; figure scenes include ladies in a garden or children at play, the Eight Immortals and the God of Longevity, official promotion or ennoblement, scenes from the play *The Tale of the Western Chamber*,[1] or the story of "Picking the red leaf from the palace moat" (fig. 92),[2] showing popular interest in the ideas of official success, long life, and happy love-matches.

There are two types of Shunzhi polychrome porcelain: underglaze blue with overglaze pigments, and overglaze pigments only. The use of color continues the polychrome style of the Ming Wanli era, and includes red, green, yellow, black, and purple, though there is still no overglaze blue; where blue is needed it is applied under the glaze. Red and green are the most used: the red is a dark blood-red, while the green has a strong, deep tone, so that the red and green contrast sharply, but the yellow is

rather pale. Vessel forms are mostly plates, bottles, jars, and beaker-vases, while the most common decorative designs are peonies with golden pheasants, rocks with bamboos and flowers, and figure scenes; most images are accompanied by inscriptions. They are usually painted with washes of color; the facial features of human figures are sketchily indicated with simple lines. The overglaze colors are quite thin and easily wear away or flake off. All these characteristics are very typical of the period. Most polychrome porcelain of the Shunzhi period was produced in unofficial kilns, and since many pieces were exported to Europe, few remain within China.

The bodies of Shunzhi-era porcelain are thicker and heavier than in the late Ming, and most vases have rough, unglazed bases. Overall, they are less pleasing than those of the previous dynasty, and they were also more costly. The unofficial kilns mostly produced everyday pieces for display or daily use, or else export ware. The main destinations for export ware were Japan and Europe, and these pieces often bear the Ming-dynasty reign-marks of Chenghua and Jiajing, thus maintaining the characteristics of late-Ming export ware.

1 A famous *zaju* play of the Yuan dynasty, telling the story of how Scholar Zhang and the young lady Cui Yingying, with the help of her maid Hongniang, overcome many obstacles and are finally married.

2 A well-known story told in a Tang-dynasty vernacular tale. A lady-in-waiting in the palace writes a poem on a red leaf, which falls into the moat and floats out beyond the palace walls, where it is found by a young scholar, who writes an answering poem on another leaf and floats it back into the palace, where the lady picks it up. Ten years later the lady and the scholar, though a series of coincidences, are finally united in marriage and discover that the red leaf which each has treasured was actually written by the other.

2 Paintings Framed in Porcelain: Underglaze Blue and Polychrome Wares of the Kangxi Period

The Kangxi Emperor was on the throne for sixty-one years, the longest reign of any Qing emperor. During his reign the political situation gradually stabilized, and the economy began to prosper. The Jingdezhen porcelain industry also began to revive at this time, and gradually grew more flourishing. Thus, the porcelain of the Kangxi reign can be divided into three periods: early (before 1680), middle (1680–1701), and late (after 1701), each with its own characteristics. Porcelain of the early period is very similar to that of the Shunzhi reign, mainly consisting of products of the unofficial kilns. The most typical porcelain of the middle period is that produced when Zang Yingxuan (dates unknown) was supervisor of the Jingdezhen workshops (1680–1688) at the height of the industry's development, porcelain of that period being known as "Zang ware." The late period may be represented by the porcelain produced between 1705 and 1712, under the supervision of the Governor of Jiangxi Province Lang Tingji (1663–1715), known as "Lang ware."

In the very early Qing the Jingdezhen region, still under the control of the Southern Ming regime which continued to resist the Manchu conquest, remained in a turbulent political situation. Then between 1674 and 1678, it was fought over in the Rebellion of the Three Feudatories,[1] with serious damage to the kilns and workshops, so it was not until the middle period that the imperial

porcelain workshops really returned to normal operation. The most characteristic of the late-period "Lang ware" is a group of porcelain items made to celebrate the Kangxi Emperor's sixtieth birthday in 1713.

Overall, the most typical porcelains of the Kangxi reign are underglaze blue and polychrome, which were produced in large quantities and widely distributed. Since the official kilns mostly made porcelain for use in the palace, the materials were carefully chosen and the workmanship of a high standard. The products of the unofficial kilns were aimed at the domestic and export markets. In 1684 the ban on overseas trade was lifted, and ports in Fujian, Guangdong, Jiangsu, and Zhejiang were designated for foreign trade; trade with Europe opened up again, and the maritime trade-routes flourished, accelerating the development of the unofficial kilns at Jingdezhen, which kept coming up with new types of product. The interaction and mutual influence between official and unofficial kilns was something very distinctive of this time.

Underglaze blue porcelain in the Kangxi period used the domestic cobalt from Zhejiang. Although the color can vary considerably as a result of differences in the quality of the cobalt ore, mostly the visual impression is of an attractive bright azure, with gradations in depth of painting; large

1 In the early part of the Qing dynasty, the southern provinces of Yunnan, Guangdong, and Fujian were under the control of three Han-Chinese leaders who had been enfeoffed as princes there; their excessive military, financial, and local political power posed a serious threat to the nascent Qing regime. In 1673 the Kangxi Emperor took the decision to remove them, and their rebellion was finally put down in 1681.

Figs. 93–94
Rouleau Vase
with Scenes from
*The Tale of the
Western Chamber*
in Underglaze Blue

Qing, Kangxi period
Height 75 cm,
diameter 22.4 cm
Victoria and Albert
Museum, London

Twenty-four scenes
are painted in
underglaze blue,
telling the whole
story of *The Tale of
the Western Chamber*,
a love story well
known to everyone
in China. To date
this is a unique
piece. The rouleau
vase is a vessel
shape which first
appeared and
became widespread
during the Kangxi
period.

vessels can be particularly splendid and imposing. The craftsmen of this period had a firm grasp of the technique of extracting pigment from cobalt, and were skilled in refining the materials for body and glaze; through firing they could not only produce a sapphire blue and kingfisher blue but could also achieve a range of underglaze blue shades, reminiscent of the different shades of ink, from intense black to light grey, in traditional Chinese ink painting. This resulted in images which gave a sense of depth, variation, and chiaroscuro, making them vivid and lifelike, and made it more feasible for landscape, architectural, and figure scenes in the style of Chinese paintings to be executed on porcelain. There was a rich and dazzling variety of shapes in Kangxi underglaze blue porcelain: in addition to the traditional forms such as high-necked "phoenix-tail" vases, *meiping* vases, tall jars, beaker-vases, ewers,

brush-pots, flower-pots, covered boxes, and items for the study, distinctive new forms appeared such as rouleau vases, globular vases, and mallet vases. Decorative designs were particularly rich, with every variety of flower and animal, lively and detailed landscape and figure scenes, auspicious emblems relating to all aspects of life, and more scenes from dramas than ever before; some even told a complete story in a series of vignettes like a graphic narrative. For example, a Kangxi underglaze blue rouleau vase in the Victoria and Albert Museum with scenes from *The Tale of the Western Chamber* is a substantial piece with twenty-four scenes in four bands on the body of the vase in the manner of a graphic narrative telling the complete love story (figs. 93 and 94). This is a most unusual piece which provides an outstanding example of the painterly skills of porcelain craftsmen in the Kangxi era.

Traditional polychrome or "five-colored" (*wucai*) porcelain is also known in Chinese as "hard polychrome," or in English by the French term "famille verte" because of its green palette. The firing temperature is between 750 and 850 degrees Celsius. Polychrome porcelain first appeared in the Ming Xuande reign, and by the Kangxi period had reached a peak of development, having advanced by leaps and bounds in terms of both artistic quality and craftsmanship. There were two main reasons for this: (1) with the development of the urban economy, demand had increased from both the urban mercantile class and the literati; (2) in the export trade, there had been a great increase in demand from Europe for polychrome porcelain. Because of military upheavals and the ban on overseas trade under the Shunzhi Emperor in the early Qing, the VOC (Dutch United East India Company) had been unable to buy from Jingdezhen, so they had transferred their purchasing to Japan, stimulating the rapid development of Imari ware. This is a brightly-colored polychrome porcelain decorated in underglaze blue and overglaze red and gold. The Japanese porcelain industry imitated the porcelain—both underglaze blue and polychrome—exported to Japan from China. Around 1670, the special types of polychrome painted porcelain invented in Japan such as kinrande and kakiemon were imported by the VOC to Europe, where they met with great favor and expanding demand. When the Chinese ban on overseas trade was lifted in 1684–86, and the various East India Companies were permitted to open their "factories" in Guangzhou (Canton), there was a revival of the maritime trade between China and Europe, which had been interrupted for nearly thirty years. Orders from Europe started to return to Jingdezhen, and the large orders for polychrome porcelain encouraged the Jingdezhen potters to produce more polychrome wares, including some imitations

of the Japanese Imari ware (fig. 95). Chinese polychrome had a great advantage over Japanese in both quality and price, and under the stimulus of foreign demand the production of polychrome porcelain in the Kangxi period, whether by official or unofficial kilns, grew ever more refined and brilliant, reaching a peak of excellence.

Kangxi polychrome includes both underglaze blue with overglaze colors and pure overglaze colors. From the mid-Kangxi period, when overglaze blue was first successfully applied, the use of underglaze blue with polychrome diminished, the firing process becoming simpler; thus porcelain decorated only with overglaze colors became dominant. The most widely used colors were red, green, yellow, purple, blue, and black, with some use of gold. A new formulation was discovered for black pigment, which was no longer used only for outlines, but for larger areas of color such as people's

Fig. 95 European-Style Tankard in Underglaze Blue and Polychrome, Imitating Imari Ware

Qing, Kangxi period
Height 12 cm, rim diameter 9 cm, foot diameter 7.8 cm

The shape of this colored porcelain piece, produced at Jingdezhen in imitation of Japanese Imari ware, copies European silver tankards.

Fig. 96 Polychrome Rouleau Vase with Farewell Scene

Qing, Kangxi period
Height 46.3 cm, mouth diameter 12.8 cm, foot diameter 14.6 cm
National Museum of China

This farewell scene taken from the Ming dynasty novel *Journey to the West* shows the Tang monk Xuanzang (Tripitaka) setting out on his journey west to India to bring back the Buddhist scriptures; here he is being seen off on the outskirts of the capital Chang'an by military and civilian officials. The composition of the scene is beautifully arranged, and the colors are attractive. It is a masterpiece of Kangxi-era polychrome porcelain.

hair, the trunks of trees, buildings, or rocks. Pigments were used at different levels of intensity, especially green, which might appear in five or six different shades, and was widely used for mountain landscapes, trees, flowering plants, objects, and clothing on human figures. As a result, the palette of Kangxi polychrome tends towards green, hence the term "famille verte." The most commonly occurring forms are plates, bowls, cups, rouleau vases (fig. 96), water basins, and brush-pots. The most innovative and refined of the polychrome from the official kilns are the so-called Zang wares, such as a water-pot with polychrome floral decoration (fig. 97). The Lang wares are mostly vessels with congratulatory themes for the emperor's birthday, such as plates showing the goddess Magu offering wishes for long life (see fig. 98 on page 96), in which the potting, glazing, and painting are all of a very high standard. Polychrome from the unofficial kilns is

Fig. 97 Water-Pot with Polychrome Floral Decoration

Qing, Kangxi period
Height 7.9 cm, mouth diameter 7.3 cm, foot diameter 11 cm
Shanghai Museum

This water-pot, an example of what is commonly known as "Zang ware," is for use in the study. The design, in a combination of underglaze red and overglaze pigments, is fresh and refined.

(Illustration from: *Kangxi Porcelain Ware from the Shanghai Museum Collection* [Shanghai bowuguan cang kangxici tulu], Shanghai: Shanghai Museum [Shanghai bowuguan], Hongkong: The Woods Publishing Company [Yumu chubanshe], 1998.)

densely covered with large-scale designs, of which the most popular were narrative figure scenes or scenes of combat and martial arts. Overall the painting on Kangxi polychrome was of a very refined quality, with the features on human figures finely rendered, and their costumes shown in flowing, expressive lines. The use of European-style perspective began to be used, giving the scenes a greater impression of reality.

During the Kangxi period, both underglaze blue and polychrome reached the highest level of the entire Qing dynasty. Great care was given to both the craftsmanship and the design. The underglaze blue wares are splendid in their relatively somber way, while the polychrome pieces are both colorful and restrained. Both types are very impressive. There are examples of pieces from the official kilns in most major museum collections in China, while pieces from the unofficial kilns are better represented in European and American museums.

3 Western Technique Comes to the East: Yongzheng Polychrome

The Yongzheng Emperor was a highly cultured ruler; although he was on the throne for only thirteen years, during this time the craftsmanship and artistry of porcelain achieved a level unsurpassed in later reigns. Overglaze enamels and famille rose, in particular, further developed the techniques newly created in the Kangxi era and went beyond the traditional forms of decoration to give porcelain the feel of a literati painting scroll, increasing the sense of dynamic interaction between users and work of art, as well as pushing the development of Chinese polychrome porcelain in a new direction.

Enamel pigments consist of a low-fired mineral frit with boric acid as the alkaline fluxing agent. This opaque white soluble substance, when combined with a metal oxide colorant (such as gold, cobalt, or antimony), will form various colors; when combined with an arsenical oxide it will produce an opaque opalescence. This glazing material when applied as decoration to the surface of a vessel is known as enamel. The use of enamel colors was derived from the French champlevé enamel technique used in Limoges at the end of the 15th century; in

Fig. 98 Polychrome Plate with Design of the Goddess Magu Offering Wishes for Long Life

Qing, Kangxi period
Height 8.2 cm, rim diameter 18.5 cm, foot diameter 8.2 cm
Palace Museum, Beijing

This finely painted plate was made in the late Kangxi period for the sixtieth birthday of the emperor. In Daoist belief, Magu is the goddess of longevity.

the late 17th century, enamel pigments were brought to China through Guangzhou via the great maritime trade routes of the age of exploration. In the late Kangxi period, French missionaries introduced the technique to the imperial palace, where the imperial workshops succeeded in firing enamel pigments on porcelain.

Kangxi-era porcelain decorated with enamel colors represents an early use of the technique, and mainly consists of small pieces such as bowls and cups. Initially the enamel pigments did not adhere well over the glaze, and the craftsmen made use of bowls and cups supplied by Jingdezhen with the exterior body plain and unglazed (figs. 99 and 100); the exterior body was then painted with a dark red, yellow, blue, pink, or purple background and decorated with a colored floral pattern, all using enamel pigments. The Kangxi Emperor was very intrigued by the process of painting the porcelain body with enamel, and often took a personal interest in the design and adaptation of the patterns; once the pattern had been finalized, enamel specialists in the palace workshops undertook the painting and firing. The pigments used were imported from Europe. These vessels all have the Kangxi reign-mark painted in overglaze red or blue within a square frame on the exterior base.

The bright colors and the texture of enamel pigments were equally attractive to Kangxi's successor the Yongzheng Emperor. During his reign the craftsmanship and

Figs. 99–100 Enameled Bowl with Peony Pattern Made for Imperial Use
Qing, Kangxi period
Height 7.6 cm, rim diameter 15.6 cm, foot diameter 6.1 cm
National Museum of China
The formal, restrained style and the unevenness of the base color show that this was produced during the early development of the technique of enamel painting on porcelain in the Kangxi era.

artistry of enamel-painted porcelain reached unprecedented levels of achievement. In order to avoid reliance on imported materials, the emperor's half-brother Prince Yi (Aisingioro Yinxiang, 1686–1730), who was in charge of the palace workshops, participated personally in the development of locally-sourced enamel pigments. In 1728, the palace workshops succeeded in the experimental manufacture of enamel pigments, not only reproducing nine European colors, but developing another nine new colors. Subsequently, the problem of adhesion of pigment to glaze was solved, so that designs could be painted directly on to a pure white glaze, and as a result, the designs on Yongzheng-era enamel-painted porcelain became still richer and finer.

The Yongzheng Emperor took an even greater interest than his father in the palace workshops' production of enamel-painted porcelain. He wanted them to achieve the highest possible standards, suitable for imperial use alone, and not to fall to the level of "civilian" use. He commanded leading court painters, including Tang Dai (1673– 1752?) and the Italian missionary Giuseppe

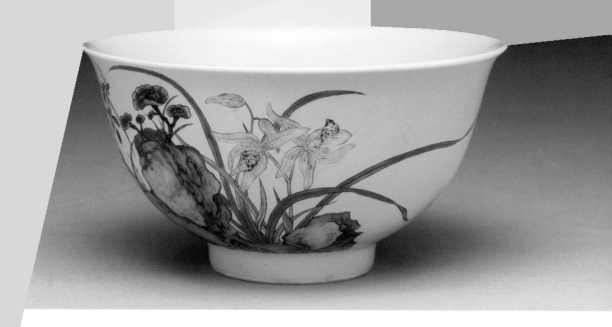

astiglione (Lang Shining, 1688–1766), to create designs for enamel-painted porcelain, and commissioned calligraphers to write verses to be inscribed on such pieces, thus combining all the elements of traditional Chinese painting—image, poetry, calligraphy, and seals—on porcelain vessels. Additionally, these elements had to be carefully balanced and related. For example, a piece with a design of chrysanthemum flowers might be embellished with a quotation from the famous Tang poet Luo Binwang (ca. 638–?) on yellow chrysanthemums glowing in the autumn sunshine, while the accompanying seal might read "peerless beauty," "golden splendor," or "glowing sunlight." A landscape rendered in blue pigment might bear a quotation such as "Woods stretch to the

Figs. 101–103 Bowl with Design of Ganoderma Fungus, Orchids and Rocks, Symbolizing Long Life, in Enamel Pigments on a Yellow Ground

Qing, Yongzheng period
Height 6 cm, rim diameter 12 cm
Palace Museum, Taibei

The design shows ganoderma fungus, flowering orchids, and Taihu rocks, with a poetic couplet in black pigment reading "Deep in the clouds on the onyx island the immortals' path opens up. In the warm spring air the flowers of ganoderma and orchids emit their fragrance." This is accompanied by three seals depicted in red pigment reading "Beauty," "Longevity," and "Pure fragrance." The base bears the reign-mark "Made in the Yongzheng reign-period" in blue pigment.

Fig. 104 Famille Rose Bottle Vase with Design of Swallows amid Apricot Blossom in Spring

Qing, Yongzheng period
Height 32.7 cm, mouth diameter 7.2 cm, foot diameter 14.1 cm
National Museum of China

The design of swallows amid apricot blossom in spring on this vase was a traditional auspicious image in China, symbolizing success in the imperial government examinations and the start of an official career.

southern hills, mist envelops the northern isle," with a seal reading "life long-lasting as the hills," "lofty mountains," or "expansive waters." These meticulous and elegant compositions held a profundity of meaning, combining the tactile pleasure of porcelain with the traditional enjoyment of painting and appreciation of poetry. Most Yongzheng enamel-painted porcelain pieces are small, usually bowls (figs. 101 to 103), plates, cups, or tea-pots, often made in pairs, with an overglaze blue four-character Yongzheng reign-mark written in Song-style script in a square frame on the exterior base. Yongzheng enamel-painted porcelain reached the highest artistic level and was closely guarded within the imperial palace; most pieces are now in the Taibei Palace Museum collection.

Famille rose decoration developed out of the famille verte pigments. The main difference was the addition to the pigment of powdered lead and glass white (containing arsenical oxide, which gives an opaque effect), making the color softer and pinkish, and also providing a sense of depth. The "piled white" technique (the application of a layer of glass white before painting the pattern) might also be used to give the effect of very low relief in the decoration. The firing temperature for famille rose was lower than for famille verte, just 700–750 degrees Celsius. Because of the gentle, delicate effect of famille rose decoration, it is also known in Chinese as "soft color" (*ruancai*). The technique first appeared in the late Kangxi period. Because the cost of production was much lower than for enamels while the decorative effect was very similar, it became widespread during the Yongzheng

period, with official and unofficial kilns competing to produce it.

The official kilns painted on fine white-glazed porcelain, and pieces with decoration on a colored glaze are very rare. The decorative character is similar to enamels, mainly consisting of birds and flowers, landscape scenes, ladies in gardens, or children at play. The lines are soft and gentle, and the painting highly meticulous, in a style similar to a painted handscroll, strongly influenced by the "boneless" (*mogu*) technique of the early-Qing flower painter Yun Shouping (1633–1690). The reign-mark appears on the base in underglaze blue. An example is a famille rose bottle vase with design of swallows amid apricot blossom in spring (fig. 104). The craftsmanship and painting of famille rose porcelain produced by unofficial kilns was relatively crude, with many utilitarian pieces destined for export, usually decorated with narrative figure scenes

or birds and flowers.

Imperial Yongzheng famille rose porcelain is splendid and ornamental, yet elegant and refined, and is the most highly valued of all Qing-dynasty famille rose. The high proportion of white background in the designs gives a visual sense of tranquility. A frequent type of design is the extended flower branch, in which a flowering or fruit branch appearing on the exterior surface of the vessel extends to the inner wall, so that there is movement in the image space, increasing the sense of articulation and imaginative space. An example is a famille rose plate with design of extended branch bearing eight peaches (see figs. 89 and 90 on page 88).

The craftsmanship of Yongzheng porcelain is distinguished for its meticulous refinement. The Yongzheng Emperor himself was a porcelain aficionado, and paid close and careful attention to the creation of porcelain items for use in the imperial palace. Outstanding achievements were made in many fields, including enamels, famille rose, imitations of antique vessels, monochrome glazes, and kiln-transmuted glazes. New vessel types include the so-called "reward vases" (long-necked bottle vases given as gifts by the emperor), pomegranate vases, and "three sheep" vases. The wide use of a dark rose color referred to in Chinese as "gold red" or "rouge red" and in English as "ruby back"(because often used on the exterior of vessels) is a unique characteristic of this period.

The Yongzheng period pushed the craft of colored porcelain to new heights. In the late Qianlong period, famille rose porcelain gradually replaced the costly enamels which had been the palace favorite. From Jiaqing and Daoguang onwards, famille rose became the most widespread type not just in the palace but in ordinary domestic use, with famille verte polychrome and enamels as exceptional pieces only.

4 The Ultimate in Skill: Qianlong Porcelain

Qianlong's reign was the strongest and most prosperous period of the Qing dynasty. On the throne for sixty years, he was an emperor skilled in the arts of both peace and war, with a great enthusiasm for antiques and aesthetic appreciation. As well as appreciating the literary and artistic skills of others, he was himself often moved to verse, which he had inscribed on various objets d'art. More than two hundred of his poems appear on porcelain vessels. Qianlong's interest in porcelain was well served by the supervisor of the porcelain workshops Tang Ying (1682–ca. 1755), who assembled the most skillful craftsmen and racked his brains to invent new creations, producing a series of uniquely splendid and ingenious pieces. Porcelain production at Jingdezhen was able to advance rapidly under Qianlong's auspices, thanks to the work of Tang Ying. Tang was both creative and hard-working; under the Yongzheng Emperor he had held a position overseeing the palace workshops, and in 1728 he was posted to Jingdezhen to assist the then supervisor Nian Xiyao (1671–1739), whom he succeeded in 1737. In his almost thirty-year career as a supervisor of porcelain production he served both Yongzheng and Qianlong. Later generations named the porcelain produced by the imperial kilns under his supervision "Tang ware."

The brilliance of Qianlong-era porcelain is manifested in the following ways:

Regularity in the shapes of vessels, with large and small pieces being equally meticulously formed. At the same time, there are numerous variations in the shapes of particular vessel types, giving rise to many unusual pieces. For example, among vases alone, there is a stupendous variety of types, including globular vases, reward vases, gourd-shaped vases, conjoined vases, gall-bladder

shaped vases, sweet dew vases (pairs of vases used in Buddhist worship), garlic-bulb-mouthed vases, square and *cong*-shaped vases, interlocking vases, wall vases, and rotating vases. Of these, the conjoined, rotating (fig. 105), and interlocking vases are all new and ingenious inventions, never previously seen.

An almost endless variety in glaze colors. Around fifty-seven different colors of glaze can be identified, often used to reproduce the products of the five great kilns

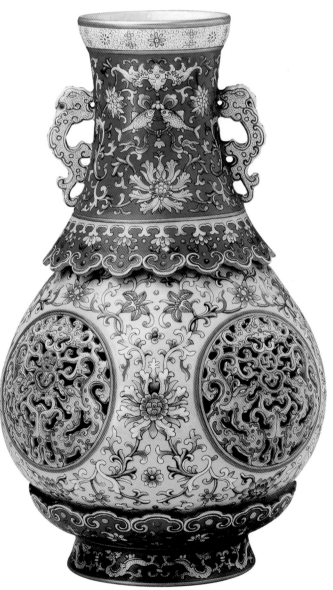

of the Song dynasty, or to imitate vessels made of wood, bronze, lacquer, and other materials. Qianlong's particular fondness for Song porcelain, with its wonderfully subtle glazes, prompted the kilns supervised by Tang Ying to experiment in techniques to imitate the wares of the five great kilns. The key to this was the ability to reproduce the color and quality of the glaze. As a result, the palace archives list these reproductions according to their glazes as, for example, "Ru glaze brush-washer" or "Ge glaze incense-burner," whereas in the case of actual antiques in the palace collection, they would be listed as "Ru ware brush-washer" or "Ge ware incense-burner," and so on. Reproduction Song porcelain at the Qianlong court was usually made for display or for use in the study, and it was often the emperor himself who specified what type of vessel was required. Although these pieces were very close copies of Song porcelain in glaze color and quality, they still fell short in some respects; for example, the glaze was too shiny, or insufficiently opalescent. The most convincing reproductions were those of the crackle-glazed Ge ware. In shape, on the other hand, the imitations were not confined to Song forms, but conformed to contemporary tastes. The pieces which copied vessels made of materials other than porcelain were even more remarkable: some even

Fig. 105 *Famille Rose Rotating Vase*
Qing, Qianlong period
Height 30.3 cm, mouth diameter 8.5 cm, foot diameter 10.5 cm
National Museum of China

Rotating vases were an ingenious innovation of the Qianlong period for the enjoyment of the imperial family. They consist of three parts, an inner vase, an outer vase, and a base: an axle on the inner vase fits into a socket in the base so that it can rotate, while the outer vase is decorated with openwork panels through which a continuous scene painted on the inner vase can be enjoyed as it revolves.

reproduced exactly the texture of other materials, such as an imitation bronze vase, imitation wood, an imitation lacquer plate (fig. 106), or an imitation marble incense-burner.

Dazzlingly complex decorative patterns, in which Chinese and European motifs were combined to produce an astonishingly colorful variety of effects. Patterns in the Qianlong period retained many traditional designs, particularly those with auspicious meanings, such as pomegranates symbolizing many offspring, bats symbolizing good fortune, the Eight Immortals denoting long life and happiness, or cassia branches suggesting official success. All these express the pursuit of a happy life by a population enjoying a time of peace and prosperity. Colorful and regular decorative styles such as floral grounds, incised grounds, poetic or other inscriptions, and so on appear quite frequently in the Qianlong period. Trade between China and Europe was at its greatest extent in this period, and many examples of European craftsmanship were introduced to the Qing court, where they were much appreciated by the Qianlong Emperor. A number of scientifically educated and artistically gifted Catholic missionaries were employed at court; this broadened the scope of artistic and technical exchange between China and the west, leading to a greater use of European artistic motifs and techniques in the decoration of Chinese porcelain. For example, the very fine, dense patterns on Qianlong-era porcelain may show the influence of the 18th-century European

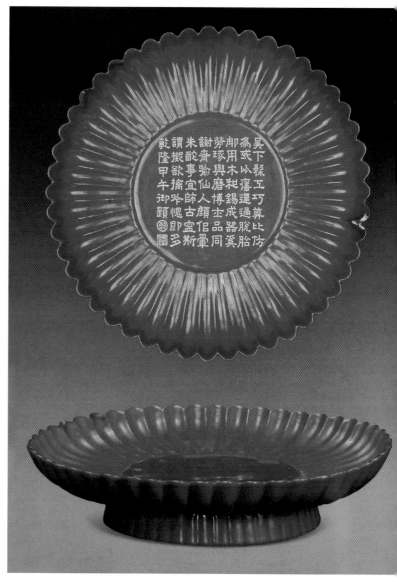

Fig. 106 Chrysanthemum-Petal Plate Imitating Red Lacquer

Qing, Qianlong period
Height 3.5 cm, rim diameter 16.8 cm, foot diameter 9.7 cm
National Museum of China

What appears to be a red lacquer plate is in fact made of porcelain, ingeniously using vermilion and black glazes to imitate lacquer.

Rococo style. Additionally, European people, flowering plants, and scenes also appear as decoration on porcelain, forming a unique Sino-European decorative style.

The Qianlong Emperor, as a connoisseur of antiques, greatly valued the enamel-painted porcelain preserved in the palace from the previous reigns, and continued

the manufacture of such pieces in the palace workshops. Indeed, in quantity, range of types, and decorative content they surpassed the preceding reigns of Kangxi and Yongzheng. The Qianlong Emperor also gave orders that a case of valuable *nanmu* wood should be made for each piece, in which they could be stored in a store-room dedicated to enameled porcelain in the Qianqing Hall of the palace. The number of taller vessels decorated in overglaze enamels (figs. 107 and 108) increased under Qianlong, while their decoration added to the subjects carried on from the previous reigns motifs of human figures such as children at play or mothers and children. Court painters such as Yu Sheng (1736–1795), who specialized in flowers, birds, fish, and insects, Zhang Tingyan (1735–1794), a specialist in architectural and figure scenes, or Jin Tingbiao (dates unknown), a specialist in human figures and flower painting, all participated in the painting of designs for porcelain decoration. Even the backgrounds of designs were elaborate, with frequent use of incised grounds, floral grounds, or panels reserved in a monochrome surround. There was a wide variety of subject matter in the decoration of Qianlong enamel-painted porcelain, and it was very splendid, continuing the traditions of imperial artistic style.

About five hundred pieces of enamel-painted porcelain from the Qing palace survive in collections world-wide, consisting of about two hundred different vessel types. After the

treasures of the palace collection were moved out of Beijing in 1933 to avoid the dangers of war, the great majority of the enamel-painted porcelain eventually ended up in the Taibei Palace Museum collection along with other works of art regarded as the finest pieces. As a result, about four hundred of these imperial porcelains are held in Taibei, while about forty remain in the Beijing Palace Museum.

Famille rose porcelain of the Qianlong period is very widespread, since it was produced by both official and unofficial kilns, although to varying standards of quality. For example, a famille rose vase from the official

Figs. 107–108 Garlic-Bulb-Mouthed Vase with Floral Scrolls in Enamel Pigments

Qing, Qianlong period
Height 18.6 cm, mouth diameter 2.8 cm, foot diameter 5.3 cm
National Museum of China

The decorative style is influenced by European art. The interior and base of the vase have a pale green glaze to enhance the impression of a cloisonné enamel vase.

kilns decorated with deer (fig. 109) is entirely covered with a powerfully rendered scene showing a three-dimensional landscape with a herd of deer in a variety of natural postures, extremely finely painted: this is a classic piece of its period.

Refinement of the production of traditional types of porcelain. Traditional varieties of porcelain such as underglaze blue, underglaze red, alum red, and monochrome glazes continued to be produced in the Qianlong period. Underglaze blue remained an important type, and was made using high-quality Zhejiang cobalt. The technique for producing the color had been fully mastered, so the patterns were drawn with great regularity in stable, rich color. Some pieces made in imitation of Ming underglaze blue of the Yongle and Xuande periods also bore the characteristic dark patches resulting from precipitation. An underglaze blue beaker-vase with an inscription by Tang Ying (fig. 110) bears a precise date (1741) and is a fine example of such ware in the early Qianlong period. This beaker-vase is one of a set of five altar vessels dedicated by Tang Ying in the temple of the Heavenly Immortal Holy Mother at Dongba to the north-east of Beijing, the complete set consisting of one incense-burner, two candlesticks, and two beaker-vases. The temple

was built in 1696 on the pilgrimage route to the Daoist holy site of Yaji Mountain, and was a place of Daoist worship much patronized by the elite. The color of underglaze blue in the mid- to late Qianlong period remained rich, but the tendency of the pigment to run diminished; at the same time, a fresh and elegant style of underglaze blue decoration emerged, in which the motifs were drawn in outline only.

The bodies of porcelain produced at Jingdezhen in the Qianlong period were an exquisite pure white, of a dense, hard consistency, though slightly thicker than in the Yongzheng period. The glaze surface was uniform and glossy. The standard of

Fig. 109 Famille Rose *Zun* Vase with Design of Deer

Qing, Qianlong period
Height 44.6 cm, mouth diameter 16 cm, foot diameter 24.3 cm
National Museum of China

The shape of this type of porcelain vessel is inspired by a deer's head, so it is also known as a deer-head *zun*. They are often decorated with continuous scenes of landscapes with herds of deer.

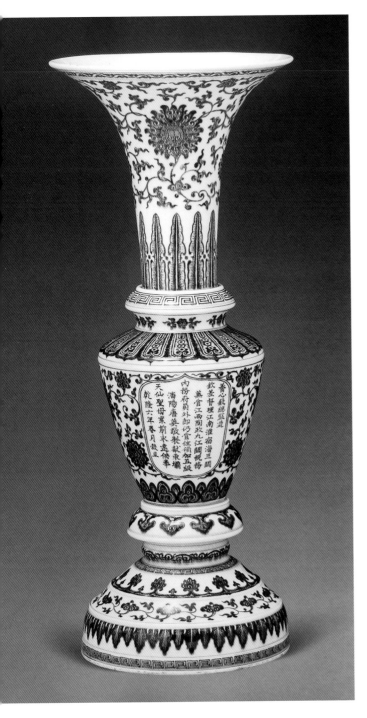

Fig. 110 Underglaze Blue Beaker-Vase with Inscription by Tang Ying

Qing, Qianlong period
Height 63.5 cm, mouth diameter 26.5 cm,
foot diameter 23.1 cm
National Museum of China

Beaker-vases were an antique-style type of flower vase, used in the Qing dynasty for religious offerings.

5 Return to Basics: Porcelain in the Late Qing

The late Qing period covers the reigns of six emperors, from Jiaqing to Xuantong (1909–1911), lasting altogether for 116 years. The Jingdezhen porcelain industry began to show signs of decline from Jiaqing onwards. As a result of war and financial difficulties, the number of official kilns decreased from over 270 in the Daoguang period to sixty by the Tongzhi period (1862–1875). In 1907, the official kilns at Jingdezhen were taken over by a commercial concern, the Jiangxi Porcelain Company Limited, and the imperial workshops were reduced to being part of a corporate entity, although they continued to produce porcelain for imperial use. In this way, porcelain bearing the Xuantong reign-mark was actually manufactured by the Jiangxi Porcelain Company. With the collapse of the Qing dynasty in 1911, 260 years of production in the Qing imperial workshops came to an end.

Having lived through the golden age of the Kangxi, Yongzheng, and Qianlong reigns, the Jingdezhen porcelain industry was already on the wane in the late Qianlong period. This tendency continued throughout the Jiaqing period, when official supervisors were no longer sent from the court to oversee the imperial workshops; this duty was taken

craftsmanship at each stage of the production process was highly meticulous, showing continuous improvement, and the creation of different shapes showed an unprecedented level of skill. Huge advances took place in the quantity and variety of pieces produced, bringing the Qing-dynasty porcelain industry to the highest standard, and indeed to an unsurpassable level of skill.

over by local officials. The types of pieces made in the early Jiaqing period were much the same as before, with little innovation, but the quality of pieces from the official kilns remained outstanding, and the bodies maintained the fineness of mid- to late Qianlong. Cylindrical porcelain hat-stands (for official head-gear) were one innovation of the Jiaqing era, replacing the spherical hat-stands of earlier reigns.

From late Jiaqing to Xuantong, the manufacture of porcelain at Jingdezhen gradually declined; products from both official and unofficial kilns became coarser, with less graceful outlines, but they were still quite carefully made. Most orders from the palace were for everyday use. In the Daoguang reign, in addition to porcelain bearing the usual reign-mark, there were also pieces marked with the name of the emperor's residence in the Garden of Perfect Brightness (*Yuanming Yuan* or "Old Summer Palace"), the Hall of Attentive Virtue (*Shende Tang*; fig. 111). The porcelain (fig. 112) made for the marriage at the age of seventeen of the Tongzhi Emperor (1856–1875, r. 1861–1875), who died only two years later, is representative of the products of the imperial kilns in his reign. The Guangxu Emperor (1871–1908, r. 1875–1908) was on the throne for 34 years, but for most of this time the government was in the hands of his formidable aunt, the Empress Dowager Cixi (1835–1908). The Empress Dowager was thus the most powerful person in the palace, and there is a group of very fine imperial-style porcelains bearing

Fig. 111 Famille Rose Vase with Cloud-Shaped Lugs and Design of Children at Play, with *Shende Tang* Mark

Qing, Daoguang period
Height 29.9 cm, mouth diameter 8.2 cm, foot diameter 10.3 cm
National Museum of China

Children at play formed a frequent type of design on porcelain from the official kilns in the late Qing dynasty. These children playing in a courtyard, full of life and movement, are symbolic of good fortune and many descendants. The *Shende Tang* mark (below) was one used by the imperial kilns. The *Shende Tang* or Hall of Attentive Virtue was the Daoguang Emperor's (1782–1850, r. 1820–1850) residence in the Garden of Perfect Brightness.

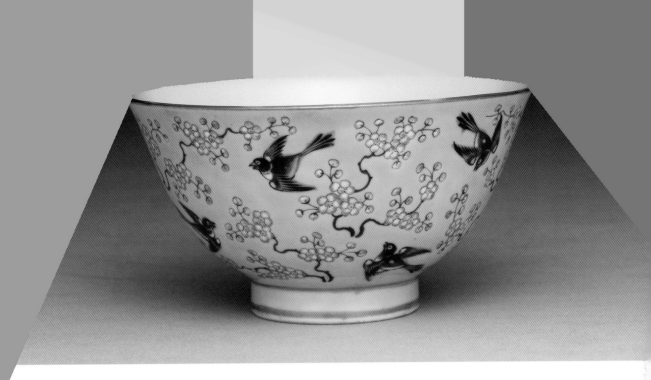

the names of her dining-room, the Hall of Bodily Harmony (*Tihe Dian*; fig. 113), her residence in the Garden of Perfect Brightness, Universal Springtime (*Tiandi Yijia Chun*), and her Studio of Great Refinement (*Daya Zhai*; see fig. 114 on page 108). This kind of inscription on porcelain, of the names of buildings unrelated to the emperor himself, was unprecedented throughout both the

Fig. 112 Famille Rose Bowl with Design of Magpies among Plum Blossom on a Yellow Ground

Qing, Tongzhi period
Height 5.6 cm, rim diameter 10.6 cm, base diameter 4.2 cm
Palace Museum, Taibei

The body of the bowl is quite thin. The exterior is covered with a pale yellow glaze, painted in famille rose pigments with scrolls of plum blossom and eight magpies, a rebus or punning picture symbolizing great happiness. On the rim and foot are three lines painted in gold. The interior has a pure white glaze, entirely plain with no decoration. The exterior of the base has a Tongzhi reign-mark written in regular script in alum red.

Fig. 113 Covered Box with Design of Flowers and Fruit and *Tihe Dian* Mark in Underglaze Blue

Qing, Guangxu period
Height 18.3 cm, rim diameter 26.9 cm, foot diameter 17.3 cm
National Museum of China

The mark on the base reads *Tihe Dian zhi* (Made for the Hall of Bodily Harmony) (below). The Hall of Bodily Harmony was where the Empress Dowager Cixi dined, located in the Chuxiu Palace, her residence in the Forbidden City. This is one of a set of porcelain vessels ordered in the final year of the Tongzhi reign; it was only in the first year of the Guangxu reign that firing was completed and they were delivered to the Palace.

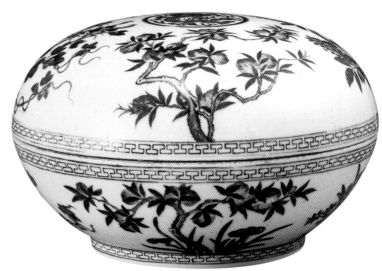

Ming and Qing dynasties. During the Guangxu reign several tens of thousands of porcelain items for palace use were made to celebrate the Empress Dowager's fiftieth, sixtieth, and seventieth birthdays, at a cost which exceeded even the Qianlong Emperor's expenditure on porcelain. Specialists regard the Guangxu period as a time of revival of antique-style ceramics. Although the Xuantong reign lasted only three years, porcelain bearing the Xuantong reign-mark continued to be made for imperial use, such as a *doucai* plate with the emblems of the Eight Immortals (figs. 115 and 116), reward vases, and pear-shaped bottle vases. A group of white-glazed ceremonial vessels was also made for the Eastern and Western Tombs of the Qing imperial family.

The main types of late-Qing porcelain are underglaze blue, famille rose, monochrome

glazes, and reproduction antique glazes, with the first two being the most common. The main decorative motifs are birds and flowers of the four seasons, butterflies and other insects, antiquities, and auspicious emblems. During the Tongzhi and Guangxu reigns, the great majority of palace porcelain was made according to official patterns and measurements provided by the imperial household. During the Jiaqing, Daoguang, and Tongzhi reigns, the unofficial kilns produced many pieces decorated with personages from the *Catalogue of the Peerless*.[1] During the Jiaqing and Daoguang reigns, widespread types of figural porcelain were items for the studio made to look like bamboo carvings, such as brush-washers, boxes, brush-pots (fig. 117); these were

1 The *Catalogue of the Peerless* (*Wushuang Pu*) was a book describing famous historical figures through a combination of illustrations and poems, published in 1694. The editors selected forty celebrated figures from 1,400 years of history from the Han to the Song dynasty, such as the Tang poet Li Bai (701–762) or the Western Han historian Sima Qian (b. 145 or 135 BC), and composed poems about them accompanied by portrait illustrations. The book was named *Catalogue of the Peerless* because these individuals' achievements were considered unparalleled. It is a typical example of early Qing woodblock printing, and because of the fame of the historical figures included, it had a wide circulation among the public.

Fig. 114 Fish-Bowl with Design of Butterflies and Flowers in Ink and Color on a Yellow Ground, with *Daya Zhai* Mark

Qing, Guangxu period
Height 23.2 cm, rim diameter 29 cm, foot diameter 16.5 cm
National Museum of China

These *Daya Zhai* porcelains were manufactured by the imperial workshops at Jingdezhen according to designs, shapes, colors, and dimensions specified and provided by the Palace. The *Daya Zhai* (Studio of Great Refinement) mark usually appears on the body of porcelain vessels together with the mark *Tiandi Yijia Chun* (Universal Springtime) in seal form. In 1855, two new plaques with the name of the Studio of Great Refinement were made in the Palace, one to be hung in the Peaceful Tranquility Room (*Ping'an Shi*) of the Hall for Nourishing the Heart (*Yangxin Dian*) in the Forbidden City, and one in the Universal Springtime Hall in the Garden of Perfect Brightness. The Peaceful Tranquility Room was where Cixi had lived when she was a concubine of the Xianfeng Emperor (1831–1861, r. 1850–1861); Universal Springtime was her residence in the Garden of Perfect Brightness after she became Empress Dowager.

often inscribed with the name of the potter, marking the emergence at this time of distinguished ceramic sculptors.

The decorative designs of late-Qing porcelain were not as fluent as those of earlier periods, being somewhat rigid and formulaic and sticking closely to established models rather than showing a sense of ease and freedom. In pieces from both official and unofficial kilns, the precision of manufacture declined, with clumsier forms and stiffer patterns, making them works of craft rather than art. By the Xuantong period, porcelain started to be produced mechanically, with the patterns transfer-printed rather than hand-painted. Under the impact of the western industrial revolution, China's millennia-old tradition of hand-crafted ceramics had embarked on the path of industrial production.

Fig. 117 Yellow-Glazed Carved Porcelain Brush-Pot with Design of the "Three Flavors"

Qing, Daoguang period
Height 12 cm
Jiangxi Provincial Museum

This design, originating in a vernacular tale from the Song dynasty, shows a scene of the famous Northern Song writer Su Dongpo (1037–1101) with Huang Tingjian (1045–1105) and Zen Master Foyin (1032–1098) tasting a famous type of vinegar from the Tang dynasty known as "Peach Blossom Acid." The different reactions of the three men on tasting the flavor of the vinegar represent the differing attitudes to life of the three doctrines of Confucianism, Buddhism, and Daoism. Confucians find life sour but believe that this can be rectified by education and self-discipline; Buddhists maintain that the essence of life is suffering and thus life is inherently bitter; Daoists believe that life is beautiful by nature and people are troubled only because they have not found true knowledge, so they find life sweet.

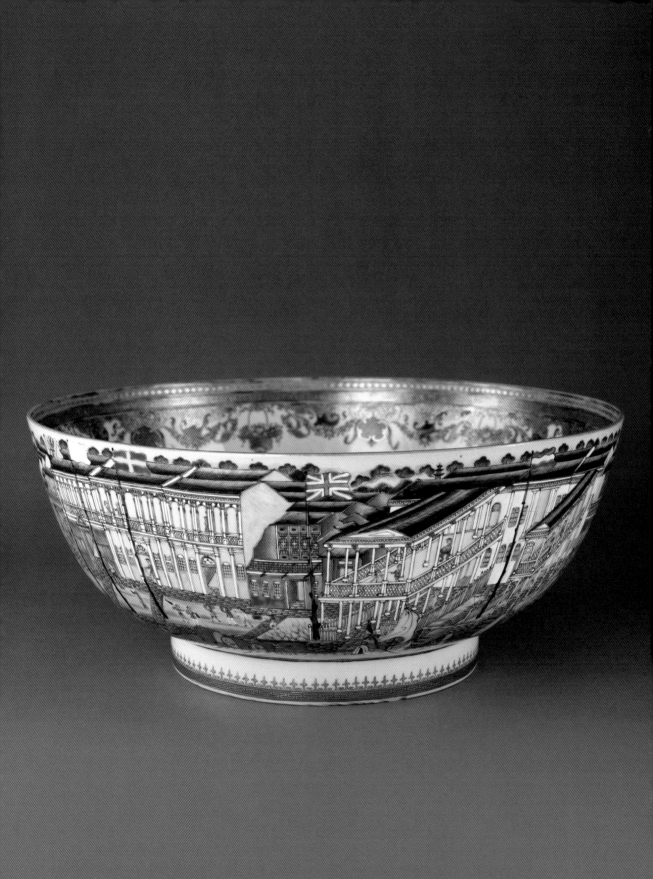

CHAPTER VII

FLOWERS OF A FOREIGN LAND: EXPORT PORCELAIN OF THE MING AND QING

The export porcelains of the Ming and Qing appear as exotic blooms among Chinese ceramics: although produced within China, they made their name overseas, and are now to be seen in all major museums in the west. They are characteristic of their period, as well as representing cultural interchange between China and the west. The vogue for Chinese porcelain which swept Europe in the 18th century was an important vehicle to introduce Chinese art and culture to the west. The smooth, refined texture, artistic shapes, and meticulous decoration of Chinese porcelain came like a breath of fresh air to the art of Europe, dominated as it had been by the Baroque style, and ushered in the new, lighter, and more playful Rococo style.

The Ming and Qing dynasties were the golden age of Chinese export porcelain. Starting in the year 1405, the third year of the Yongle reign, the seven great voyages of the Ming admiral Zheng He stimulated tribute and trade exchange between the Ming government and other countries. The export

of porcelain reached great heights, with large quantities of underglaze blue porcelain being transported to Asia, the Middle East, and Africa. During the mid- to late Ming, with the Spanish and Portuguese in command of the high seas, the Portuguese, regarding East Asia as their sphere of interest, were the first to send their merchant ships to its shores. In 1685, China allowed foreign traders to set up their offices or "factories" in Guangzhou, and the large-scale export of Chinese porcelain to Europe began, opening a dialogue between Chinese and Europeans on their requirements for merchandise. As the Europeans began by simply importing

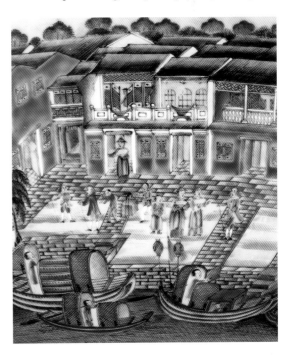

Figs. 118–119 Guangzhou Porcelain Punch-Bowl with Scene of the Thirteen Factories
Qing, Qianlong period
Height 15.7 cm, rim diameter 36.7 cm
British Museum

This type of large bowl was used by Europeans to mix punch, a popular alcoholic drink originally introduced from India to Britain by employees of the British East India Company. The design on this example is notable for its rich colors and dense composition.

porcelain manufactured in China, or "china-ware," and then went on to order pieces to be made in accordance with European taste, and finally imitated and reproduced Chinese-style porcelain, Chinese export porcelain traced a trajectory from high demand to decline. The height of demand came during the late Ming and early Qing, when "chinoiserie" was all the rage in Europe.

1 The Merchant Middlemen: the East India Companies

After the occupation of Macao by Portuguese merchants in 1553, the number of merchant vessels coming to China to trade greatly increased. The Portuguese capital Lisbon soon replaced Venice as the European center for the sale of oriental arts and crafts. In order to suit the European market, Portuguese merchants started to order porcelain items adapted to European ways of life and artistic styles. The vast profits they made out of dealing in Chinese porcelain prompted other European countries to buy porcelain directly from China. England, the Netherlands, France, and Sweden all established East India Companies to undertake the Chinese trade.

Fig. 120 Famille Rose and Gilt Fruit-Dish and Plates Decorated with Arms of the Honorable East India Company

Qing, Jiaqing period
Fruit-dish height 11.3 cm, large plate width 26.5 cm, small plate width 23.5 cm
Victoria and Albert Museum, London

The plates are decorated with the coat of arms of the Honorable (British) East India Company. This set of porcelain was made to order at Jingdezhen.

These East India Companies, established to carry out seaborne trade, became the main intermediaries for the transport of Chinese porcelain to Europe. Their merchant ships sailing between China and Europe became a bridge for the exchange of Chinese and western merchandise and also provided openings for cultural exchange. Orders for porcelain were placed by the head merchant or "supercargo" on each ship, or sometimes by individual crew members, and it was the supercargos who were responsible for transmitting the requirements and preferences of their aristocratic customers and for ensuring the quality of the finished products. Since China would accept payment only in silver, the merchant ships on their outward voyage had to carry cargo which they could sell en route for silver to pay for Chinese merchandise.

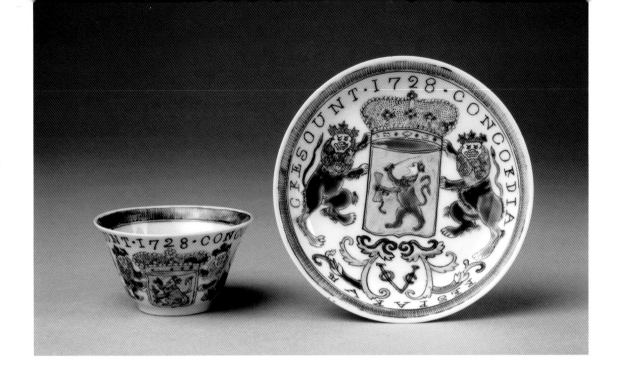

The English (later British) East India Company, established in 1600, initially carried out only indirect trade with China, mainly through ports in Japan. In 1670 it acquired the right to establish a "factory" or office in Taiwan. In 1698, a new East India Company known as the English Company Trading to the East Indies was established by act of Parliament, but the original company remained powerful and in 1708 the two companies were amalgamated as the United Company of Merchants of England Trading to the East Indies, more often known as the Honorable East India Company. A fruit-dish and two plates (fig. 120), made in Jingdezhen in the Jiaqing reign of the Qing dynasty, are decorated with the Company's coat of arms in the center. Subsequently trade conditions became more stable, with more ships carrying greater quantities of merchandise between Europe and China. During nearly one hundred years of trading activity, the volume of trade carried by the Honorable East India Company was the largest in Europe.

The Dutch United East India Company (Vereenigde Oostindische Compagnie or VOC) was established in 1602, and eventually dissolved in 1799. A famille rose cup and saucer (fig. 121) with the initials

Fig. 121 Famille Rose Cup and Saucer with the Initials VOC

Qing, Yongzheng period
Cup height 3.5 cm, saucer diameter 6.5 cm
Victoria and Albert Museum, London

VOC are the initials of the Dutch United East India Company. This cup and saucer set, made at Jingdezhen, is a commercial product made to order for the foreign market in the Yongzheng reign of the Qing dynasty.

VOC surmounted by the arms of the Dutch Republic, made in Jingdezhen during the Yongzheng reign, forms just one item in a complete set of porcelain specially ordered by the VOC. The East Asian headquarters of the VOC was in Batavia (present-day Jakarta in Indonesia); in the nearly two hundred years of its trading operations, the company sent to sea a total of 1,772 ships. Before the establishment by Britain of the Honorable East India Company, the VOC virtually monopolized the European trade in Chinese porcelain. Between 1602 and 1682, as many as 10.1 million pieces of Chinese porcelain were carried by the VOC's merchant ships.

The Swedish East India Company was established in 1731, and its ships first arrived in Guangzhou in 1732. Between 1731 and 1813, the company organized 132 voyages to

East Asia, and transported about 30 million porcelain items. A porcelain mug (fig. 122) ordered for a Swedish merchant vessel is painted with a scene of ships in harbor flying the Swedish flag, and an inscription commemorates the anchorage of a Swedish ship at a port in Hainan in 1784–85. The piece was made to order in Guangdong specifically as a memento.

Not to be outdone by the British, Dutch, and Swedish East India Companies, France, Austria, Denmark, and Spain all set up similar trading companies to take advantage of the great profits to be made. The French East India Company (Compagnie Française pour le Commerce des Indes Orientales) was established in 1664, while the Ostend Company was established in the Austrian Netherlands in 1722 by Charles VI, Archduke of Austria and Holy Roman Emperor, as a forerunner of the Imperial Asiatic Company or Austrian East India Company. Spain's trade with China, on the other hand, mostly went through the Philippines, a Spanish colony.

The European East India Companies did not only bring a flourishing trade to 17th and 18th century China; those of the Catholic countries also provided transport for a large number of missionaries, who introduced western science and art to the Qing court. At the same time, Chinese products such as silk, porcelain, lacquer, and tea were exported to Europe, bringing changes to European ways of life and artistic preferences.

Fig. 122 Large Famille Rose Mug Made for a Crew Member on a Swedish Ship
Qing, Qianlong period
Height 10.2 cm, rim diameter 4.8 cm
British Museum
This shape of mug with a single handle would be used as a beer tankard in Europe. The image and inscription on the mug commemorate the Swedish East India Company's merchant vessel the "Gustaf Adolph" taking refuge in the port of Yalong on Hainan Island from 8 December 1784 to 21 April 1785.

2 Crossroads of Trade: the Guangzhou Factories

Guangzhou had been a foreign trade port from at least as early as the Song dynasty. In 1757, the Qing court closed the ports in Zhejiang and Fujian provinces to overseas trade, so that Guangzhou became the only outlet for foreign trade, though foreigners and their ships were still not allowed into the city itself.

Between 1757 and 1842, the "Thirteen Factories" of Guangzhou were the only organizations permitted by the Qing government to conduct overseas trade, effectively combining trading, administration, and diplomacy. In this period, export products from all over China were all funneled through the Thirteen Factories and sold on throughout the world, while products imported from all over the world were distributed from here throughout China.

The institution of the Thirteen Factories was the outcome of the Qing government's ban on maritime trade and establishment of the so-called "Canton System" whereby Guangzhou was the only port allowed to conduct foreign

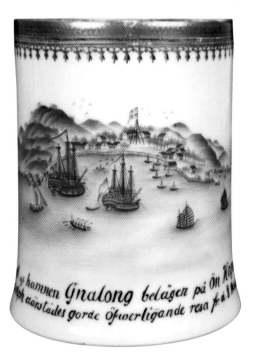

trade. The small group of Chinese "Hong Merchants" or "Co-hong"[1] who dealt with the foreign traders acted under orders from officials of the government, undertaking all aspects of the import and export trade, not only customs procedures, collection of taxes, and the communication of government orders, but also the control and management of the foreign traders' everyday lives. In 1685, the government permitted foreign companies to set up "factories" (agencies or offices) in Guangzhou. The British East India Company was the first to do so, in 1715, followed by the French (1728), the Dutch (1729), the Danes (1731), and the Swedes (1732). Later they were joined by Spain, Austria, the United States, Russia, Switzerland, and others. The thirteen buildings constructed along the banks of the Pearl River to provide accommodation and offices for the foreign merchants became known as the "Thirteen Factories." Each factory flew the national flag of its occupants. These Thirteen Factories provided the headquarters for the foreign merchants to conduct trade with China; generally the ground floor formed a warehouse and packing area, while the better ventilated upper floor comprised accommodation and offices. Guangzhou porcelain workshops were established specifically to fill orders from the foreign merchants on the south bank of the Pearl River, making communication and transport very easy.

A punch-bowl in the British Museum collection (fig. 7-4), made in the Qing Qianlong period, is decorated on the exterior with a vivid scene of the Thirteen Factories at that time. In front of the buildings in European colonial style, flagpoles are flying the flags of the Netherlands, Britain, Sweden, France, Austria, and Denmark, while Chinese

merchant vessels are moored alongside and Chinese merchants wearing Qing costume do business on the quay with European merchants clad in frock coats and breeches. The Thirteen Factories are also recorded in a large number of paintings, known as export paintings, undertaken by Chinese artists on the orders of western customers, as well as in oil paintings, watercolors, and prints produced by European artists.

3 European Styles Made in China: the Forms of Export Porcelain

A total of well over a hundred million pieces of porcelain were shipped from China to Europe during the Ming and Qing dynasties. Chinese porcelain was particularly fashionable in Europe during the period of the late Ming to early Qing. For a time, the possession of Chinese porcelain became a marker of status among the upper classes of European society. During the 15th and 16th centuries, European aristocrats had used their immensely costly pieces of porcelain only for decoration and display; there was a craze for using ceramics in interior décor, inlaying walls, ceilings, and window embrasures with porcelain, and the remarkably shiny porcelain objects were often placed in front of mirrors to create dazzling effects of light and shade.

During the Ming and Qing, however, the great majority of export porcelain consisted of ordinary domestic items; to start with these mostly took traditional Chinese forms, but from the mid-Qing onwards the number of specially made types increased, though they were still produced en masse. Only about 5% of export porcelain was made by special order, and these pieces were of the highest standard of potting and decoration. Such pieces made according to the specific requirements of the customer were usually also decorated in

1 Translator's note: "Hong" is the Cantonese pronunciation of Mandarin *hang*, meaning a business or company; "Co-hong" is the Europeans' attempt to pronounce *gong hang*, meaning public (or semi-official) company.

particular ways according to patterns which the customer supplied. Porcelain exported to Europe was always manufactured in Jingdezhen, and takes three main forms:

Traditional Chinese shapes. In the early period of the new trading routes, European merchants would directly purchase porcelain items used in everyday life in China, such as various bottles, ewers, jars, *zun* vases, bowls, plates, or cups (fig. 123), though in Europe they were destined to be used for display only. The kraak porcelain which took Europe by storm in the 17th century was a type of underglaze blue export porcelain in a unique style of decoration (fig. 124) which was popular during the Wanli to Chongzhen reigns of the Ming dynasty. The term "kraak" comes from the Dutch name for the Portuguese carracks or merchant ships which first transported the Chinese porcelain. Its most conspicuous characteristic is the form of decoration, in which the central motif on a plate, dish, bowl, or other vessel is surrounded by panels like a fan; the panels are decorated

Fig. 123 Export porcelain in traditional Chinese shapes displayed in the Victoria and Albert Museum.

with flowering plants, birds, insects, or other motifs, while the central motif usually consists of a landscape, human figures, dragons, and so on. This decorative style often appears in early export porcelain.

The main kilns producing kraak porcelain were at Jingdezhen, Pinghe, and Dehua; later, Japan, the Netherlands, and other countries also imitated kraak

Fig. 124 Underglaze Blue Kraak Porcelain Plate

Ming, Wanli period (ca. 1600–1624)
Diameter 50.5 cm
Rijksmuseum, Amsterdam, Netherlands

The central motif on this typical kraak porcelain plate is a scene of birds and flowers. Eight panels on the rim containing designs of antiquities, flowers, and leaves are interspersed with stylized "long life" (*shou*) characters on alternating key-fret and beaded grounds.

porcelain in large numbers.

Tall covered jars and cylindrical beaker-type vases of the Kangxi period were also favored shapes in Europe, and gradually a custom developed of collecting and displaying five-piece sets consisting of three covered jars and two beaker-vases (fig. 125), while the vessels themselves became taller and slimmer; these five-piece garnitures were usually displayed on the mantelpiece.

Chinese shapes with new fittings. Some porcelain vessels in traditional Chinese shapes, once transported to Europe, had metal fittings added in order to adapt them to European dining customs. The earliest pieces of porcelain to appear in Europe were both beautiful and costly, and were often displayed by royalty or the aristocracy in special cabinets of curiosities or in their homes alongside other treasures from far-off lands. Some porcelain vessels were fitted with silver mounts both to emphasize their value and to assimilate them to European vessel types (fig. 126).

European shapes. At the end of the 17th and beginning of the 18th centuries, Europeans realized that by contrast with their traditional metal and wooden tableware which easily rusted or decayed and was hard to keep clean, Chinese porcelain was not only pretty but easy to clean and preserve. Grand dinners held by the aristocracy or the wealthy

Fig. 126 Tankard with Underglaze Blue Body and Silver-Gilt Mounts

Late Ming–early Qing (ca. 1630–1645)
Height 23.5 cm, width 16.5 cm
Victoria and Albert Museum, London

The underglaze blue ginger jar which forms the body of this tankard was made in Jingdezhen in the Chongzhen reign of the Ming dynasty, while the silver-gilt mounting was added in London ca. 1650–1690, converting it into a large tankard suited to European beer-drinking habits.

Fig. 125 A variety of five-piece garnitures of Kangxi-era underglaze blue porcelain displayed in the Porcelain Collection of the Staatliche Kunstsammlungen Dresden (Dresden State Art Collections), Germany.

of Europe required large dinner services sometimes consisting of several hundred pieces, or more than two thousand in the case of royalty. As large orders for domestic porcelain started to reach Jingdezhen from Europe, the production of European style items began to increase, such as beer tankards, condiment flasks (fig. 127), wine-jugs, wine-coolers, coffee-pots, shaving basins, bonbonnières, soup tureens, candelabras, and scent bottles. The Chinese potters had no idea what these items were to be used for, but simply followed the models they were given. Such products, intended purely for export, are almost unknown in China itself.

4 For Export Only: "Kwon-Glazed" Porcelain

Guangzhou porcelain (see figs. 118 and 119 on pages 110 and 111; fig. 128), or "Kwon-glazed" porcelain as it is sometimes known, was a particular type which developed in the course of Chinese porcelain history. Consisting of porcelain painted in overglaze enamel and gilt, it was one of the most numerous types of export porcelain in the mid- to late Qing. It combined traditional polychrome decoration with the famille rose palette and European pictorial technique; after painting it was given a second firing, at a low temperature. The style developed in Guangzhou as a response to foreign trade demand, and first appeared in the Kangxi or Yongzheng reigns of the Qing dynasty, reaching its height during the Qianlong and Jiaqing reigns, further developing during the late Qing, and surviving to the present day.

Porcelain exported during the early period of Sino-European trade, in the mid- to late Ming, mostly consisted of blue-and-white manufactured at Jingdezhen. The dynastic transition of the late Ming to early Qing was a period of instability, and this led to a decline in foreign trade, so the Dutch East India Company turned its attention to Japan, prompting rapid development and improvement in Japanese porcelain manufacture. At the same time as making imitations of Jingdezhen underglaze blue for the European market, the Japanese also marketed their own Imari ware to the European merchants. This was the earliest

Fig. 127 Underglaze Blue Double Condiment Flask with Silver Mounts

Qing, Kangxi period
Height 20.4 cm
Victoria and Albert Museum, London

This underglaze blue porcelain vessel was made in Jingdezhen, in imitation of European glassware, as a condiment flask to hold oil and vinegar. The metal stoppers with their chains were added in Europe.

Fig. 128 Guangzhou Porcelain Plate with Figures in a Courtyard

Late Qing
Diameter 24 cm
Staatliche Kunstsammlungen Dresden, Germany

The colors of Guangzhou porcelain are rich, with a liberal use of gilding. As it was specifically made for export, there are numerous examples of the type shown in the illustration in European museums, whereas examples in Chinese museums are very rare.

type of East Asian polychrome porcelain of which Europeans became aware, and its arrival in Europe sparked interest there in such colorful pieces. In the mid-Kangxi period, with China now politically stable, direct Chinese trade with the various East India Companies revived, and the European merchants started to place orders for large quantities of polychrome porcelain. Initially Jingdezhen responded by producing objects which imitated the Japanese Imari style. Because of the sharp increase in demand for such pieces, and the need to raise productivity by shortening the time from order to completion, workshops in which the second stage of manufacture could be carried out started to appear in Guangzhou on the banks of the Pearl River, not far from the Thirteen Factories. Here, the overglaze polychrome painting could be carried out according to the buyers' requirements on plain white porcelain from Jingdezhen, which could then be given a second, low-temperature firing to fuse the enamel pigments. In the early period, the work of the local potters was overseen by specialist officials from Jingdezhen, but as the scale of the Guangzhou workshops increased and the local potters' skills developed, the quality of Guangzhou porcelain became finer and finer; a stylized color palette and decoration gradually came into being, and the products were exported in large numbers.

The overglaze painting on Guangzhou porcelain is typically done with thick washes of pigment, in a style combining the techniques of European oil painting and the *gongbi* and "boneless" styles of Chinese ink painting. At least a dozen different pigments were used, the most common being alum red, pink, green, gold, and lilac. The painting style of early Guangzhou porcelain resembled the polychrome from Jingdezhen, though the work of the Guangzhou painters was not so careful. In the early 19th century, Guangzhou porcelain designs began to imitate the patterns of Chinese woven brocade. Later, the painters used a liquid gold paint on all kinds of different vessels, and this became an important feature of Guangzhou porcelain decoration. Changes in the design of Guangzhou ware reflect its commercial fortunes. In the 18th century it was mainly exported to Europe, where most customers belonged to the nobility. As trade routes between China and the United States opened up in the 19th century, Guangzhou porcelain began to penetrate the American market, which gradually took over from Europe as its main destination. In the United States, Guangzhou porcelain was popular at all levels of society. The enthusiasm of American consumers at the time for gilt decoration of all kinds caused the decorative style of Guangzhou porcelain to evolve towards the use of strong, bright reds, greens, and gold, with gold being particularly prominent. This style of decoration has lasted to the present day.

APPENDICES

GLOSSARY

Alum red/iron red: a glaze color.

Apsara: a female spirit of Buddhist legend, somewhat analogous to the Judeo-Christian concept of an angel, often depicted flying, dancing, or playing a musical instrument.

Beaker-vase (*gu*): a vase imitating the shape of a type of ancient bronze vessel known as a beaker or goblet (*gu*, q.v.).

Bent-waist bowl (*zheyao wan*): bowl with a sharp angle in the side, near the foot, and a slightly everted side above the angle.

Blue-and-white/underglaze blue (*qinghua*): porcelain particularly from the Yuan, Ming, and Qing dynasties with cobalt-blue decoration on a white ground under a clear glaze.

Body: the basic clay form of the vessel before the application of any slip or glaze.

"Boneless" painting: see *mogu* painting.

Burin: a tool for incising or engraving, in China often made from bamboo.

Canton system: the foreign trade system instituted in the Qing dynasty. All ports other than Guangzhou (Canton) were closed to foreign trade, and the trade in Guangzhou was controlled by a small group of Chinese merchants acting on behalf of the government (the Hong merchants, q.v.). Foreign merchants were allowed to reside in Guangzhou for part of the year only.

Cavetto: the concave part of a bowl or deep dish between the rim and base.

Celadon: a green or grey-green glaze, particularly associated with the Longquan kilns. Often used to refer to porcelain vessels covered with this glaze. The English word, whose Chinese equivalent (*qingci*) simply means "blue-green porcelain," is the name of a character in an 18th-century French play who habitually wore this color.

Ceramic: refers to any type of fired clay, including earthenware, stoneware, porcelain, etc.

Chicken-leg vase (*jituiping*): a tall, narrow jar with rounded shoulder and a very narrow neck, similar to a *meiping* vase (q.v.) but with a slimmer profile. The shape is reminiscent of a chicken drumstick.

Co-hong: see Hong merchants.

Combing: a means of decorating clay with a pattern of fine parallel lines, achieved by the use of a comb-like tool.

Cong: an ancient type of ceremonial vessel, often made of jade, in which square corners are added to a cylindrical body, representing the union of earth (square) with heaven (round).

Crackle: a pattern of lines in the glaze as a result of a deliberate process in the firing. Sometimes enhanced by adding a colored slip (q.v.) between body and glaze, or by rubbing a pigment into the cracks.

Crazing: cracks appearing in the glaze as a result of faulty firing when the body expands or contracts at a different rate from the glaze. If done deliberately, the effect is known as "crackle" (q.v.).

Deer-head *zun*: a type of squat vase with handles or lugs on the shoulders, often decorated with a design of deer in a landscape. The shape of the body is supposed to resemble the head of a deer. A *zun* (q.v.) is an ancient type of vase originally made of bronze.

Doucai: literally meaning "fitted colors" or "dove-tailed colors," this refers to a decorative technique in which underglaze blue outlines were filled in, after a first, high-temperature firing, with overglaze pigments, which were thus "fitted" or "dove-tailed" into the design; this was followed by a second firing at a low temperature.

Dragon kiln: a type of kiln peculiar to south-east China. A kiln many meters long is built on the slope of a hill, so that the rise in height encourages oxygen to be drawn through the kiln, thus increasing the temperatures that can be achieved.

Drum-nail: a type of decoration in which the surface is covered with small raised bosses, supposed to resemble the nails securing a drum-skin.

Eared cup: a shallow drinking vessel with two "ears" or lugs used as handles.

Earthenware: clay vessels fired at a low temperature. They absorb water, and are not as strong as porcelain.

Egg-white glaze (*luanbai you*): named for its similarity to the color and texture of egg-shells, this high-fired glaze was developed in the Yuan dynasty for government use. Porcelain with this glaze may also be referred to as "Shufu ware."

Eight treasures: eight symbols of the Buddhist religion, consisting of conch-shell, endless knot (infinity knot), pair of fish, lotus, parasol, vase, wheel, and banner, often used together as decorative motifs.

Enamel: the Chinese term *falangcai*, usually translated as "enamel," refers to a type of pigment composed of a mineral frit (q.v.), which is painted over a high-fired glaze and then fired at a low temperature. The term "enamel" is sometimes used in English to refer to other types of overglaze pigment used on porcelain.

Factory: in 18th-century parlance, a trading office or agency occupied by a "factor" or agent. The Thirteen Factories were the combined offices, warehouses, and accommodation of the foreign merchants permitted to live and work in Guangzhou for part of each year during the operation of the Canton system (q.v.) of foreign trade.

Famille rose: this French term, invented by French scholars in the mid-19th century and meaning "pink family," refers to a palette of pigments dominated by pink, which became a standard for the decoration of porcelain in overglaze enamels during the Qing dynasty. The Chinese equivalent is *fencai* (pink color); it is sometimes known as *ruancai* (soft color).

Famille verte: this French term meaning "green family" refers to decoration in a palette of pigments dominated by green, which was widespread in the early Qing dynasty.

Feldspar: a mineral which can form an ingredient in both

body clays and glazes.

Flux/fluxing agent: a mineral component added to a glaze to enable it to melt and adhere to the clay body at a lower temperature than would otherwise be the case.

Frit: a finely-ground fusion of different materials, used in the preparation of glazes.

Garniture: a set of porcelain vessels, often a five-piece set consisting of three covered jars and two beaker-type vases, displayed as decoration, usually on a mantelpiece.

Ginger jar (*lianzi guan*): a squat, rounded type of jar with a lid, usually decorated in underglaze blue. In Chinese this is known as a "lotus-seed jar" because of the resemblance of the shape to a lotus seed; the English name comes from the use of such vases as containers for preserved ginger exported from China to Europe.

Glaze: a viscous liquid applied to a clay body; when fired it fuses and adheres to the clay, forming a glassy substance which makes the vessel waterproof, increases its strength, and also adds a decorative element.

"Gold red" (*jinhong*): Chinese term for the pigment known in English as "ruby back" (q.v.).

Gongbi painting: a highly realistic style of painting, practiced in the late imperial period mainly by artisan painters. The Chinese name literally means "work brush," which can be interpreted as "craftsman's style" or "highly-worked style."

Greenware: porcelain or stoneware fired with a green glaze, a precursor of celadon (q.v.). The Chinese language makes no distinction between greenware and celadon.

Gu goblet: an ancient bronze vessel of a roughly cylindrical shape with a flaring or everted rim and often with a rounded protrusion at mid-height.

Guan jar: a large type of jar with a rounded belly, flattish shoulders, and a short neck. They were usually covered, although the lids do not always survive.

Guangzhou porcelain/kwon-glazed porcelain (*guangcai*): a style of porcelain made in Guangzhou from the Qing dynasty, in which plain white vessels high-fired in Jingdezhen and transported to Guangzhou were then decorated in overglaze enamels and given a second low-temperature firing.

Gui: a type of ancient bronze vessel, used for the consumption or offering of grain, with a circular shape, on a narrower foot, with either two or four handles, and sometimes a lid.

Hard polychrome, hard colors (*yingcai*): see *wucai*.

Heaven jar: a small lidded jar of a rounded shape and a standard type of decoration, with the character *tian*, meaning heaven, inscribed on the base. Such vessels are said to have been gifts from the Ming Chenghua Emperor to his consorts.

High-firing: the firing of clay vessels in a kiln at a high temperature. This causes the components of the clay body to fuse together, making a stronger and, in the case of porcelain, waterproof vessel, and it also enables the glaze to fuse and adhere to the body. When so fired the vessels can be described as "high-fired."

Hong merchants/co-hong: a small group of wealthy merchants in Guangzhou who on behalf of the government controlled foreign trade and were responsible for the well-being and good behavior of the foreign merchants under the Canton system (q.v.).

Imari ware: a type of Japanese porcelain with underglaze blue and overglaze polychrome decoration developed in imitation of Chinese polychrome in response to demand from Europe.

Iron-red: see alum-red.

Jian cup: a large bowl-shaped cup with a dark brown or black glaze, used for tea-drinking in the Song dynasty.

Jue: a type of ancient tripod goblet made in earthen ware or bronze, later imitated in porcelain as an antiquarian decorative or ceremonial item.

Kakiemon: a type of Japanese porcelain with overglaze polychrome decoration, related to Imari ware (q.v.).

Kaolin: a type of clay particularly found near Jingdezhen at a site called Gaoling (Kao-ling in older romanization) and used for the manufacture of porcelain.

Kiln: the "oven" in which pottery is fired. Kilns may be built in various shapes: see dragon kiln for one Chinese type.

Kiln furniture: equipment used in a kiln during the firing process, such as saggars and kiln-stilts (qq.v.).

Kiln-stilts/spurred stands: a type of kiln furniture (q.v.) made of earthenware with upright spikes on which vessels to be fired were placed in the kiln. Where the tips of the stilts or spurs touched the body or glaze during firing they left marks known as spur-marks (q.v.).

Kiln transmutation (*yaobian*): change in the composition of a glaze as a result of firing, often resulting in particular color effects.

Kinrande: a style of Japanese porcelain related to Imari ware (q.v.) in which gold is quite liberally applied over polychrome decoration.

Kraak porcelain: a type of export porcelain, usually in the form of plates, with a distinctive form of underglaze blue decoration consisting of a central motif, often floral, on the interior base, surrounded by radiating panels on the cavetto (q.v.) or rim filled with decorative motifs. The name comes from the Dutch form of the term "carrack," a type of Portuguese merchant ship on which the porcelain was originally transported from China. The style of kraak porcelain had a strong influence on Dutch Delft ware.

Kundika water-sprinkler: a type of water-sprinkler used in Buddhist ritual. The shape originated in India.

Kwon-glazed porcelain: see Guangzhou porcelain.

Lang red (*Langyao hong*): a type of red glaze named after Lang Tingji (1663–1715), who supervised the production of porcelain at Jingdezhen in the early 18th century. This glaze color is known in English by the French term *sang de boeuf*, meaning "bull's blood," which can also be used for the color of glaze described in Chinese as the red of clearing skies (*jihong*).

Lang ware (*Langyao*): porcelain made during the tenure of Lang Tingji (see also "Lang red") as superintendent of the imperial workshops at Jingdezhen, especially that made to celebrate the Kangxi Emperor's sixtieth birthday in 1713.

Leather-hard: description of the partially dried body of a clay vessel after shaping but before firing. This condition meant that crisp lines in the clay could be achieved by

incising or engraving before glazing and firing.

Lei: An ancient type of vessel usually made in earthenware or bronze, with a squat, open shape; the type was later often imitated in porcelain as an incense-burner.

Leys jar: a jar with a wide everted mouth and bulbous belly used for the disposal of waste, e.g. used tea-leaves. Sometimes referred to (and used as) a spittoon.

Li: a tripod cauldron, an ancient type of earthenware or bronze cooking vessel, with a bulbous body on three legs, and sometimes with two ring handles set upright on the rim.

Liquid gold: pigment formed by melting a combination of gold and organic compounds, giving a more durable form of decoration than gilding.

Lotus jar: a distinctive type of funerary or ritual urn with elaborate sprigged (q.v.) decoration, usually incorporating Buddhist motifs.

Low-firing: the firing of vessels in the kiln at a low temperature. This is characteristic of the firing of earthenware, the temperature being insufficient to fuse porcelain clay. Vessels so fired can be referred to as low-fired.

Lug: an "ear" or handle, sometimes pierced but often solid, attached to a cup, vase, or other vessel.

Mallet vase: the English term for a type of vase in the shape of a mallet, with a squat, approximately cylindrical body and a narrow, high neck. The Chinese term is *yaolingzun* or handbell vase, as it also resembles a handbell.

Mangkou: this Chinese term, meaning rough mouth or bare rim, refers to the unglazed rim of a bowl or plate which has been fired "rim-down" (q.v.). The unglazed rim on some types of porcelain would be bound in metal for a more pleasing aesthetic effect.

Meiping vase: a tall slim vase with wide, rounded shoulders and a short, narrow neck. The Chinese name means "plum-blossom vase," as the shape is suitable for displaying a single branch or twig of blossom.

Mise/secret color/bise: a type of celadon (q.v.) glaze particularly used in the 10th century for imperial porcelain. The name may refer to a particular color or to an association with Buddhist ritual.

Mogu painting: literally meaning "boneless" painting, this refers to a style of painting, often of floral subjects, using washes of color and avoiding the use of outlines.

Monk's cap ewer (sengmao hu): a distinctive shape of ewer with a high rim and pointed spout recalling the shape of a type of cap worn by Tibetan Buddhist lamas.

Monochrome: of a single color, usually referring to glaze color.

Narcissus bowl (shuixian pen): a shallow, rather thickly potted bowl used for growing narcissus bulbs in water.

Overglaze: describes painting or decoration done on the surface of the fired glaze, and usually then subject to a second firing to fix the pigments of the decoration.

Oxidizing atmosphere: when the atmosphere inside the kiln during firing has a high oxygen content, as a result of a strong through draught of air, this is referred to as an oxidizing atmosphere. The effect is to make the body color of earthenware (not porcelain) darker, and to produce various color effects in the glaze, depending on its constituent parts.

Peach bloom: English term for a soft copper-red glaze color known in Chinese as "cowpea red" (*jiangdou hong*).

Piled white (duibai): application of a layer of glass white over regular white glaze before decoration, in order to give an effect of low relief.

Pilgrim flask: a term used in English-language scholarship for a round, flat-sided flask, often with pierced lugs to attach a carrying cord; this is known in Chinese as a "flat flask" (*bianhu*).

Polychrome: many-colored, usually referring to overglaze decoration. In relation to Chinese ceramics, the term is generally used as a translation for the Chinese *sancai* (three-colored) or *wucai* (five-colored).

Pomegranate vase (shiliu zun): a squat, more or less spherical vase with a short neck which is sometimes foliated to increase the resemblance to a pomegranate fruit.

Porcelain: a type of ceramic with a kaolin (q.v.) body and a lustrous glaze, regarded in most Chinese scholarship as having the characteristics of being hard, resistant to heat, waterproof, and making a metallic sound when struck. In English-language scholarship, porcelain is also defined as being translucent. The Chinese term *ci*, usually translated as porcelain, therefore covers a wider range of ceramics than the English term porcelain. Types of ceramic which in Chinese are treated as early forms of porcelain may in English be characterized as stoneware or porcelaneous ware (qq.v.).

Porcelain stone: a mineral which when mixed with kaolin (q.v.) forms the body of porcelain ware.

Porcelaneous ware: a term used in English-language scholarship for stoneware of a very refined quality, verging on what would be defined in English as porcelain. Porcelaneous ware is not distinguished from porcelain in Chinese scholarship.

Pouring bowl: see spouted bowl.

Precipitation: a chemical process occurring during the firing of underglaze blue porcelain which results in the underglaze cobalt pigment forming darker patches on or near the surface of the glaze.

Proto-porcelain: a term now obsolete in English but still used in Chinese (*yuanshi ci*) to denote early forms of porcelain (which in English might be described as stoneware or porcelaneous ware, qq.v.) before porcelain attained its refined form.

Qingbai: literally "blue-white," a particular type of blue-tinged glaze used on southern porcelains produced from the 10th to 14th centuries. Sometimes called *yingqing* ("shadow-blue"), q.v.

Reducing atmosphere: a kiln atmosphere very low in oxygen, achieved by smothering the air inlet of the kiln, in order to achieve particular effects on the body or glaze.

Reign-mark: characters written, usually in underglaze blue and in a rectangular surround, on the base of high-quality vessels intended for official use in the Ming and Qing dynasties. The characters are intended to indicate the reign-period in which the vessel was made, but in some cases the vessel was made in a later period, in which case the inscription may be meant as an indication of quality rather than a deliberate attempt to deceive the viewer about the vessel's date.

Reserve: a decorative technique in which parts of the body are covered or "reserved" by the use of materials such as wax, grease, or paper, so that when the glaze is applied it does not cover those parts. After firing, the reserved areas may be left in the body color or may be further decorated before a second, low-temperature firing.

Reward vase (*shanghu*): a type of large, long-necked bottle vase awarded by the Qing emperors to those whom they favored.

Rim-down firing: the process whereby a number of concave vessels may be fired together in a single saggar (q.v.) by placing them upside down one above the other with their rims supported by steps on the inside of the saggar. In this way a much larger number of vessels can be fired in the kiln at once.

Ring-matted: a decorative technique in which the background of a design is filled in with circular marks made with the use of a bamboo cylinder or similar tool.

Rolwagen vase: known in Chinese as a *tongping* ("cylindrical vase" or "tube vase"), and sometimes called a "sleeve vase" in English, this is a vase with a more or less cylindrical form and a short wide neck. These vases were given the Dutch name "rolwagen" ("trolley," referring to the roller-like form) when the vases were exported to the Netherlands.

"Rouge red" (*yanzhihong*): Chinese term for the pigment known in English as "ruby back" (q.v.).

Rough mouth: see *mangkou*.

Rouleau vase: known in Chinese as a *bangchuiping* or club-shaped vase, this is a more or less cylindrical vase with flat shoulders and a fairly high, narrow neck. The French term *rouleau*, meaning a roll, refers to the shape.

"Ruby back": the English term for a dark rose colored pigment applied to the exterior surface of porcelain vessels in the Qing dynasty; known in Chinese as "gold red" or "rouge red" (qq.v.).

Saggar: an earthenware vessel in which ceramic items are contained for placing and firing in the kiln. This protects the items, preventing them from touching one another; it also helps to heat them more evenly, thus reducing breakage. Saggars may be re-used, or may be broken to remove the fired vessel.

Sancai: see polychrome.

Sang de boeuf: see "Lang red."

Secret color: see *mise*.

Sgraffito/sgraffiato: a decorative technique in which a glaze or outer layer of slip (q.v.) is scratched away with a sharp-pointed tool, revealing the color of the underlying body or slip.

Sherd: sometimes spelled "shard," and pronounced as though so spelled, this is a term used particularly by archeologists for a broken fragment of pottery.

Shufu ware: see egg-white glaze.

Slip: a mixture of clay diluted with water to the consistency of thin cream, applied to the body of a ceramic vessel, sometimes as a decoration in itself, giving a particular color, or to cover up impurities in the body clay, or to provide a base for glazing.

Slump: when large wide-bodied vessels are placed in the kiln for firing, the weight of the clay in the upper part of the body may cause it to sink down, thus distorting the shape; this is referred to as slumping.

Soft color (*ruancai*): see famille rose.

Spittoon: see leys jar.

Spouted bowl/pouring bowl: a particular shape of vessel, known as *yi* in Chinese, this is a fairly shallow bowl with a spout at the edge for pouring out liquid.

Sprigging: a term used in ceramics for an appliqué technique, in which small, flattish shapes are formed from clay and applied to the surface of the body to produce relief decoration.

Spur-marks: the marks left on the exterior base of a vessel by the spurred stand or kiln-stilts (q.v.) supporting it or the vessel stacked above it in firing.

Spurred stand: see kiln-stilts.

Stem-cup (*gaozubei*): a type of drinking vessel used in the Yuan dynasty, with a rounded bowl with flaring rim on a high foot, also known in Chinese as a "handle-cup" (*babei*), the "handle" being formed by the high foot, or "stirrup-cup" (*mashangbei*, literally "horseback cup"), presumably referring to the ease of holding it while on horseback.

Stoneware: a type of ceramic, usually glazed, fired at temperatures around 1,200 to 1,280 degrees Celsius. The body differs from that of mature porcelain, but Chinese terminology does not differentiate between the two.

Stupa: a dome-like Buddhist structure used to contain relics, sometimes imitated in miniature in porcelain or other materials.

Sweet dew vases (*ganlu ping*): pairs of vases used as ceremonial vessels in Buddhist worship, usually placed on an altar to hold water or flowers.

Tang ware: porcelain of high quality and innovative form produced during the tenure of Tang Ying (1682–1756) as supervisor of the imperial porcelain workshops at Jingdezhen in the early to mid-18th century.

Temper: to add an additional ingredient or ingredients to the body clay in order to achieve various effects, e.g. greater strength after firing.

"Three sheep" vase: a type of vase decorated with three heads of sheep on the neck.

Underglaze: describes painting or decoration done directly on the body which is then covered by a transparent glaze before firing.

Underglaze blue: see blue-and-white.

White-ware: a type of ceramic with a whitish color deriving from high kaolin (q.v.) content in the body. White-ware, which appears very early in the history of Chinese ceramics, provided the basis for the development of porcelain but was fired at much lower temperatures.

Wucai: literally meaning "five colors" or "five-colored," this is the term usually used in Chinese to refer to what in English is known as polychrome or famille verte (qq.v.) porcelain. It is sometimes also known in Chinese as *yingcai*, literally meaning "hard colors."

Yingqing: literally "shadow-blue," this is a name for the glaze usually called *qingbai* (blue-white), q.v.

Zang ware: porcelain made during the tenure of Zang Yingxuan as superintendent of the imperial porcelain workshops at Jingdezhen, between 1680 and 1688.

Zun: an ancient type of bronze ritual wine-vessel, often with a wide, flaring rim.

BIBLIOGRAPHY

An Jinhuai, "A Discussion of Some Questions about Shang Dynasty Porcelain from Zhengzhou," *Cultural Relics* (Wenwu), 1960, No. Z1.

Deng Heying & Tang Junjie, *Southern Song Guan Ware* (Nansong guanyao), Hangzhou: Hangzhou Publishing House (Hangzhou chubanshe), 2008.

Geng Baochang, *The Connoisseurship of Ming and Qing Porcelain* (Mingqing ciqi jianding), Beijing: Forbidden City Publishing House (Zijincheng chubanshe), 1993.

Hangzhou Cultural and Archaeological Research Institute and Lin'an Cultural Relics Office, "The Kangling Tomb of the State of Wu-Yue in the Five Dynasties," *Cultural Relics* (Wenwu), 2014, No. 6.

Huang Jing, "Remarks on Guangzhou Porcelain: the Artistic Characteristics of Guangzhou Porcelain Vessels," *Identification and Appreciation to* [sic] *Cultural Relics* (Wenwu jianding yu jianshang), 2011, No. 2.

Huang Qinghua & Huang Wei, "On the Underglaze Blue Cloud and Dragon Vases of 1351," *Cultural Relics* (Wenwu), 2010, No. 4.

Jiang Jianxin, *A Study of the Ming Official Kilns in the Hongwu Reign* (Ming Hongwu guanyao yanjiu), Beijing: Cultural Relics Press (Wenwu chubanshe), 2018.

Jiang Zanchu, "An Overview of Eastern Han and Six Dynasties Celadon from the Middle Reaches of the Yangtze River," *Jianghan Archaeology* (Jianghan Kaoku), 1986, No. 3.

Lü Chenglong, "A Unique Style of Late-Qing Official-Type Porcelain—Guangxu-Period Porcelain with the 'Hall of Bodily Harmony' Mark," *The Collector* (Shoucang jia), 2007, No. 11.

Nanjing Museum, Jiangsu Archaeological Research Institute, & Wuxi Xishan District Cultural Relics Administration Committee eds., *Excavation Report on the Yue Tombs at Hongshan* (Hongshan yuemu fajue baogao), Beijing: Cultural Relics Press (Wenwu chubanshe), 2007.

National Museum of China ed., *National Museum of China Collections Research Series—Porcelain* (Zhongguo guojia bowuguan guancang wenwu yanjiu congshu ciqi juan) (Ming and Qing Volumes), Shanghai: Shanghai Classics Publishing House (Shanghai guji chubanshe), 2007.

Peng Minghan, *Dated Underglaze Blue Porcelain from Ming-Dynasty Unofficial Kilns at Jingdezhen* (Mingdai Jingdezhen minyao jinian qinghuaci), Beijing: Cultural Relics Press (Wenwu chubanshe), 2018.

Qin Dashu, "An Investigation into the Beginnings of the Jun Kilns," *Archaeology of China* (Huaxia kaogu), 2004, No. 2.

Taibei Palace Museum, *Sunlight from Gold—Enamel-Painted Porcelain of the Yongzheng Period*, Taibei Palace Museum, 2013.

Wang Guangyao, *The Official Kiln System in Pre-Modern China* (Zhongguo gudai guanyao zhidu), Beijing: Forbidden City Publishing House (Zijincheng chubanshe), 2004.

Wang Jianhua, "A Survey of Palace Enamels in the Qing Dynasty," *Journal of the Palace Museum* (Gugong bowuyuan yuankan), 1993, No. 3.

Wang Jianhua, "Qianlong-Period Reproductions of Song Ru, Guan and Ge Ware," *The Collector* (Shoucang jia), 1997, No. 6.

Weng Yanjun, Cui Jianfeng, & Jiang Jianxin, "An Analysis of Bodies and Glazes of Song and Yuan *Qingbai* Porcelain from the Luomaqiao Kiln-Site at Jingdezhen, with a Discussion of the Origins of the Porcelain-Stone and Kaolin Mixture," *Cultural Relics of the East* (Dongfang bowu), 2015, No. 3.

Xi'an Tang City Work Team, Institute of Archaeology, Chinese Academy of Social Sciences, "Short Report on Excavation of Ximing Temple Site in Xi'an," *Archaeology* (Kaogu), 1990, No.1.

Zhao Congyue, "When Was the 'Hall of Bodily Harmony' Mark Created?", *South-Eastern Culture* (Dongnan wenhua), 2011, No. 6.

Zheng Hong, "Reflections on the Shunzhi-Period Porcelain in the Palace Museum Collection," *National Museum of China Journal* (Zhongguo guojia bowuguan guankan), 2011, No. 8.

DATES OF THE CHINESE DYNASTIES

Xia Dynasty（夏） ... 2070–1600 BC

Shang Dynasty（商） .. 1600–1046 BC

Zhou Dynasty（周） .. 1046–256 BC

 Western Zhou Dynasty（西周） 1046–771 BC

 Eastern Zhou Dynasty（东周） 770–256 BC

 Spring and Autumn Period（春秋） 770–476 BC

 Warring States Period（战国） 475–221 BC

Qin Dynasty（秦） .. 221–206 BC

Han Dynasty（汉） ... 206 BC–AD 220

 Western Han Dynasty（西汉） .. 206 BC–AD 25

 Eastern Han Dynasty（东汉） ... 25–220

Three Kingdoms（三国） ... 220–280

 Wei（魏） ... 220–265

 Shu Han（蜀） ... 221–263

 Wu（吴） .. 222–280

Jin Dynasty（晋） ... 265–420

 Western Jin Dynasty（西晋） .. 265–316

 Eastern Jin Dynasty（东晋） ... 317–420

Northern and Southern Dynasties（南北朝） 420–589

 Southern Dynasties（南朝） .. 420–589

 Liang Dynasty（梁） ... 502–557

 Northern Dynasties（北朝） .. 439–581

Sui Dynasty（隋） .. 581–618

Tang Dynasty（唐） .. 618–907

Five Dynasties and Ten Kingdoms（五代十国） 907–960

 Five Dynasties（五代） ... 907–960

 Ten Kingdoms（十国） ... 902–979

Song Dynasty（宋） .. 960–1279

 Northern Song Dynasty（北宋） 960–1127

 Southern Song Dynasty（南宋） 1127–1279

Liao Dynasty（辽） ... 916–1125

Jin Dynasty（金） ... 1115–1234

Xixia Dynasty (Tangut)（西夏） .. 1038–1227

Yuan Dynasty（元） .. 1279–1368

Ming Dynasty（明） .. 1368–1644

Qing Dynasty（清） ... 1644–1911

MAP OF CHINA WITH LIST OF MAJOR KILN SITES

Kiln	Province, Autonomous Region or Municipality
Gangwa	Inner Mongolia (Nei Mongol Zizhiqu)
Gangguantun	Liaoning
Longquanwu	Beijing
Cizhou, Ding, Xing	Hebei
Ningwu	Ningxia (Ningxia Huizu Zizhiqu)
Jiexiu	Shanxi
Yaozhou	Shaanxi
Gongxian, Hebi, Jun, Linru, Ru, Xiangzhou	Henan
Deqing, Guan, Longquan, Yue	Zhejiang
Jingdezhen	Jiangxi
Changsha	Hunan
Dehua, Jian	Fujian

INDEX